D1103831

1000
tattoos

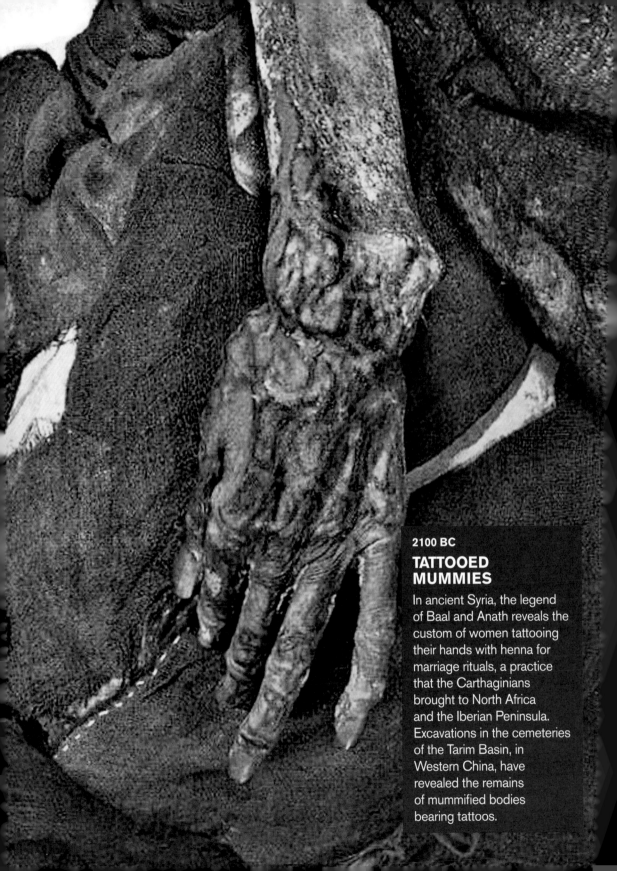

2100 BC

TATTOOED MUMMIES

In ancient Syria, the legend of Baal and Anath reveals the custom of women tattooing their hands with henna for marriage rituals, a practice that the Carthaginians brought to North Africa and the Iberian Peninsula. Excavations in the cemeteries of the Tarim Basin, in Western China, have revealed the remains of mummified bodies bearing tattoos.

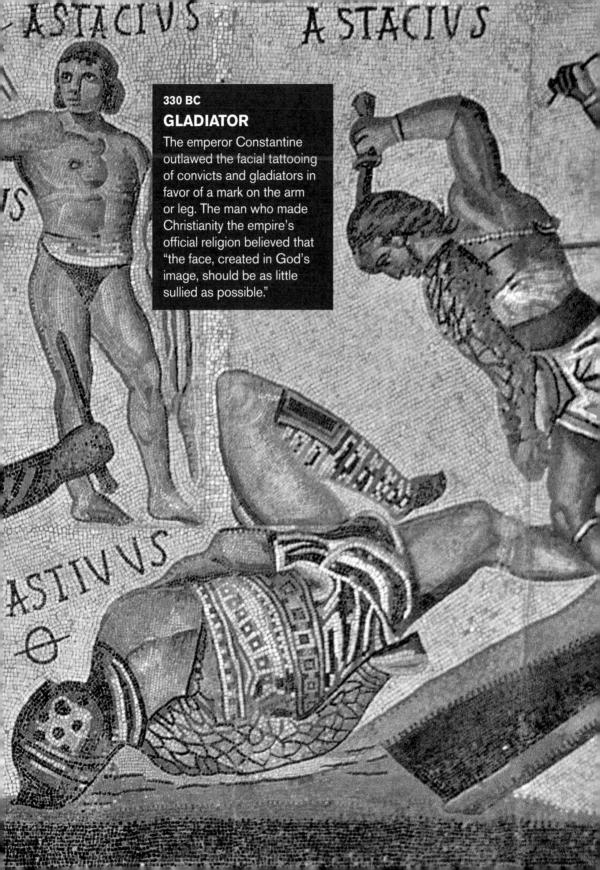

330 BC

GLADIATOR

The emperor Constantine outlawed the facial tattooing of convicts and gladiators in favor of a mark on the arm or leg. The man who made Christianity the empire's official religion believed that "the face, created in God's image, should be as little sullied as possible."

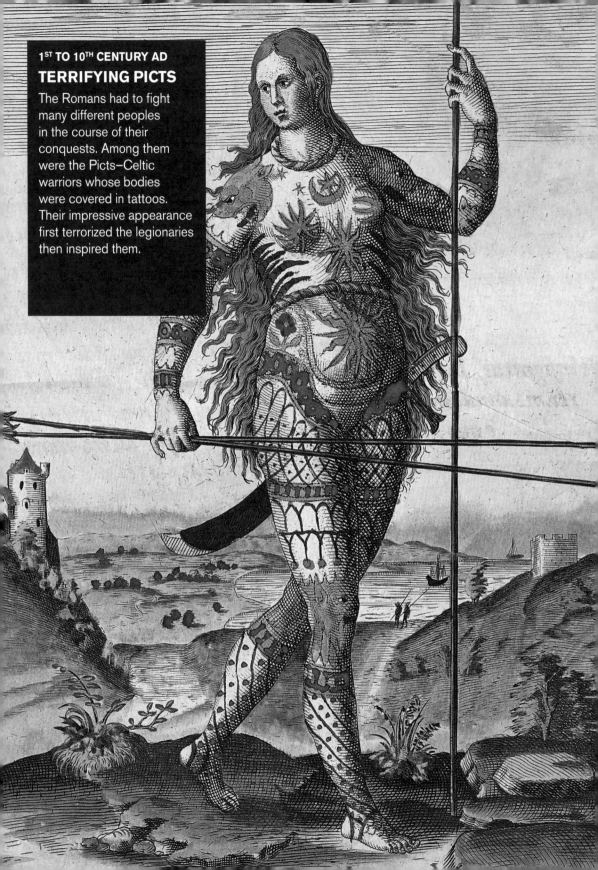

1ST TO 10TH CENTURY AD
TERRIFYING PICTS

The Romans had to fight many different peoples in the course of their conquests. Among them were the Picts–Celtic warriors whose bodies were covered in tattoos. Their impressive appearance first terrorized the legionaries then inspired them.

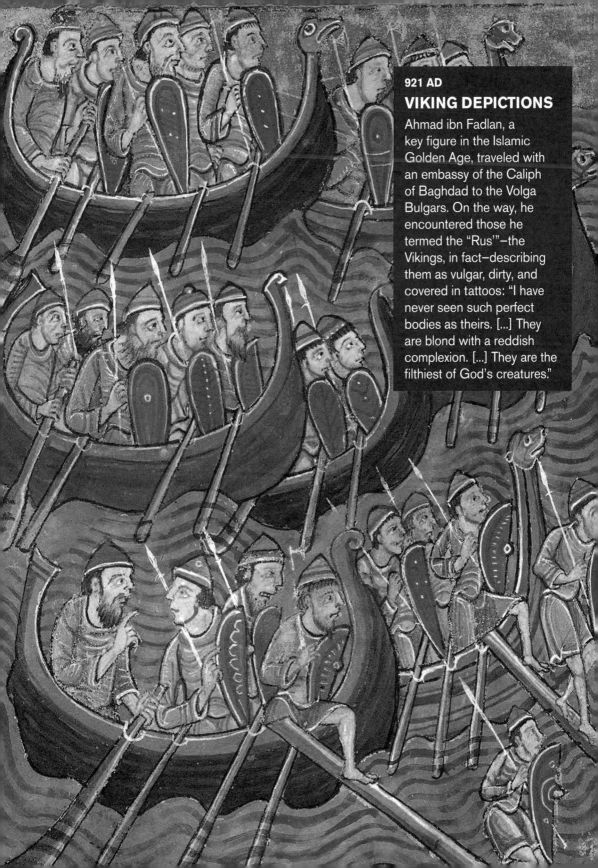

921 AD

VIKING DEPICTIONS

Ahmad ibn Fadlan, a key figure in the Islamic Golden Age, traveled with an embassy of the Caliph of Baghdad to the Volga Bulgars. On the way, he encountered those he termed the "Rus'"–the Vikings, in fact–describing them as vulgar, dirty, and covered in tattoos: "I have never seen such perfect bodies as theirs. [...] They are blond with a reddish complexion. [...] They are the filthiest of God's creatures."

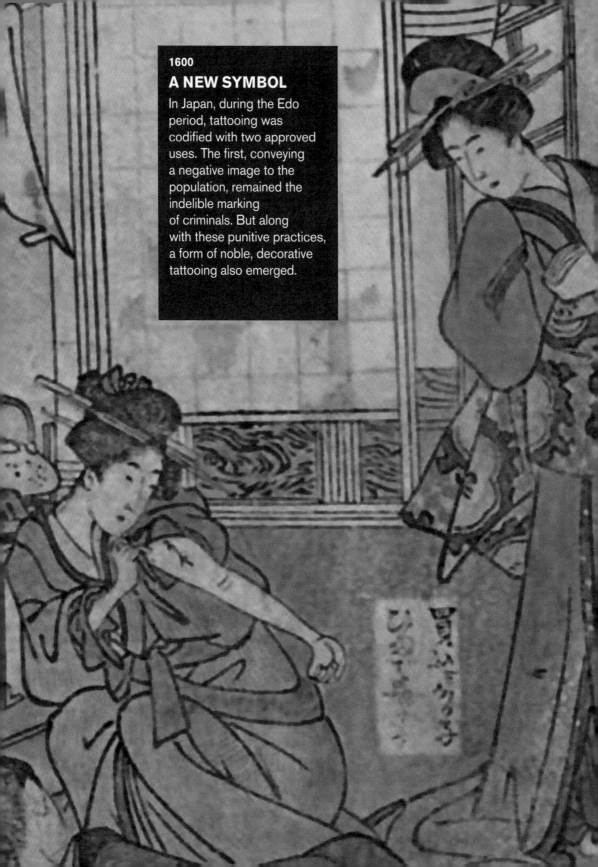

1600

A NEW SYMBOL

In Japan, during the Edo period, tattooing was codified with two approved uses. The first, conveying a negative image to the population, remained the indelible marking of criminals. But along with these punitive practices, a form of noble, decorative tattooing also emerged.

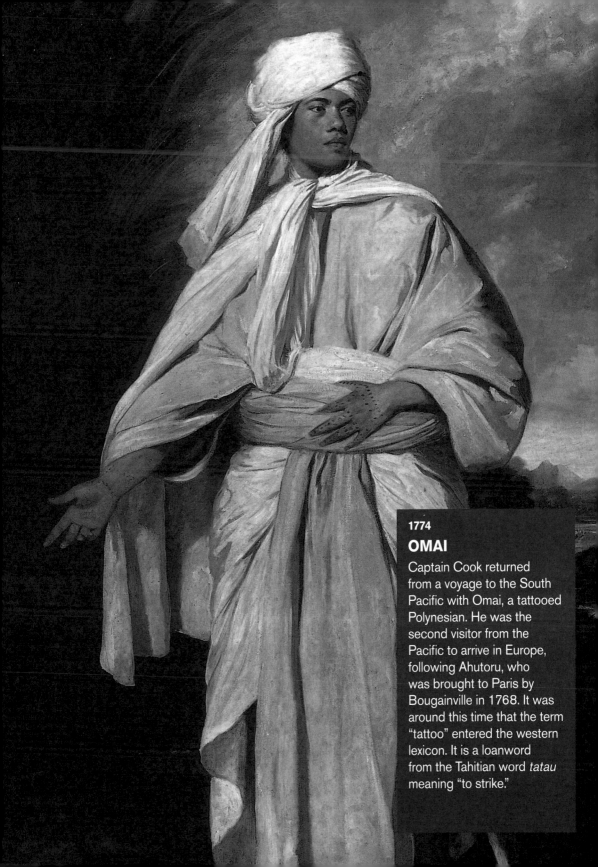

1774

OMAI

Captain Cook returned from a voyage to the South Pacific with Omai, a tattooed Polynesian. He was the second visitor from the Pacific to arrive in Europe, following Ahutoru, who was brought to Paris by Bougainville in 1768. It was around this time that the term "tattoo" entered the western lexicon. It is a loanword from the Tahitian word *tatau* meaning "to strike."

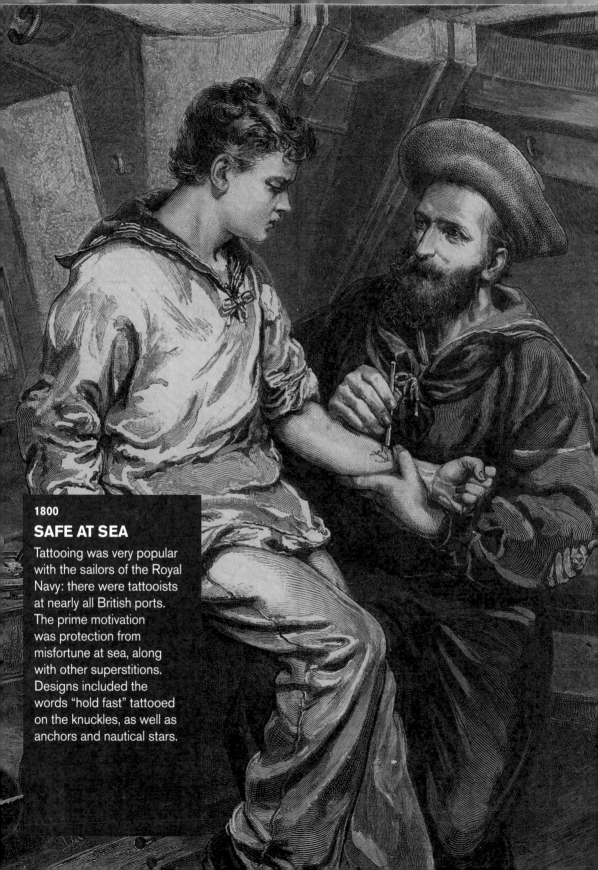

1800

SAFE AT SEA

Tattooing was very popular with the sailors of the Royal Navy: there were tattooists at nearly all British ports. The prime motivation was protection from misfortune at sea, along with other superstitions. Designs included the words "hold fast" tattooed on the knuckles, as well as anchors and nautical stars.

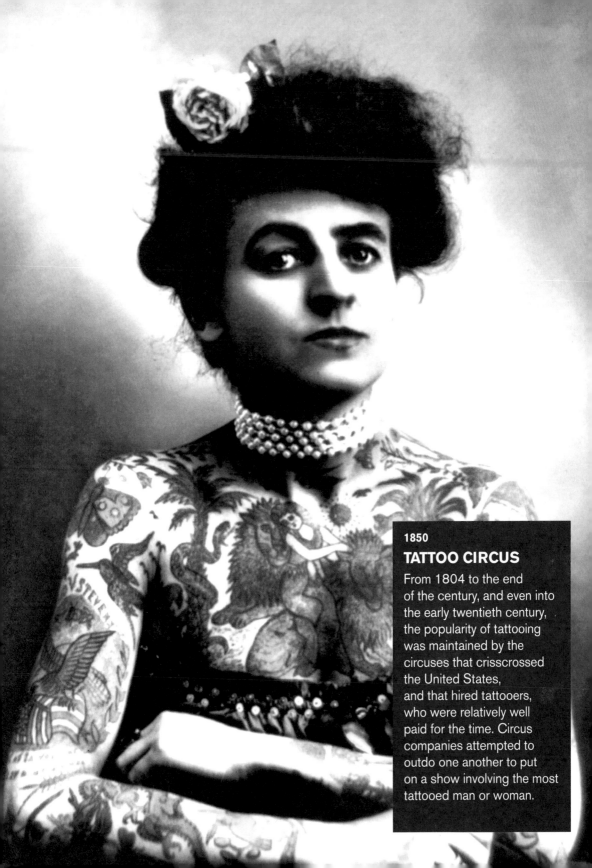

1850

TATTOO CIRCUS

From 1804 to the end of the century, and even into the early twentieth century, the popularity of tattooing was maintained by the circuses that crisscrossed the United States, and that hired tattooers, who were relatively well paid for the time. Circus companies attempted to outdo one another to put on a show involving the most tattooed man or woman.

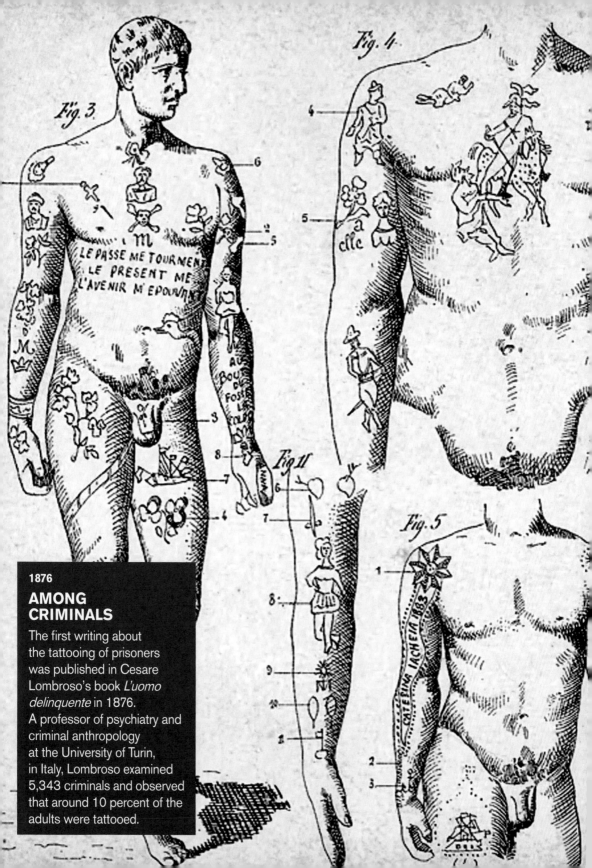

Fig. 3.

Fig. 4.

Fig. 5.

LE PASSE ME TOURMENT
LE PRESENT ME
L'AVENIR M'EPOUVAN

CATERINA IACHEIA 1883

1876

AMONG CRIMINALS

The first writing about the tattooing of prisoners was published in Cesare Lombroso's book *L'uomo delinquente* in 1876.
A professor of psychiatry and criminal anthropology at the University of Turin, in Italy, Lombroso examined 5,343 criminals and observed that around 10 percent of the adults were tattooed.

S. F. O'REILLY.
TATTOOING MACHINE,

No. 464,801. Patented Dec. 8, 1891.

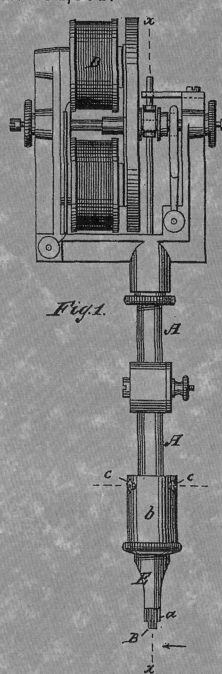

Fig.1.

Fig.2.

1891

MOVING NEEDLES

The American Samuel O'Reilly was the first star tattooist of the Bowery neighborhood. He "borrowed" Edison's electric pen and patented the first tattoo machine. His initial design comprised moving coils, a tube, and a needle bar. Today's tattoo machines are still based on technology dating from the nineteenth century.

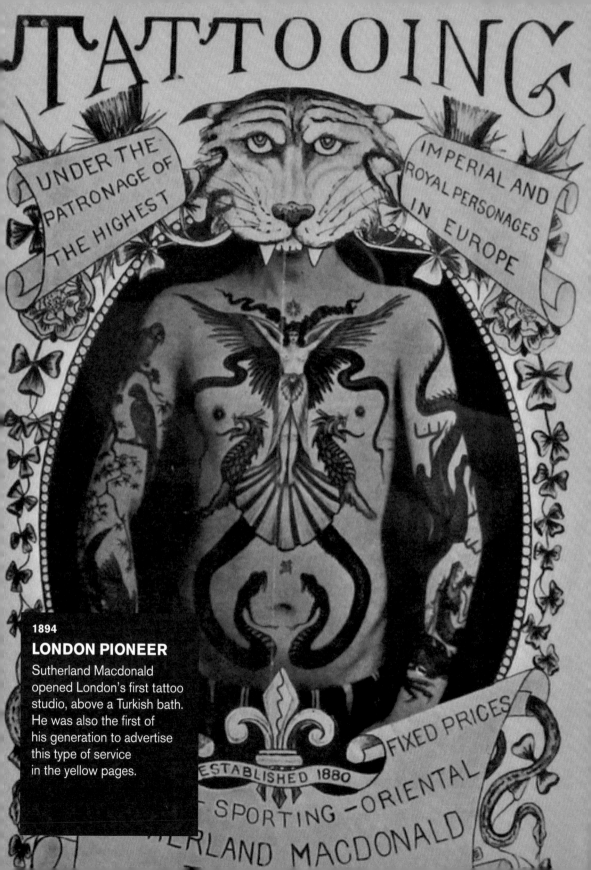

TATTOOING

UNDER THE PATRONAGE OF THE HIGHEST

IMPERIAL AND ROYAL PERSONAGES IN EUROPE

1894

LONDON PIONEER

Sutherland Macdonald opened London's first tattoo studio, above a Turkish bath. He was also the first of his generation to advertise this type of service in the yellow pages.

ESTABLISHED 1880

FIXED PRICES

SPORTING — ORIENTAL

...RLAND MACDONALD

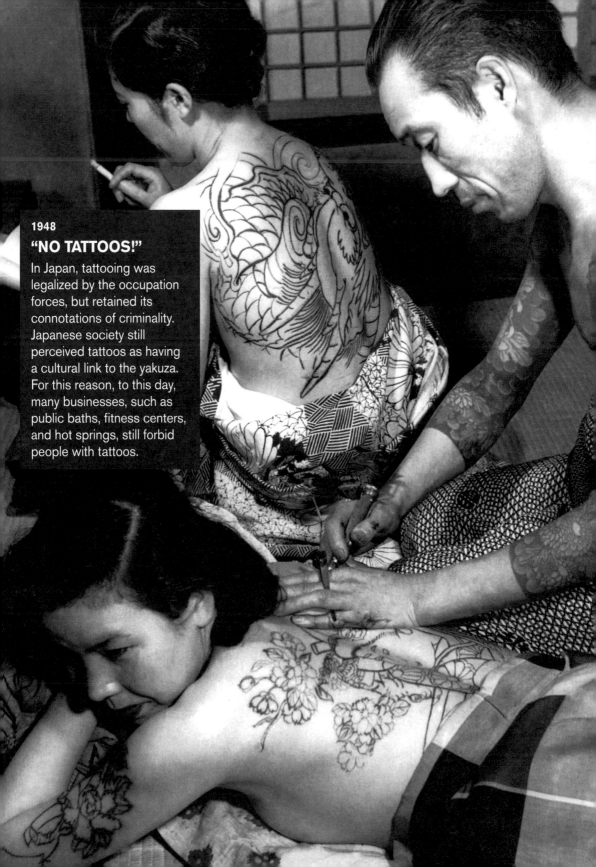

1948

"NO TATTOOS!"

In Japan, tattooing was legalized by the occupation forces, but retained its connotations of criminality. Japanese society still perceived tattoos as having a cultural link to the yakuza. For this reason, to this day, many businesses, such as public baths, fitness centers, and hot springs, still forbid people with tattoos.

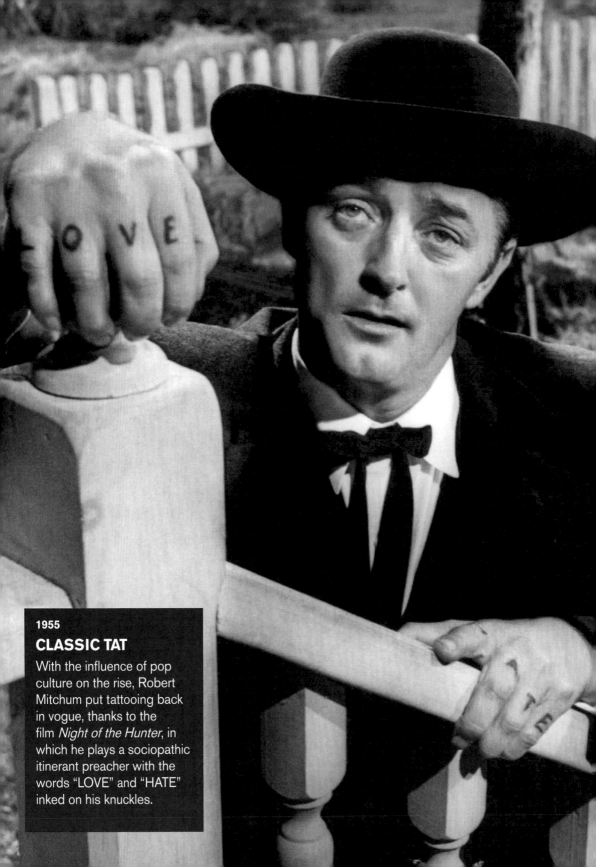

1955

CLASSIC TAT

With the influence of pop culture on the rise, Robert Mitchum put tattooing back in vogue, thanks to the film *Night of the Hunter*, in which he plays a sociopathic itinerant preacher with the words "LOVE" and "HATE" inked on his knuckles.

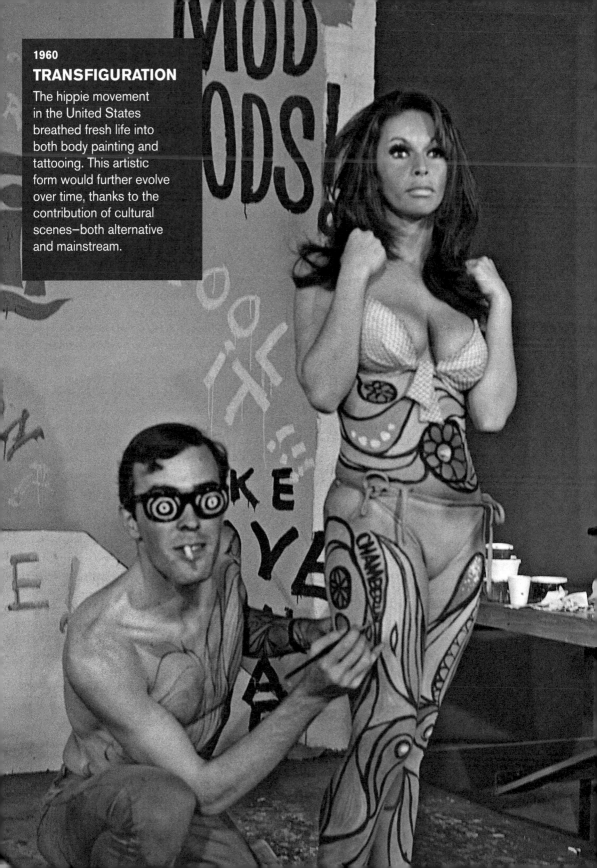

TRANSFIGURATION

The hippie movement in the United States breathed fresh life into both body painting and tattooing. This artistic form would further evolve over time, thanks to the contribution of cultural scenes—both alternative and mainstream.

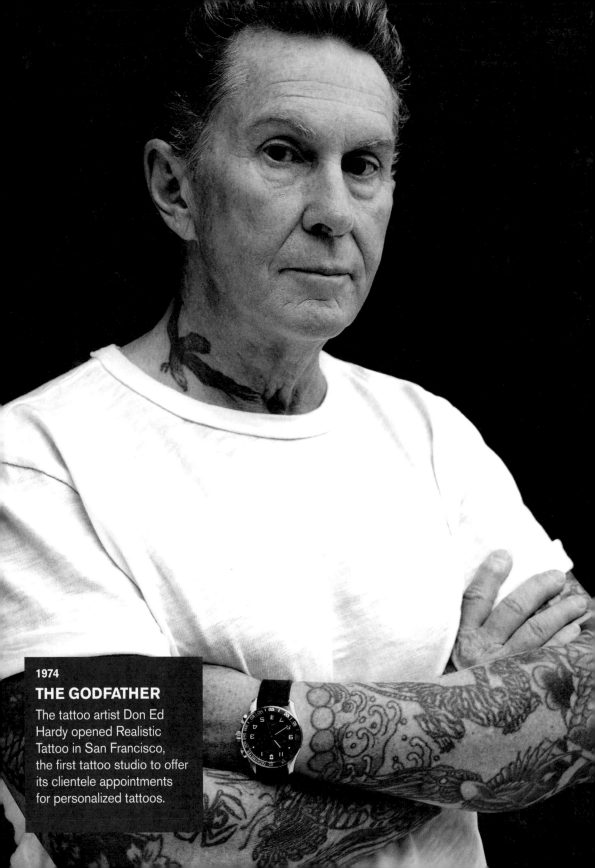

1974

THE GODFATHER

The tattoo artist Don Ed Hardy opened Realistic Tattoo in San Francisco, the first tattoo studio to offer its clientele appointments for personalized tattoos.

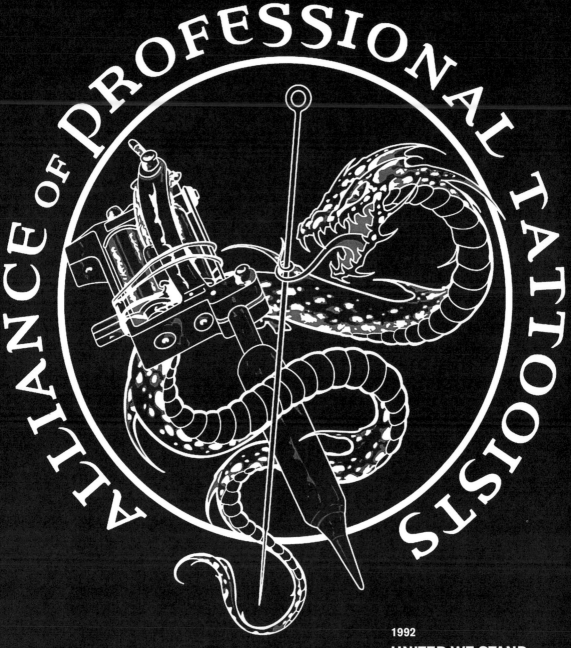

ALLIANCE OF PROFESSIONAL TATTOOISTS

1992

UNITED WE STAND

Founding of the Alliance
of Professional Tattooists
with the aim of establishing
health and safety standards
for its members
and the profession.

This book was designed by Olo Éditions.
www.oloeditions.com
36, rue Laffitte – 75009 Paris – France

Original Concept: Marçais and Marchand
Editor: Nadja Belhadj
Art Director: Philippe Marchand
Texts: Chris Coppola / Nadja Belhadj / Plan9 Entertainment
English Translation: Roland Glasser
Graphic Design and Layout: Thomas Hamel
US Cover: Kayleigh Jankowski

First published in the United States of America in 2018 by
Universe Publishing, a division of Rizzoli International Publications, Inc.
300 Park Avenue South
New York, NY 10010
www.rizzoliusa.com

Originally published in French in 2018 by Editions de La Martiniere

© 2018 Olo Éditions for all other editions

All rights reserved. No part of this publication may be reproduced, stored in a retrieval
system, or transmitted in any form or by any means, electronic, mechanical, photocopying,
recording, or otherwise, without prior consent of the publishers.

2018 2019 2020 2021 / 10 9 8 7 6 5 4 3 2 1

ISBN: 978-0-7893-3444-2

Library of Congress Control Number: 2018948387
℗ Printed in China

1000
tattoos

THE MOST CREATIVE NEW DESIGNS FROM THE WORLD'S LEADING AND UP-AND-COMING TATTOO ARTISTS

CHRIS COPPOLA

UNIVERSE

1000 Tattoos is a reflection of what's happening in the tattoo world today, across the globe. We have seen this art form undergo a major shift, not only aesthetically but also in terms of its widespread embrace by people of all generations and social strata. From stigma to mark of punishment to beauty accessory, tattooing has evolved dramatically over the centuries.

The last twenty years have seen this age-old practice turn a new page and stretch its limits. Two movements have developed simultaneously, opening up new possibilities and widening the range, not only in artistic terms, but also technically and geographically.

Some tattoo artists have made much of their desire to return to basics, to get as close as they can to what they consider to be "the essence of tattooing." They pursue an original, traditional, and ethnic form of tattooing, even touching on the spiritual and the magical. Others, however, are exploring new lands and drawing inspiration from unusual artistic trends, be it music or graffiti. These tattooists see the street and everyday life as a laboratory, as they shrug off a certain conventionalism to develop fresh techniques. Both movements have one thing in common: a perfect mastery of their craft.

1000 Tattoos lets the artists speak for themselves,
as they situate their work in a historical, affective, graphic,
or cultural context. The portraits included here are the result
of interviews, encounters, and exchanges with those who "live"
tattooing, "think" tattooing, and express themselves through
this incredible medium.

This book is an invitation to voyage across the graphic, dynamic
world of contemporary tattooing.

Chris Coppola and Nadja Belhadj

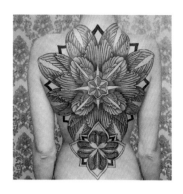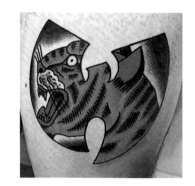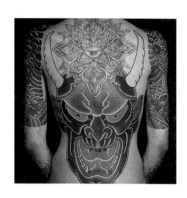

Table of Contents

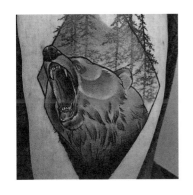 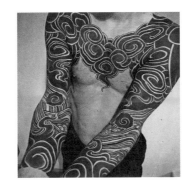 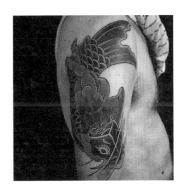

SCOTT ELLIS
@SCOTTELLISTATTOO
AUSTIN, TEXAS, USA

Scott Ellis has been tattooing since 1994. He began his career in Austin, Texas, learning from an old Texan tattooer of the 1970s: Notorious Ed Potter.

For years, Scott did all different styles of tattooing, but for the last decade he has specialized in Japanese tattooing. His influences are the artists of the ukiyo-e movement, specifically prints made from woodcuts, those famous "pictures of the floating world" by renowned artists such as Utagawa Kuniyoshi, Tsukioka Yoshitoshi, Toyohara Kunichika, and Kawanabe Kyōsai. Ukiyo-e is an infinite resource for tattoo artists. When it comes to Japanese-inspired tattoos, Scott loves the work of artists such as Yokosuka Horihide, Horikyo, Ivan Szazi, Rico Daruma and Shion, Rodrigo Melo, Greg Orie, and Amar Goucem, to name a few. There are so many good tattooists these days. As Scott says, "You can find inspiration everywhere you look." Scott works at Triple Crown Tattoo Parlour, in Austin, Texas.

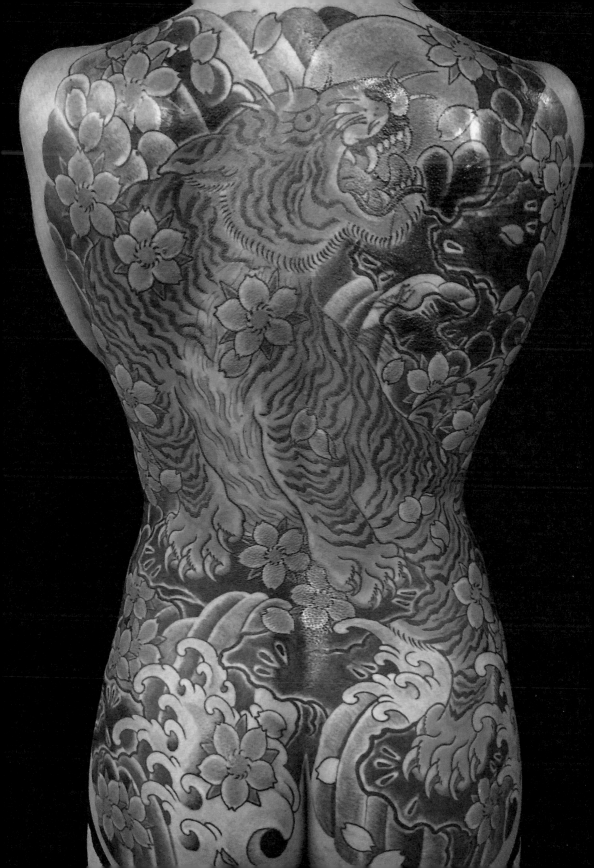

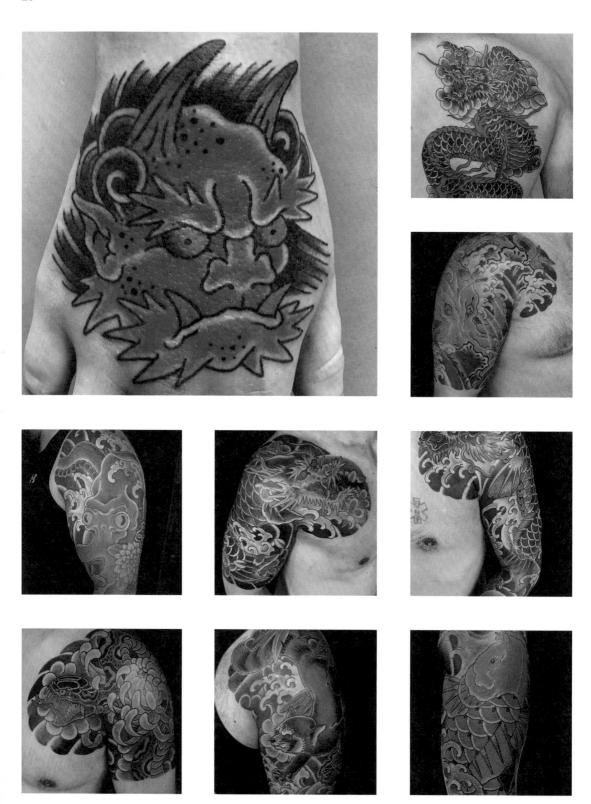

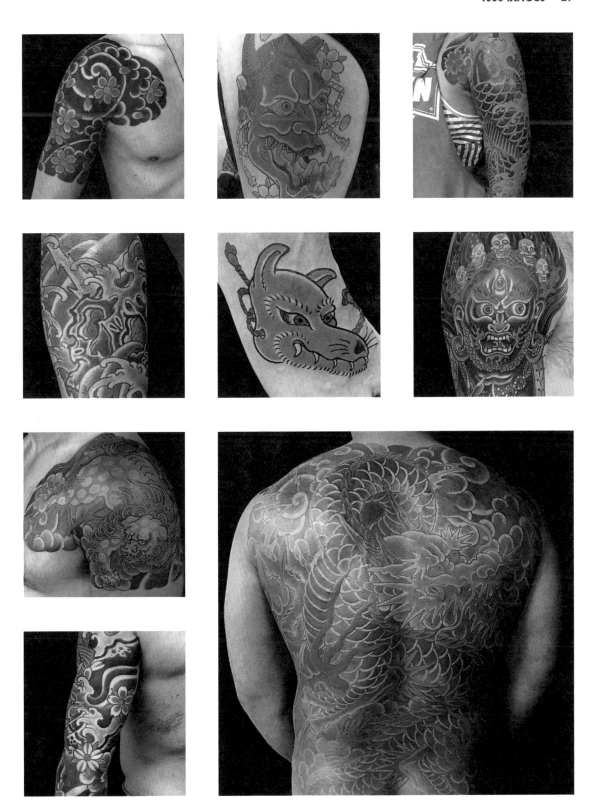

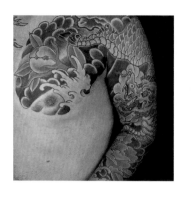
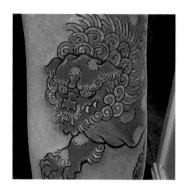
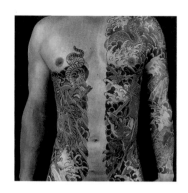
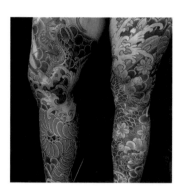
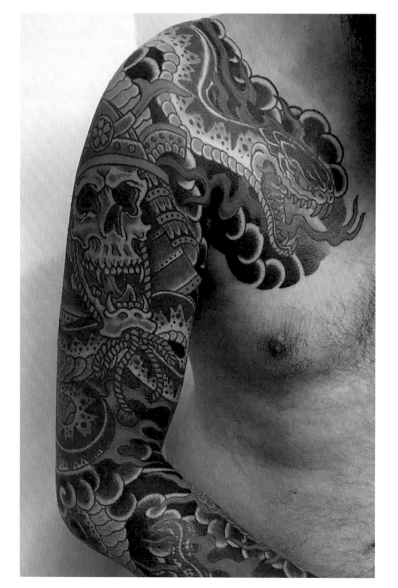
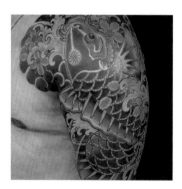
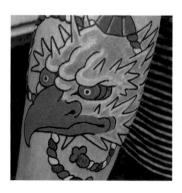

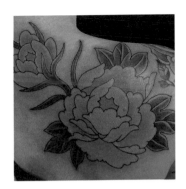

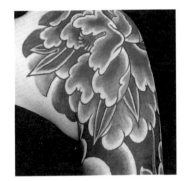

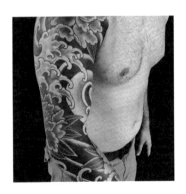

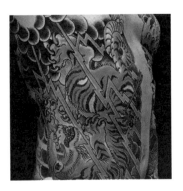

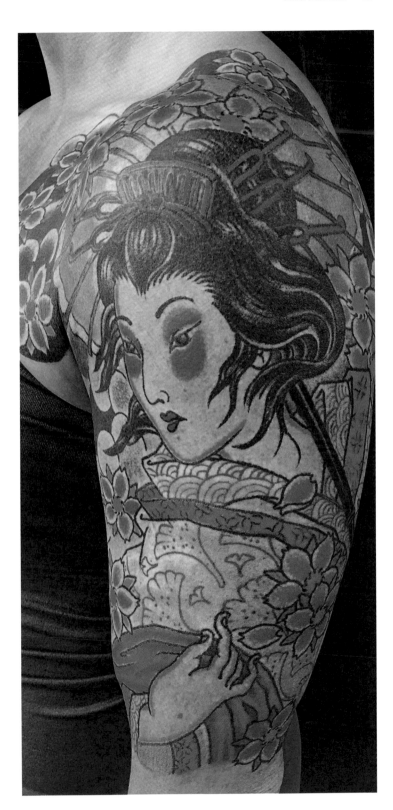

ROBERTO DARDINI

@LESDERNIERSTRAPPEURS
PARIS, FRANCE

The son of a woodcutter, Roberto Dardini spent his childhood in the forests of Alsace, in northeastern France, where he developed his sense of observation and his love of nature. At thirteen, the adventure began.

Roberto has lived a thousand lives. He has traveled, worked as a professional cook, then as a chef, bar owner, bodyguard, and bouncer, before beginning tattooing in 1998. In 2004, he opened a studio, in the center of Paris, that would become legendary: Art Corpus. After training numerous tattooists, in 2013 he opened Les Derniers Trappeurs, a tattoo studio in a barn in the Ariège region of southwestern France. He wanted to combine tattooing with a unique, natural environment, where his clients could experience something different. The adventure continued in July 2017 with the opening of a Paris branch of Les Derniers Trappeurs. Based on the output during his twenty years in tattooing, Roberto's style might best be described as "trash poetic;" and he works both in color, and in black and gray. But it is, above all, his mastery of composition and his use of different techniques, such as color inversion or print effects, that make him an artist with a unique, recognizable style.

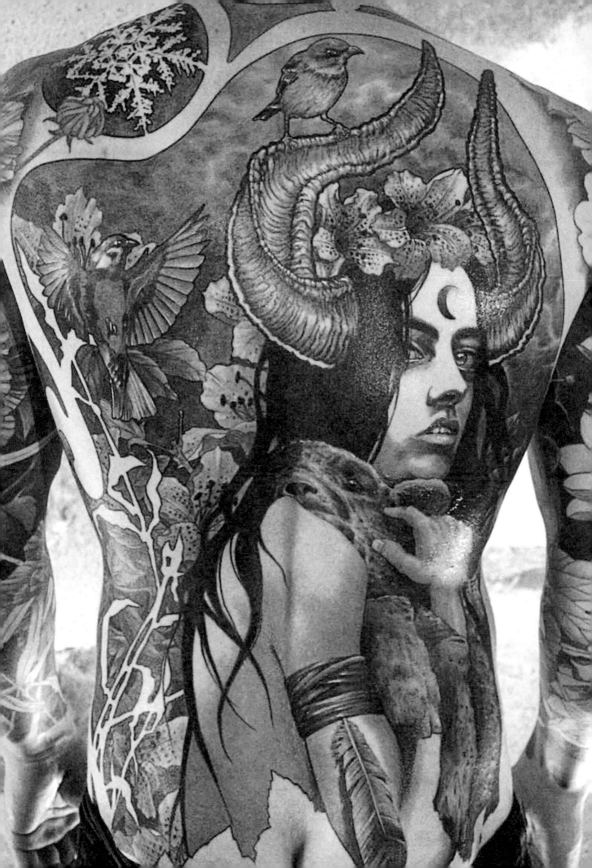

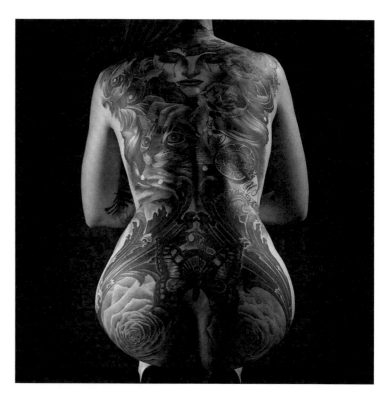

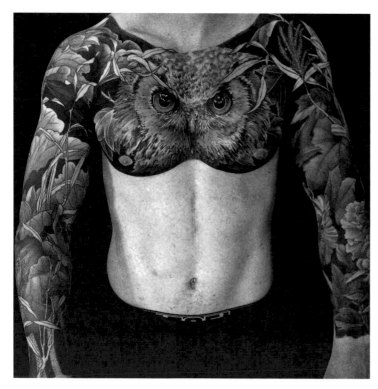

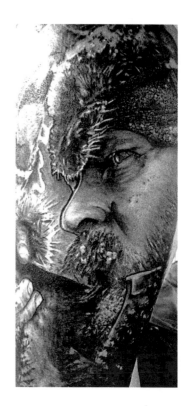

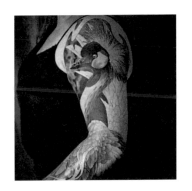

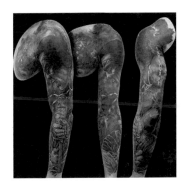

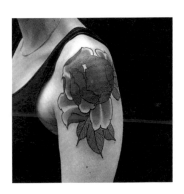

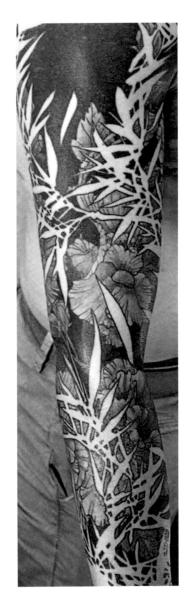

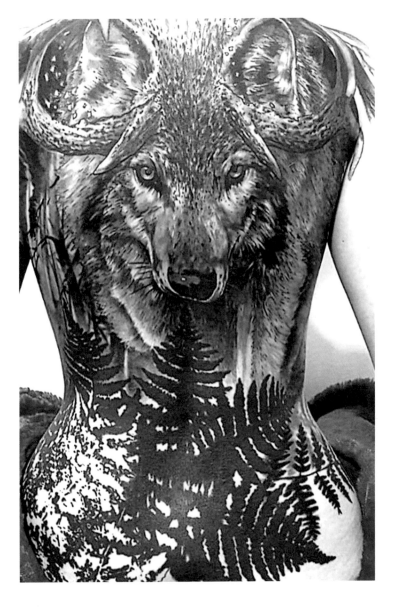

ANDREY SVETOV

@SV_A
MOSCOW, RUSSIA

Andrey Svetov uses a minimal number of elements in each of his designs, which are always very concise. His slogan: "brevity is the sister of talent." He draws great inspiration from music.

A pioneer of the Russian industrial tattoo style, Andrey lives and works in Kaliningrad, an enclave between Poland and Lithuania that forms the most western part of Russian territory. Andrey also works in Moscow and across Europe. He tattoos in a geometric style that is close to engraving, and only in black. An entrepreneur as well as a tattooist, Andrey has his own studio, Master & Tattoo, founded in 2010, as well as a shop, SVA.STORE, which is well known locally. Andrey is one of those artists who thinks that tattoos should be in black only: simple, effective, and pure, like those found on prisoners.

Every piece is subject to Andrey's own inspiration; it's impossible to dictate to the artist what he should do. There is no point turning up with a design for him to reproduce. His fame has enabled him to collaborate with numerous international brands, such as Burton and Samsung.

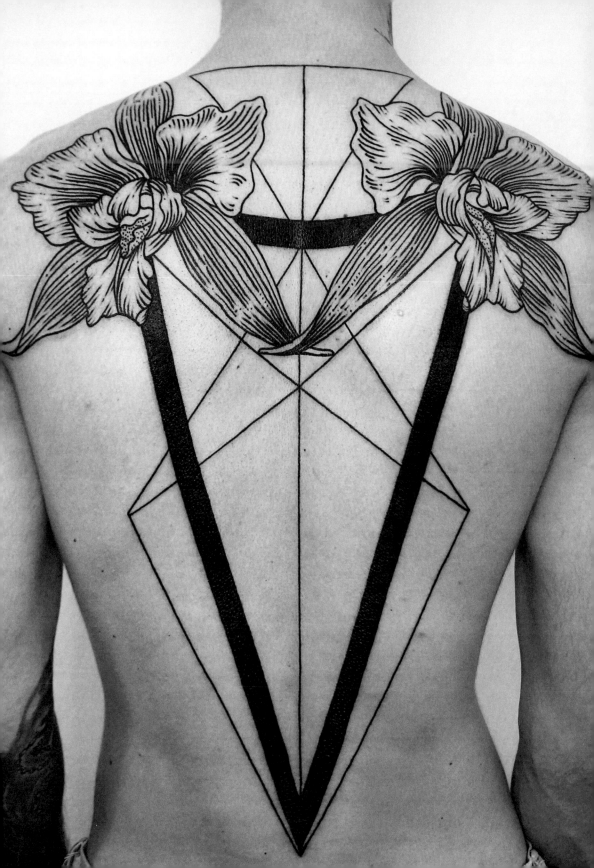

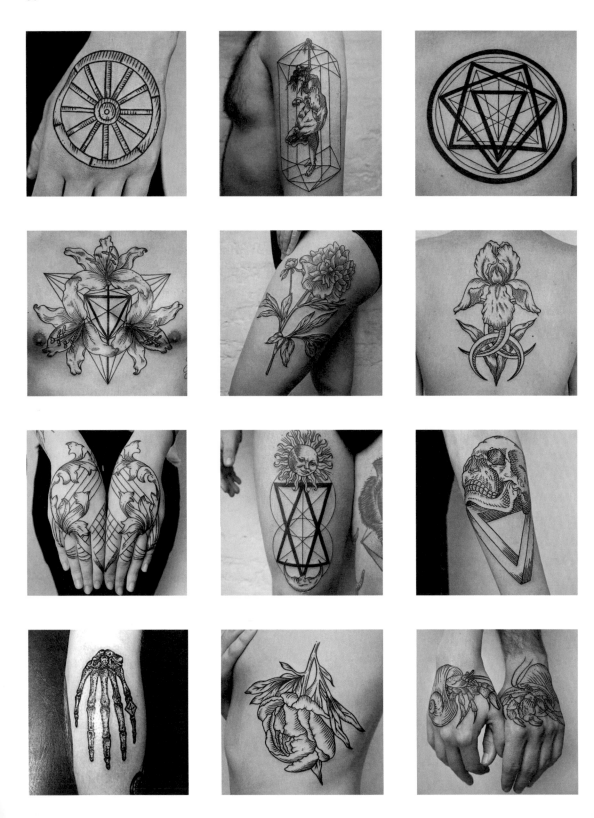

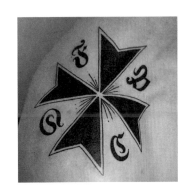

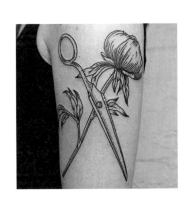

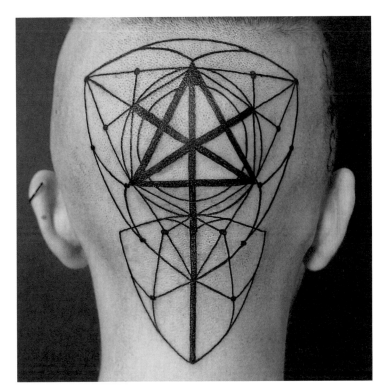

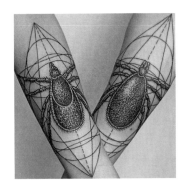

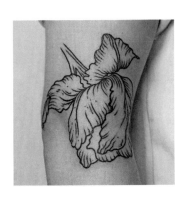

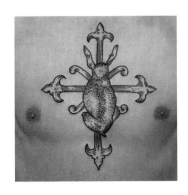

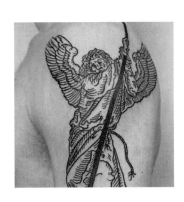

COREY WEIR

@WEIRCOREY
AUCKLAND, NEW ZEALAND

Corey Weir is forty-two years old. He was born in New Zealand, where he still lives, working in his own studio, Monk3ys, in Auckland.

Corey occasionally leaves his native land to spend time in Europe as a guest tattooer; these trips also feed his personal development. Corey began tattooing twenty-six years ago in Tokyo (where he lived for sixteen years). There, under the guidance of blackwork specialist Jun Matsui of LUZ Tattoo Studio (LUZ means LifeUnderZen and "light" in Portuguese, as Jun is half Japanese, half Brazilian, and was born in São Paulo), Corey spent six years (from 2002 to 2008) learning to be a tattooist, before returning to New Zealand. Jun remains a major influence for Corey, who loves the ethnic aspect of the blackwork style, working mainly with patterns from the Samoan Islands, Polynesia, and New Zealand, and with the Maori and other ethnic styles of the Pacific. He has a preference for tattoos that combine thick lines and really heavy blackness with fine strokes and more complex motifs, a model of simplicity and effectiveness.

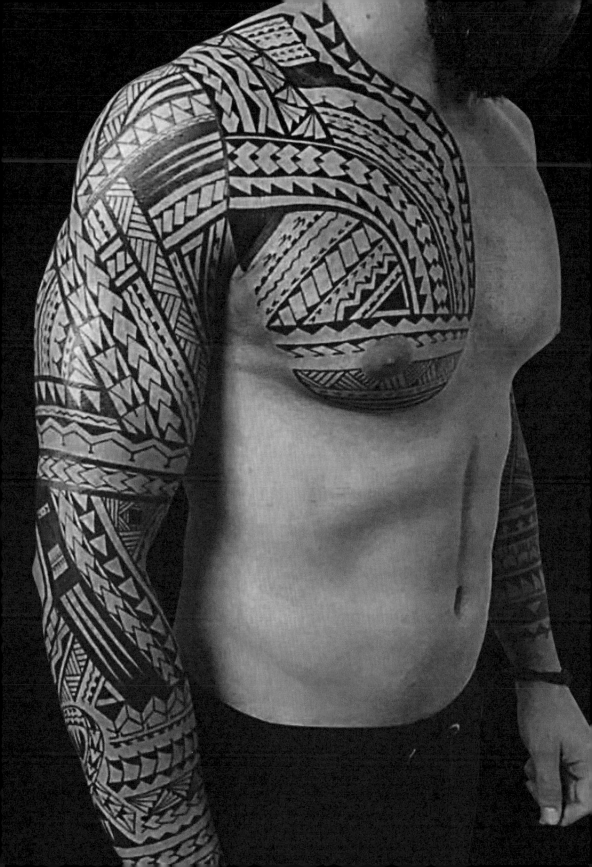

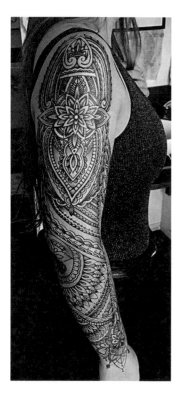

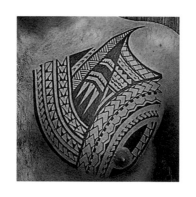
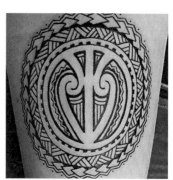
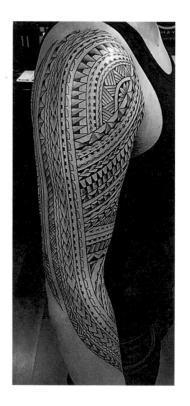
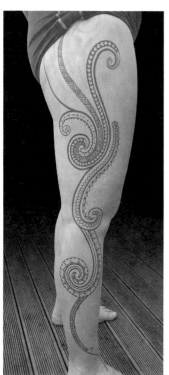
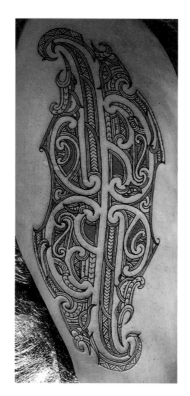
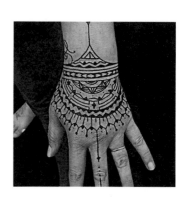

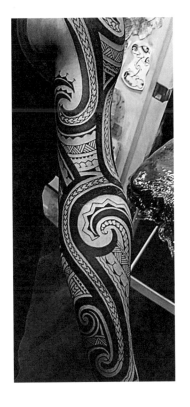

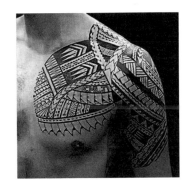

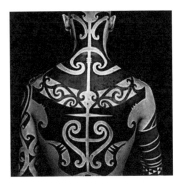

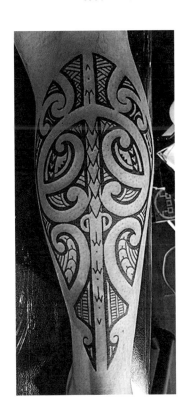

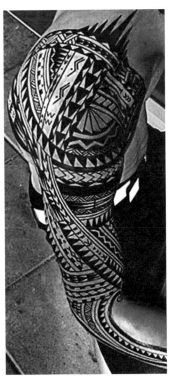

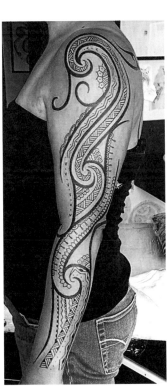

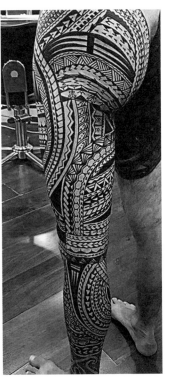

YOME
@YOMEONE
PARIS, FRANCE

Yome grew up in the western suburbs of Paris during the 1980s. He draws inspiration from the works of his grandfather, Jacques Bracquemond, a famous artist and engraver, who was also an adman. Every one of Yome's tattoos pays homage to this heritage.

The classical influences of Yome's family blended with 1980s hip-hop culture and the graffiti scene, which is where he cut his teeth. He then joined the famous VMD crew, which he is still a part of today.

Through graffiti, Yome discovered New York and American graphic art, two key elements in his own development, which put him back in touch with his artistic roots. The long-expected shift into tattooing came about in part through meeting the tattoo artists Sadhu le Serbe and Jean-Luc Navette. Beguiled by their work, Yome realized that tattooing would be a way to honor the family tradition and fulfill his artistic ambitions. He began tattooing, honing his style until he found the graphic line that would define him. Yome's work is a perfect combination of two worlds in which precise, chiseled lines artfully blend with medieval and contemporary influences. In 2015, Yome opened his first studio, Ravenink Tattoo Club, in Paris.

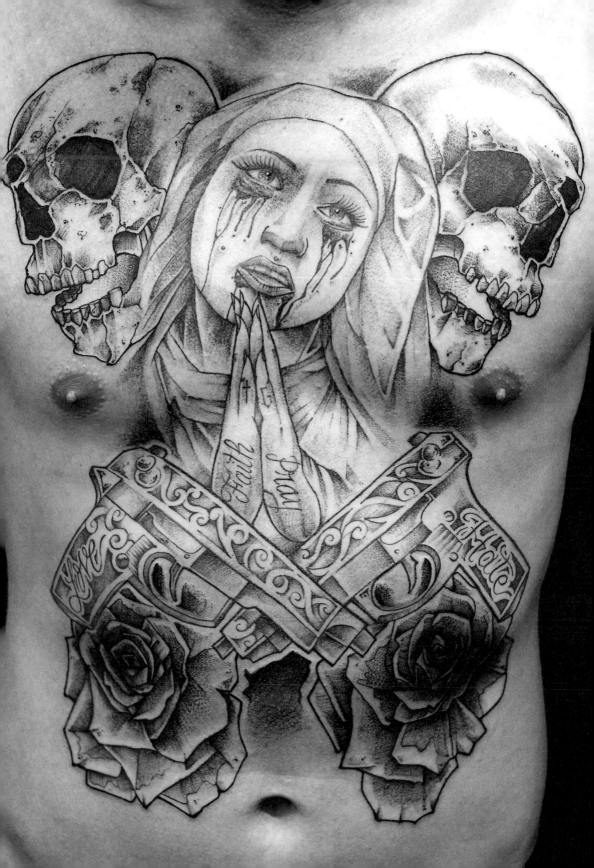

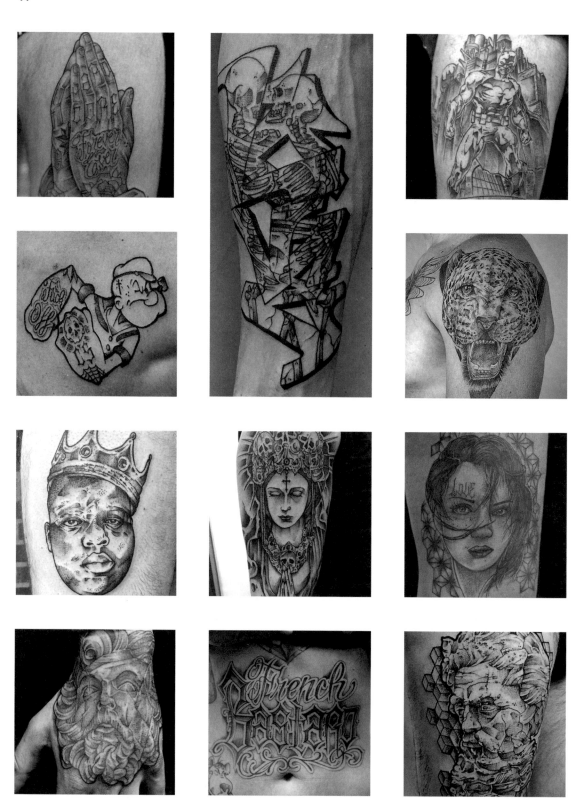

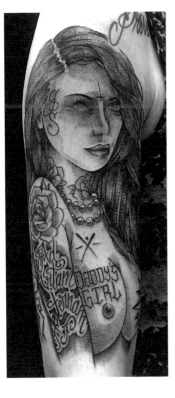

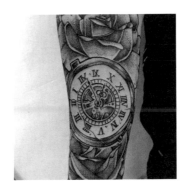

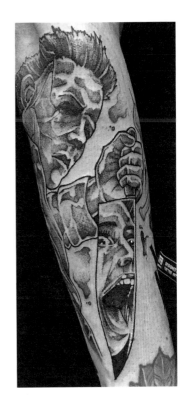

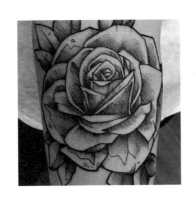

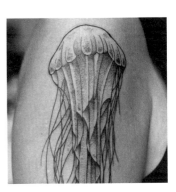

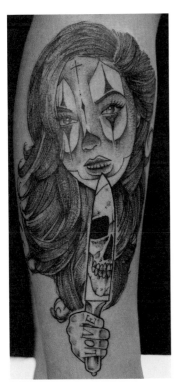

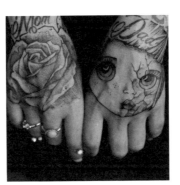

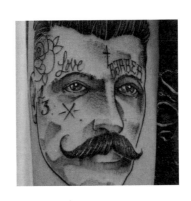

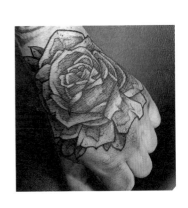

TOMAS TOMAS

@TOMASTOMAS108
LONDON, UK

Tomas Tomas has made a name for himself as a master of the blackwork technique. Working with surgical precision, his placement and handling of space are hypnotic.

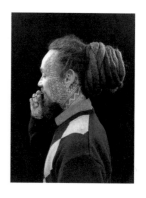

While some tattooists are recognized for creating small, magnificently detailed pieces, Tomas Tomas stands out for his creation of large, geometric designs covering the subject's back or even their whole body. His sanctuary is Seven Doors Tattoo, in London, where he officiates alongside Jondix, another master of the art.

A child of the punk scene of the 1980s, Tomas Tomas began tattooing in 1996, in Manchester, amid the totally psychedelic climate of that era's rave culture. He met El Patman and joined the staff of Evil From the Needle, in Camden Town, in London. At the time, there were only a handful of magazines and conventions where tattoo artists could get their work noticed and discover that of their peers.

Tomas Tomas describes his career as eighteen years of discovering and perfecting his style, and he defines his approach as the creation of a new graphic vocabulary in sync with a technological world.

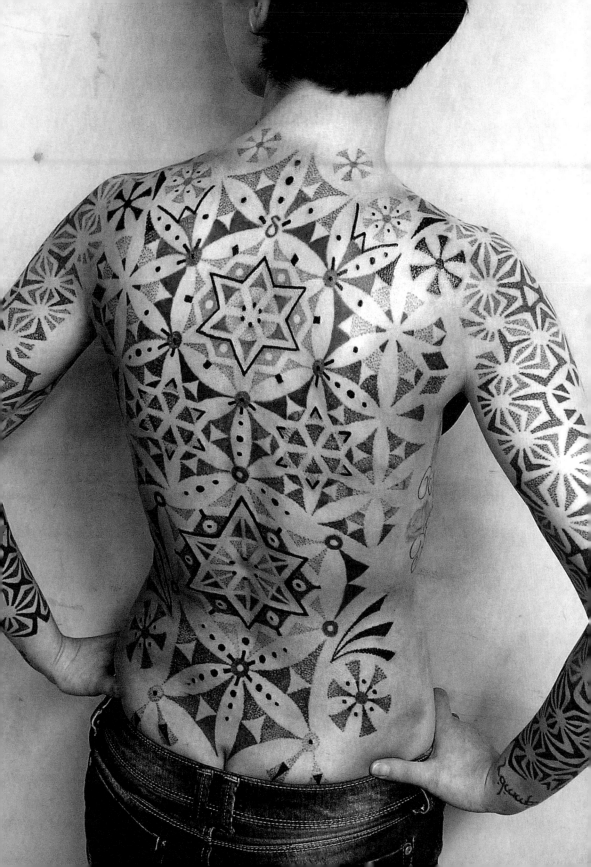

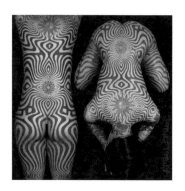

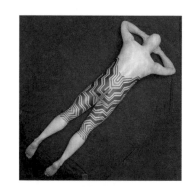

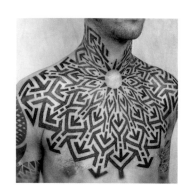

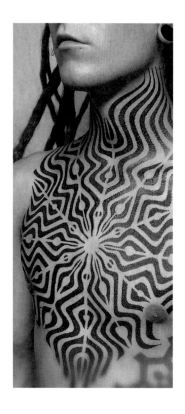

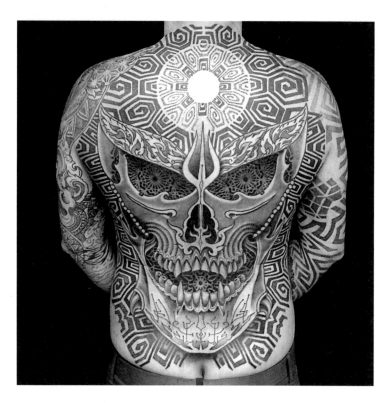

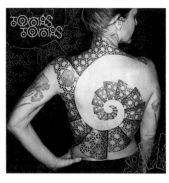

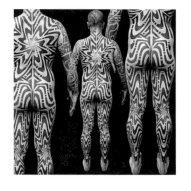

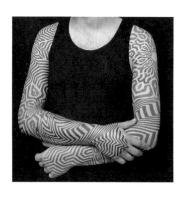

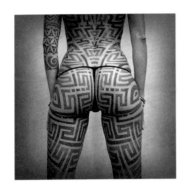

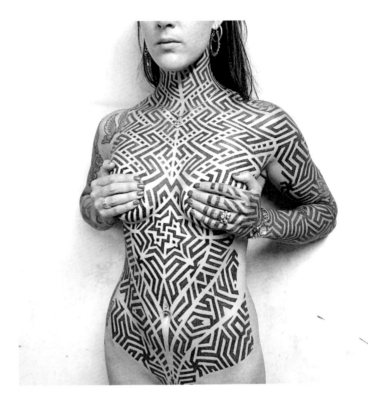

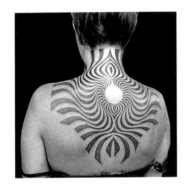

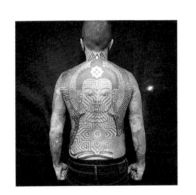

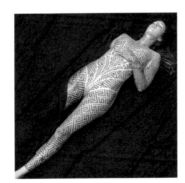

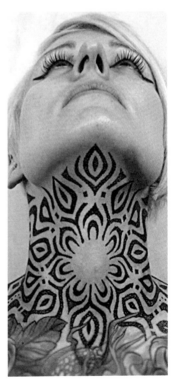

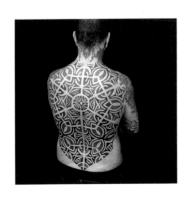

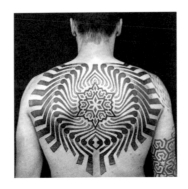

CHAIM MACHLEV

@DOTSTOLINES
BERLIN, GERMANY

Chaim Machlev is a unique and unusual character, an artist to be discovered without delay. His lines take their inspiration from his computing and mathematics background and his love of nature and movement, as well as Buddhism, which he became interested in during a long stay in India.

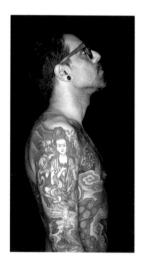

Chaim was born in Tel Aviv. In 2012, he arrived in Berlin, where he learned to tattoo. But unlike most other tattooists, he had no artistic background. He confesses to having never been interested in the art of tattooing until 2010, when he was tattooed by Avi Vanunu; it was like a spiritual experience for him. He unceremoniously quit his job at an IT company—and the associated life of luxury—to make a home in Berlin, a city he didn't know. After many rejections, he joined a studio and began to tattoo some local punks. After a while, Chaim came to feel more at ease with the practice and the medium, and he started to adapt his creations to his clients' bodies. His freehand technique, in black, began to gain some recognition. His rise, in just four years, has been impressive, particularly since he had no particular connection with the tattoo scene when he started out. Now his clients flock from all over the world to go under his needle.

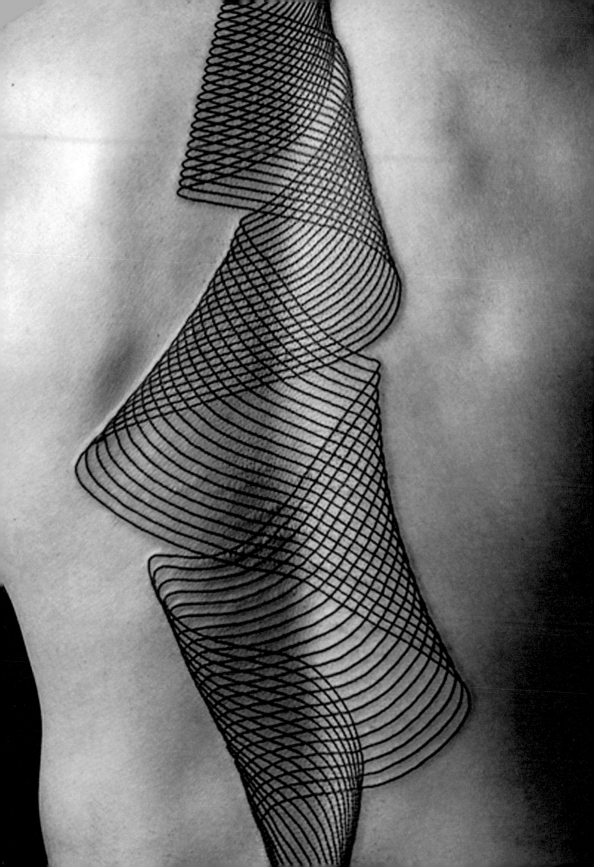

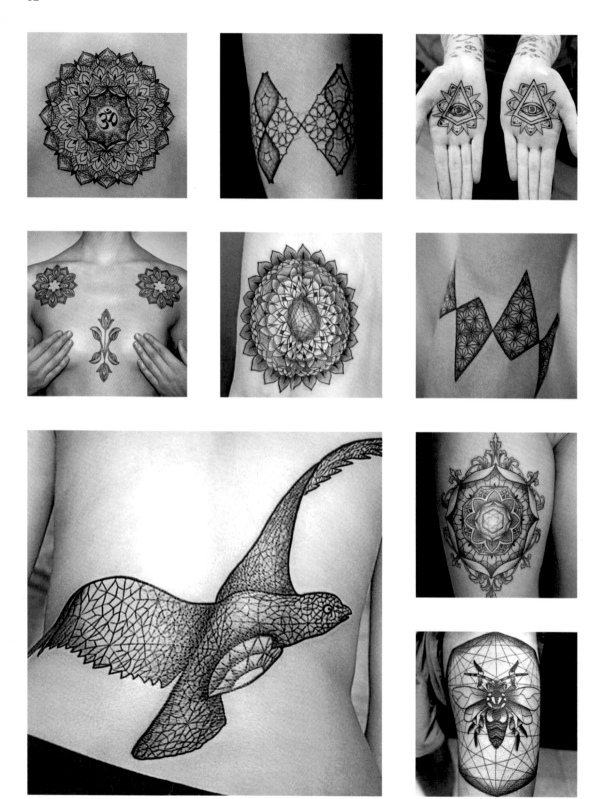

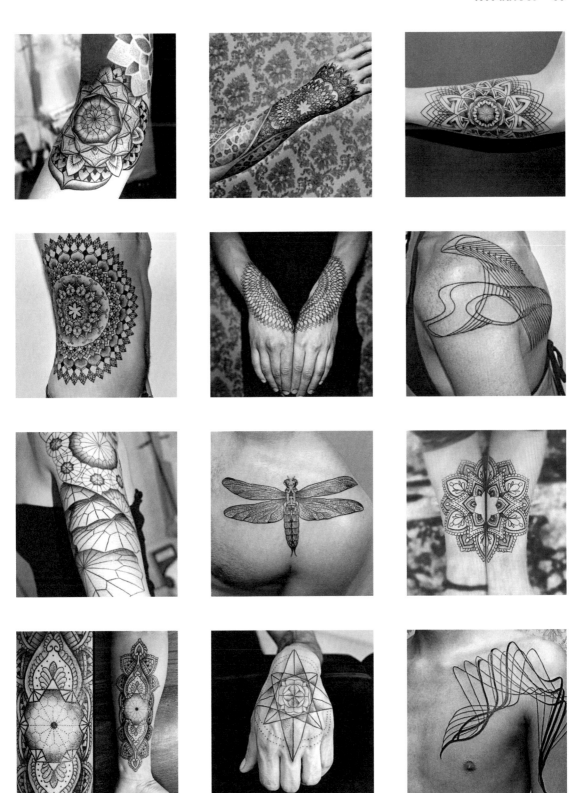

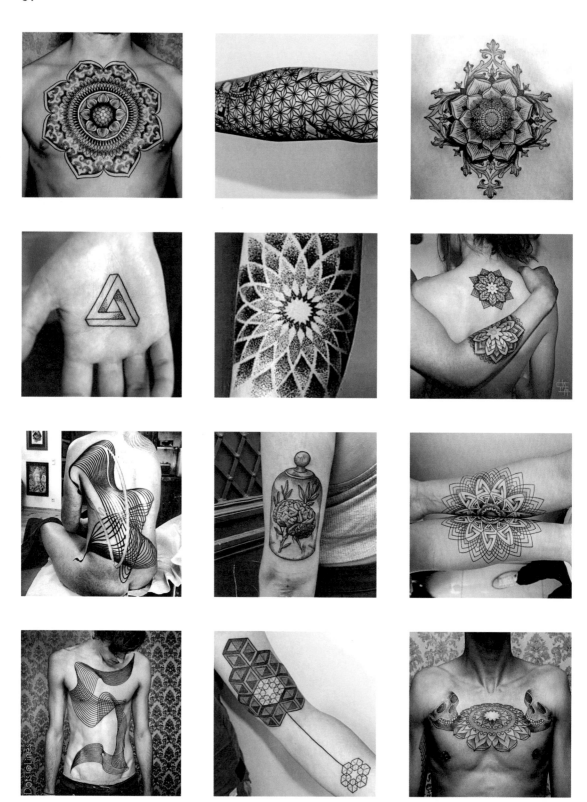

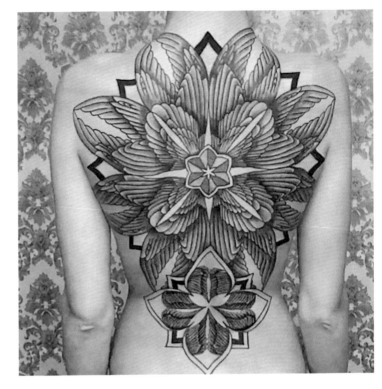

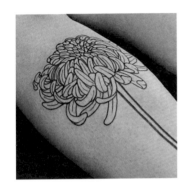

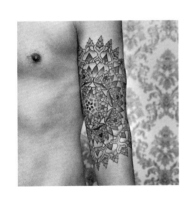

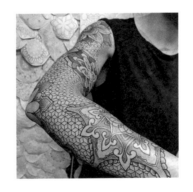

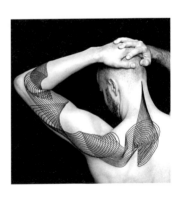

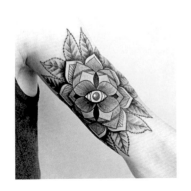

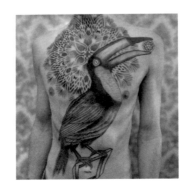

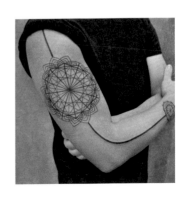

MAUD DARDEAU

@MAUDDARDEAU
BORDEAUX, FRANCE

A painter and illustrator who was part of the Jeanspezial collective for seven years, Maud Dardeau gradually made tattooing a major part of her work. In 2010, she walked into the famous Tin-Tin Tatouages studio in Paris. The owner perused her portfolio, then took her under his wing.

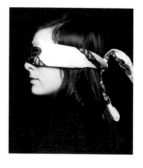

Maud confesses that she had to learn or relearn everything, starting with the framing of her designs. Goodbye color; she would keep that for her paintings. Her tattoos would be black, in a graphic style—simple, elegant, and radically different from her pictorial work. As she is passionate about linework and influenced by the works of Gustave Doré and Albrecht Dürer—whose books line her library—her style naturally shifted toward engravings. Among tattooists, she counts Tin-Tin, Jondix, and Thomas Hooper as her influences. Maud loves doing details, fills, crossed lines, and adding layers and textures like the way a musician gets carried along by a jazz score. She also does remixes, such as compiling twelve Doré illustrations into a single tattoo. A new adventure commenced in September 2016, when Maud Dardeau Tatouages opened its doors in the historic center of Bordeaux.

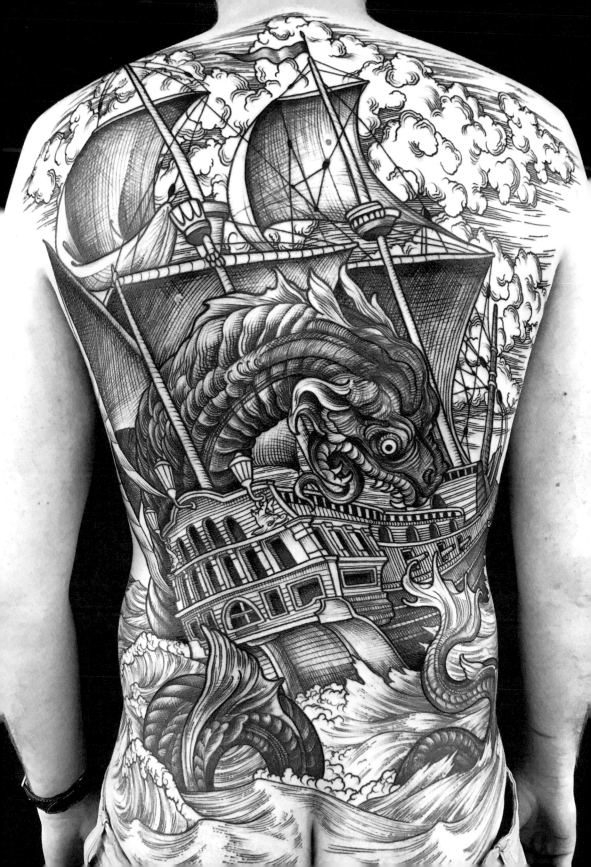

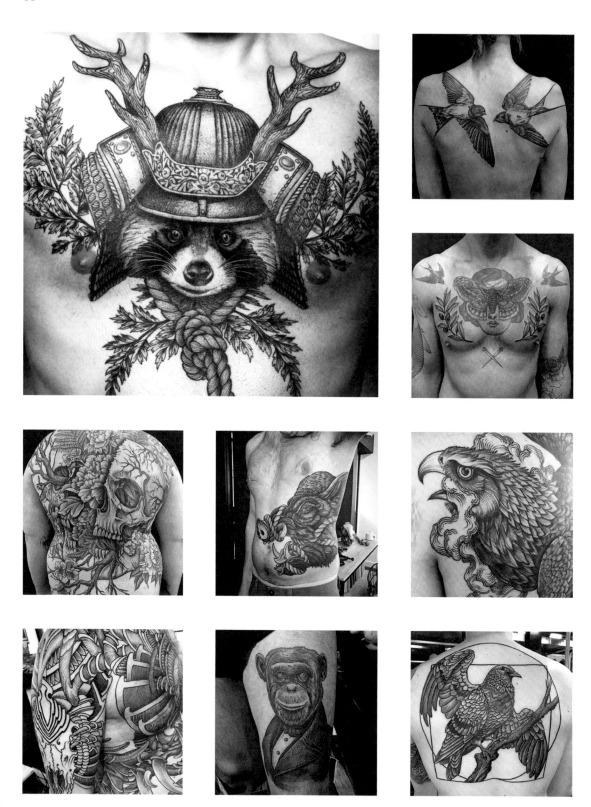

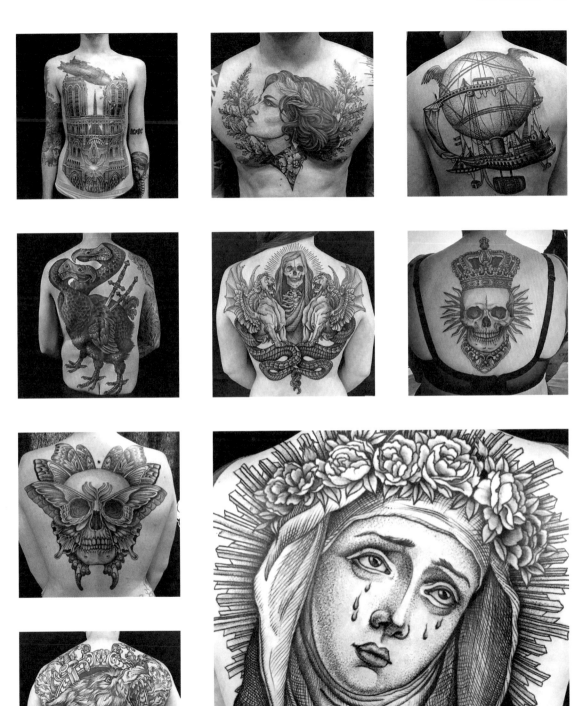

BEN VIAMONTES
@POWSONETATTOOS
ALBUQUERQUE, NEW MEXICO, USA

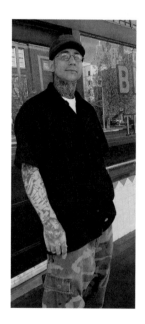

Ben Viamontes, aka Pows One, works at Blacklist Tattoo Parlour, which he opened in Albuquerque in 2009. His artistic roots lie in graffiti, a world that continues to inspire him.

Born in Texas, Ben began tattooing in 2005. It was a logical step, after years spent in the graffiti world. Ben got into street-art in a big way in 1994, and this passion for graffiti has stayed with him. These days he mixes the street art style into the neotraditionalism of his tattoos—it is not uncommon to find zombies, robots, and other scary creatures among his creations. It's a mix of black humor and dark, disturbing frescoes, which are a little morbid for sure, but the humor and weirdness are prime ingredients of the signature graphic cocktail of Pows One. Ben also has a degree in art history, and another in fine art. This academic knowledge has enabled him to study and absorb works by Rembrandt, da Vinci, and Goya, to name but his top three. In tattooing, he draws inspiration and motivation from Mike Giant, Derek Noble, and Robert Hernandez.

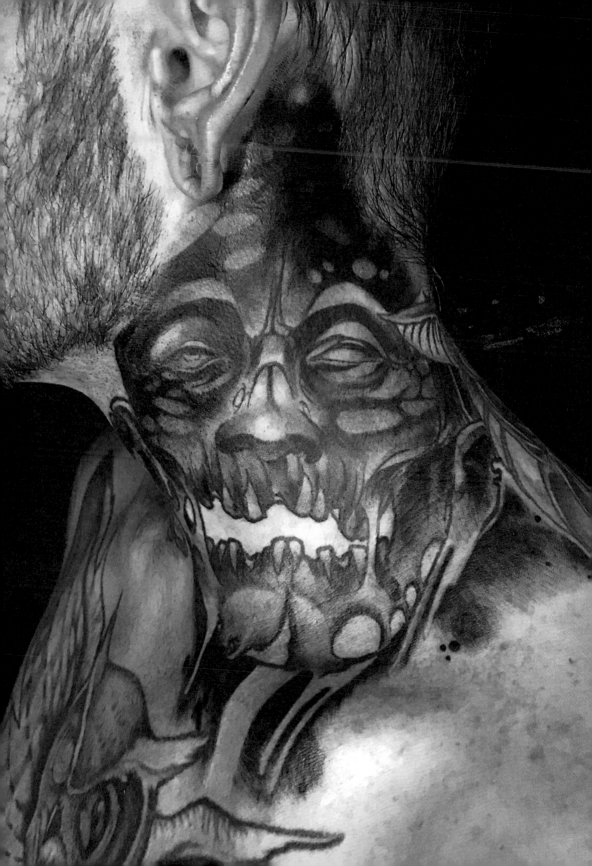

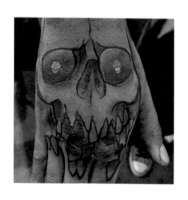

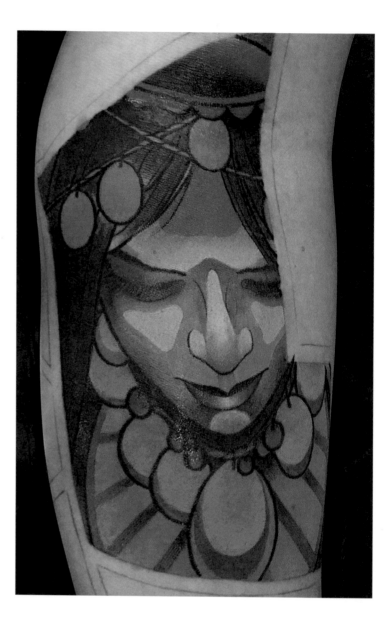

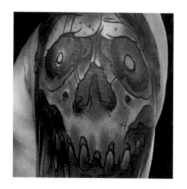

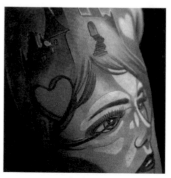

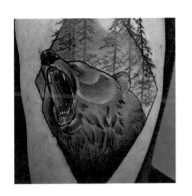

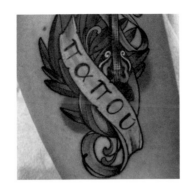

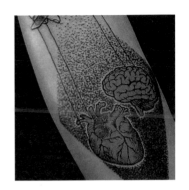

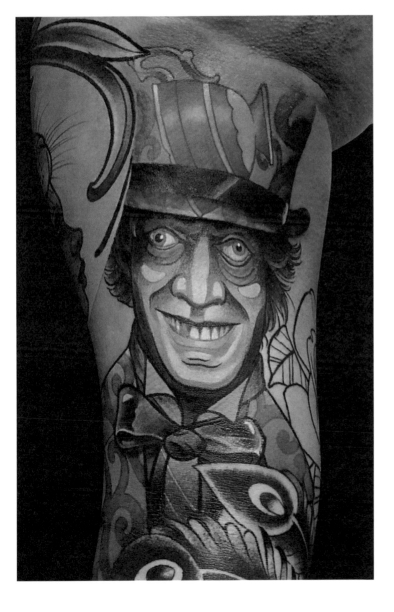

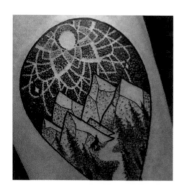
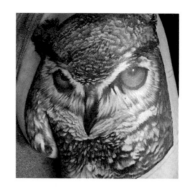
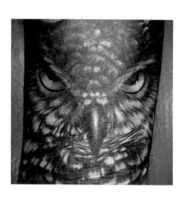
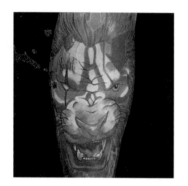
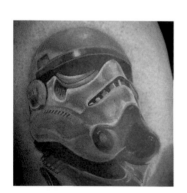

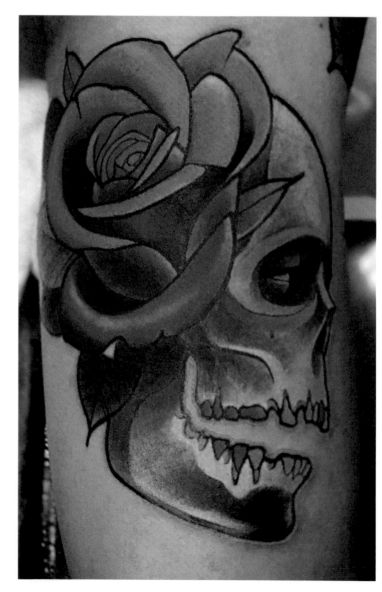

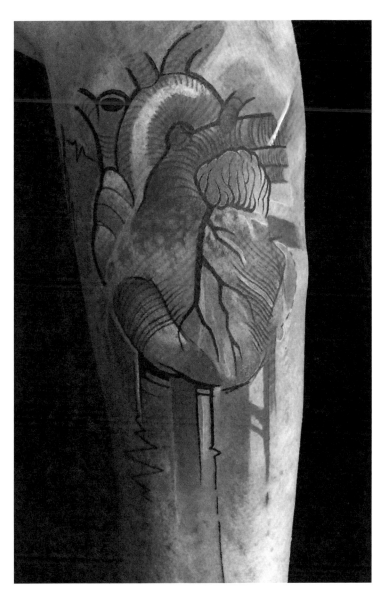

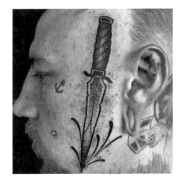

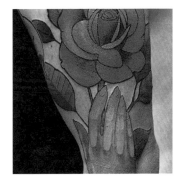

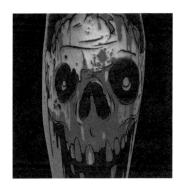

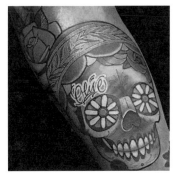

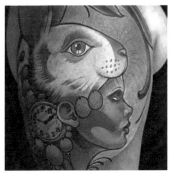

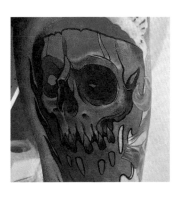

GAKKIN

@GAKKINX
AMSTERDAM, THE NETHERLANDS / KYOTO, JAPAN

Gakkin was born in Wakayama, Japan, and has been tattooing for twenty years. He left Harizanmai studio, in Kyoto, which he founded with his friend and partner in crime Gotch, to settle in Amsterdam.

In light of the very complicated situation for Japanese tattooists, following a campaign of harassment on the part of the Japanese government for nearly a decade, Gakkin doesn't think he will return to live and work in the Japanese archipelago. His unique work is recognizable at first glance: black flat-tints and radical motifs, which create very somber and extremely dense tattoos. Gakkin has a preference for large pieces, executed freehand, that cover the whole body and create an impressive visual impact. The artist clearly enjoys transforming the human body, and it works. His influences lie in the most beautiful, most intense things nature has to offer.

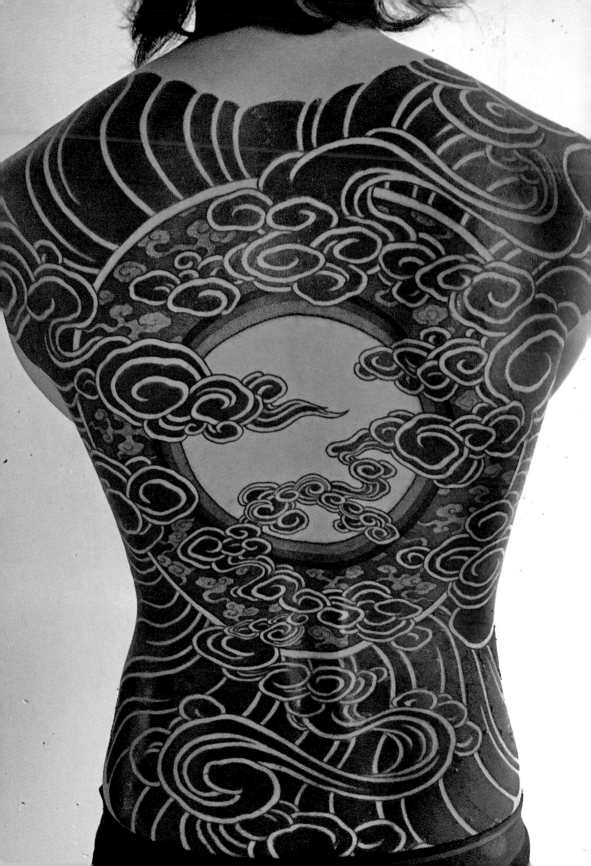

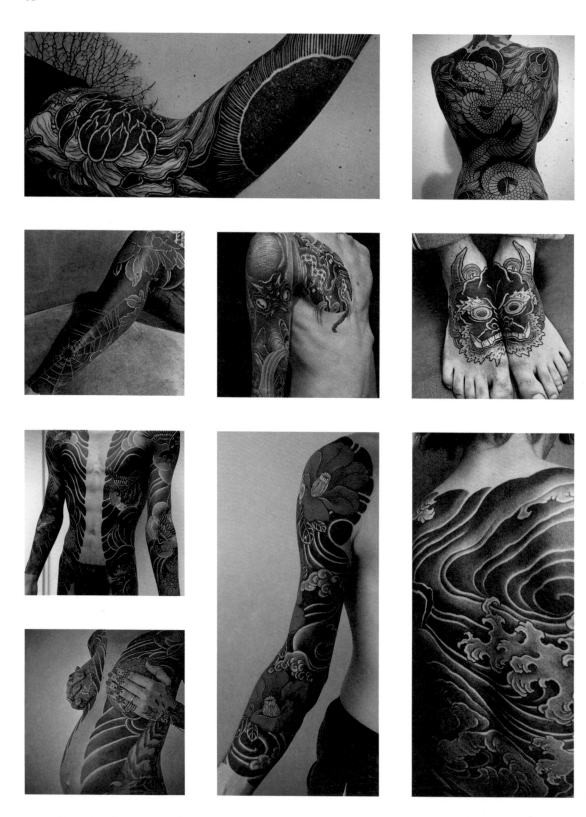

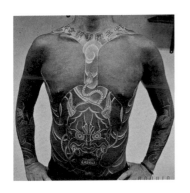

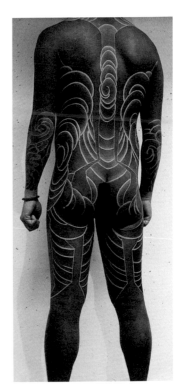

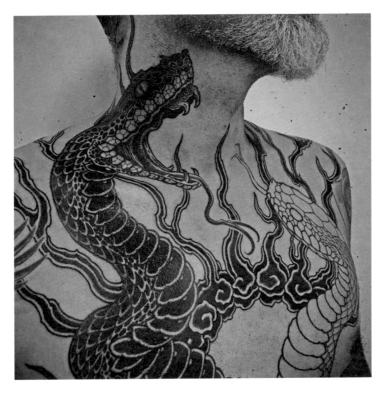

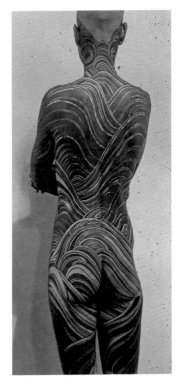

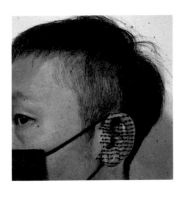

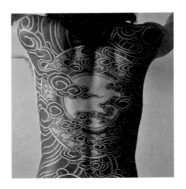

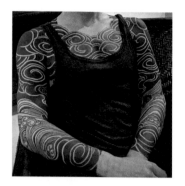

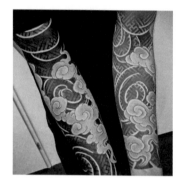

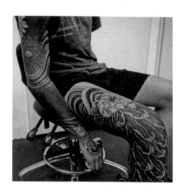

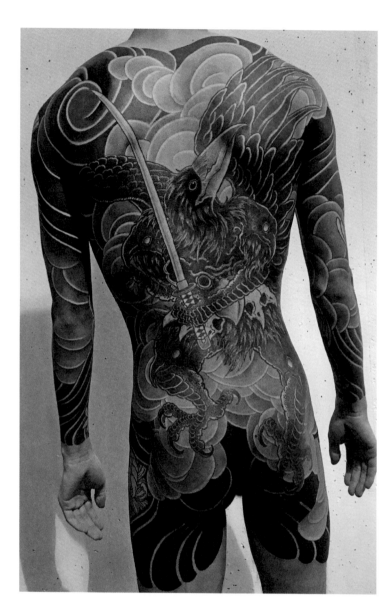

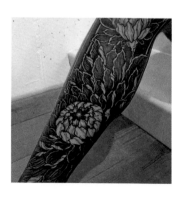

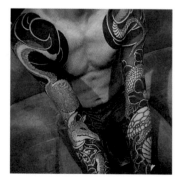

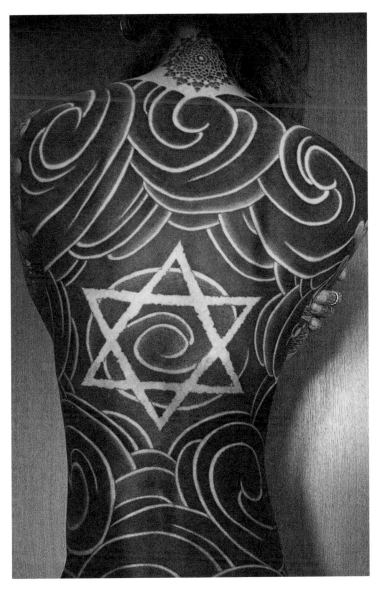

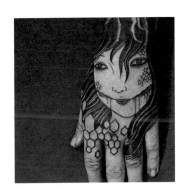

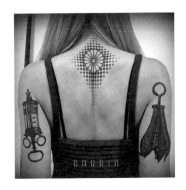

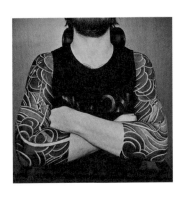

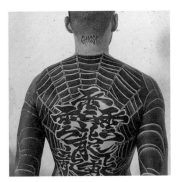

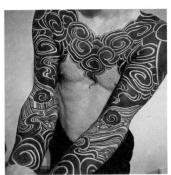

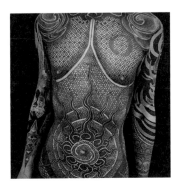

ROCKY ZERO

@ROCKYZERO_TATTOO
NANTES, FRANCE

Rocky Zero works at Les Vilains Bonshommes in Nantes, France. He revisits the traditional world of tattooing using singular colors and a clear aesthetic that stands out.

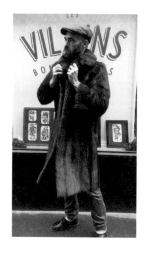

Rocky has switched from saturated colors, such as bright greens, to softer, more sober hues. "I still use mainly greens and reds, but with a wider palette. I try to expand my color choices in such a way as to say more in the compositions. The loud, poppy greens in use ten years ago have less of a place now. Skateboarding and all that crap, it's over! Easy on the 'destroy' attitude now!" These days, we see portraits, animals, ornamentation, plants, and stones—more or less primitive and barely hewn—appear in his compositions. One moment you think you're sitting comfortably in an ancient, bygone era, viewing a traditional tattoo aesthetic, then suddenly you are thrust into the present with a design incorporating the portrait of Fat Mike, the singer from American punk band NOFX, or R2-D2 from *Star Wars*. "I roam contemporary pop culture with the gaze of an old sea dog; you make do with what you have. Anyway, ciao, bye-bye, come back when you want to get tattooed by me, it's better that way."

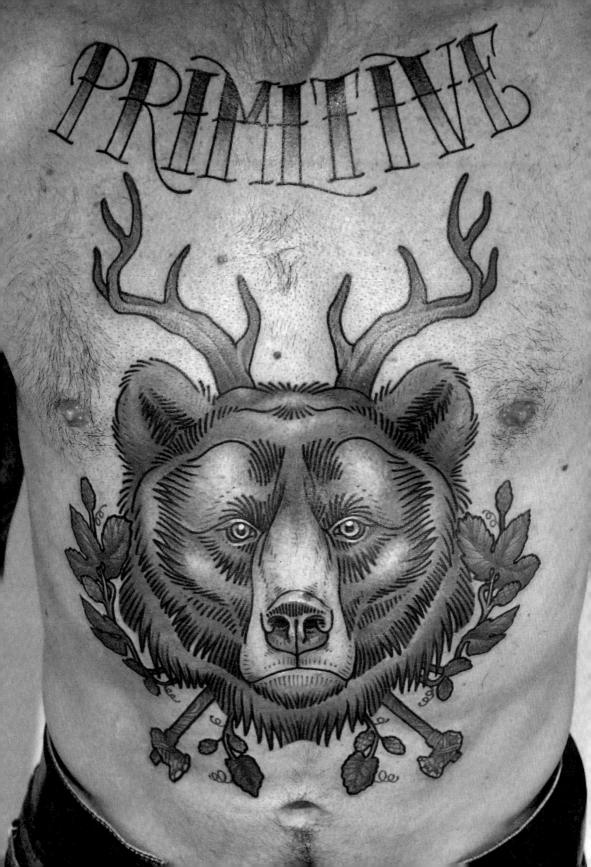

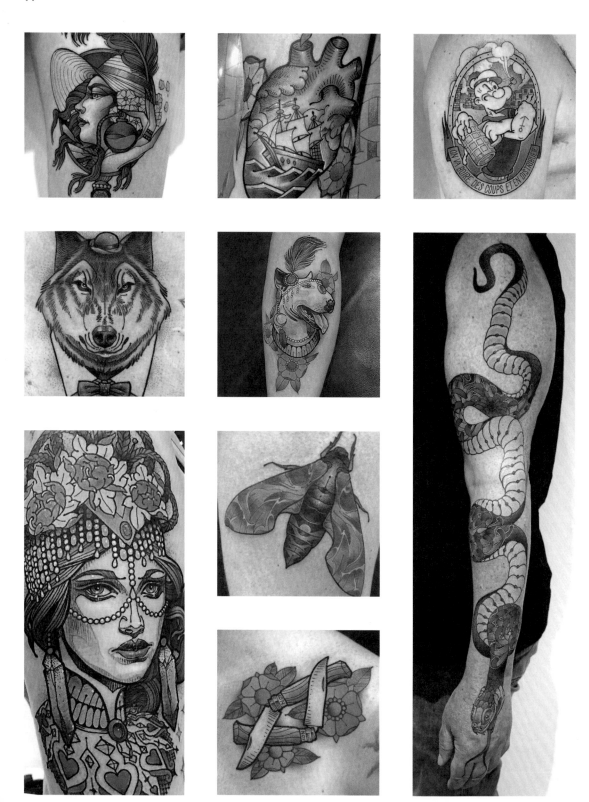

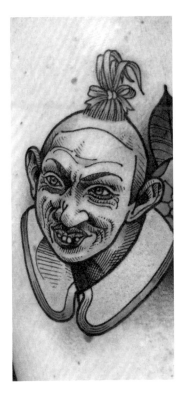

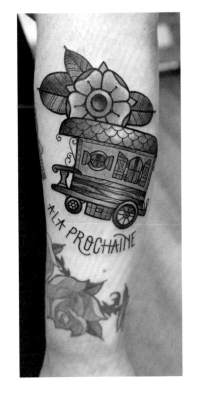

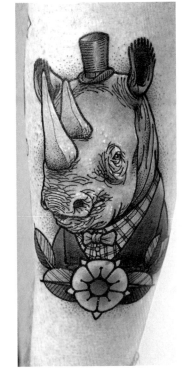

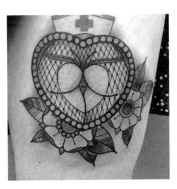

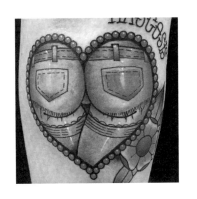

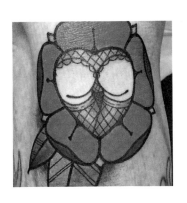

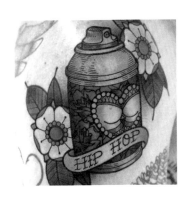

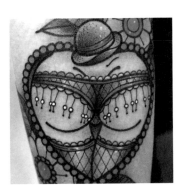

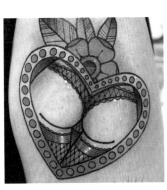

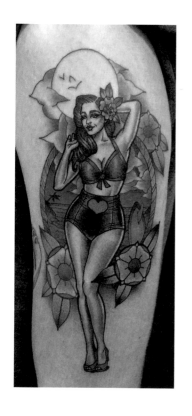

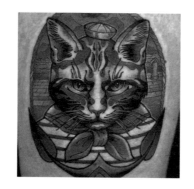

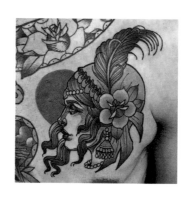

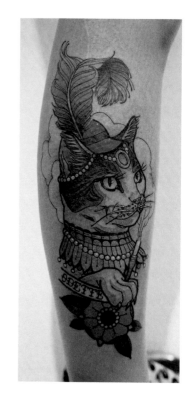

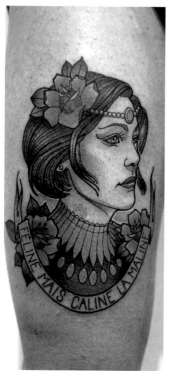

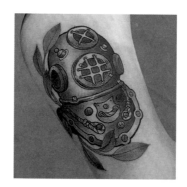

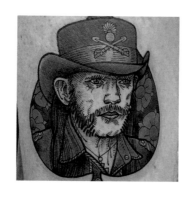

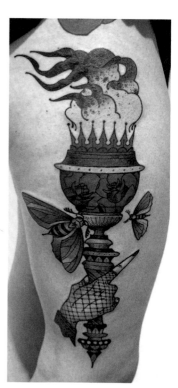

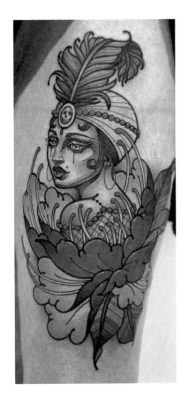

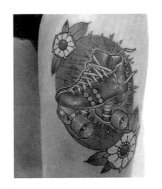

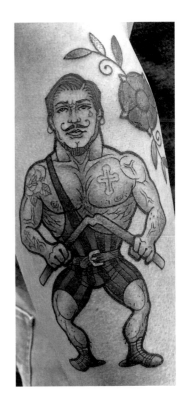

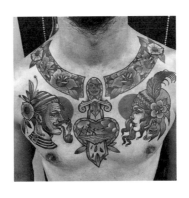

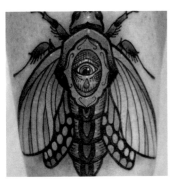

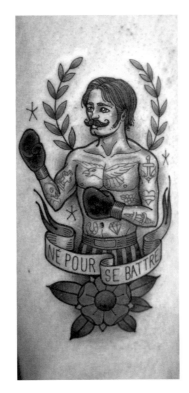

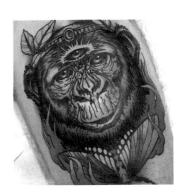

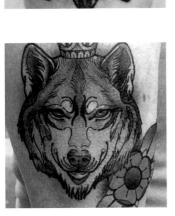

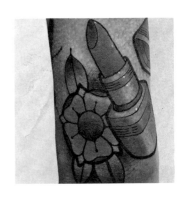

SHAMUS MAHANNAH

@SHAMUSMAHANNAH
MONTREAL, QUEBEC, CANADA

Shamus Mahannah was born in Cowansville, in the county of Brome-Missisquoi, in Canada. He is based in Montreal, where he has been tattooing for eleven years.

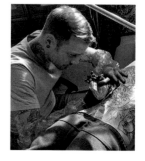

Shamus has been working at Montreal's Mtl Tattoo since the very start of his career. This was where he cut his teeth and perfected the style of traditional North American tattooing he loves so much. Vintage tattoo flashes are a major source of inspiration for Shamus. He likes to create simple, original motifs based on them, incorporating his own personal touch. Driving while listening to music provides very special moments when Shamus's mind can roam free. He also likes to spend time contemplating the vast spectrum of traditional tattooing, as well as paintings and little details from everyday life, all of which add to his array of influences.

Fat lines, flashy colors, reinvented characters, and a really punchy, seductive style make for weighty tattoos that are very much in keeping with traditional tattooing: welcome to the world of Shamus Mahannah.

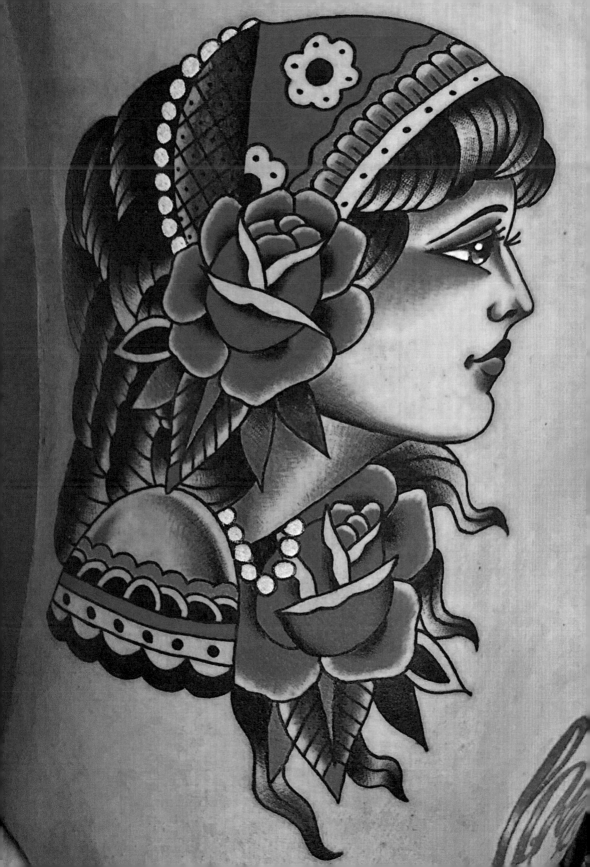

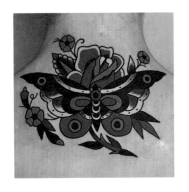

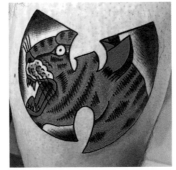

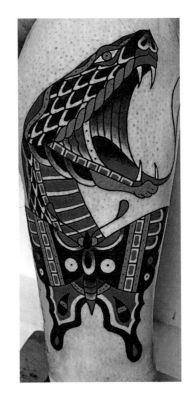

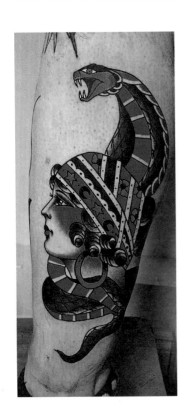

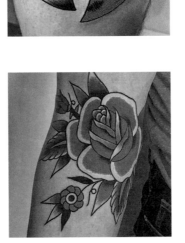

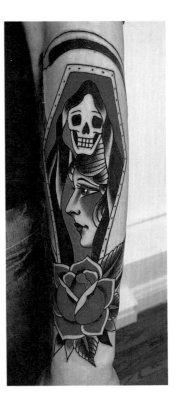

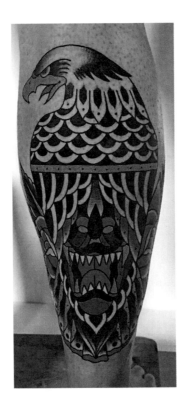

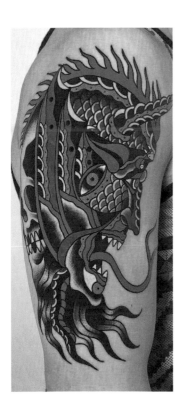

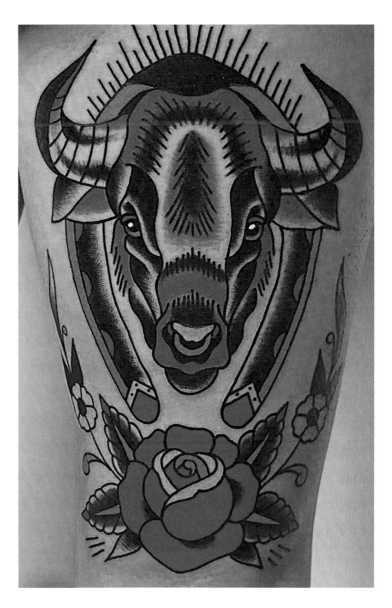

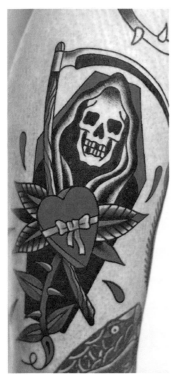

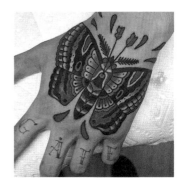

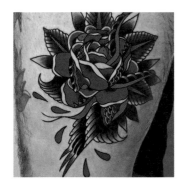

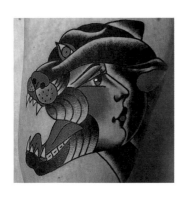

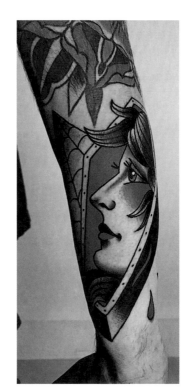

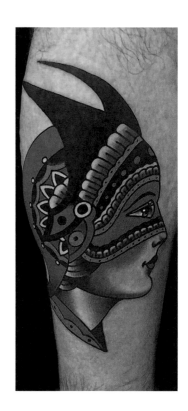

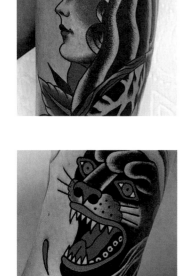

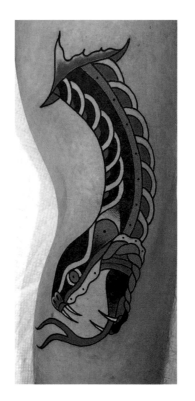

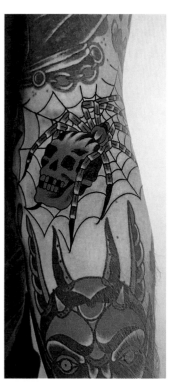

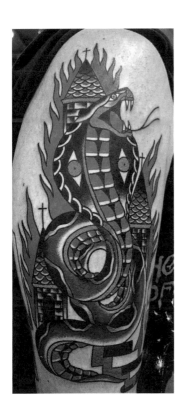

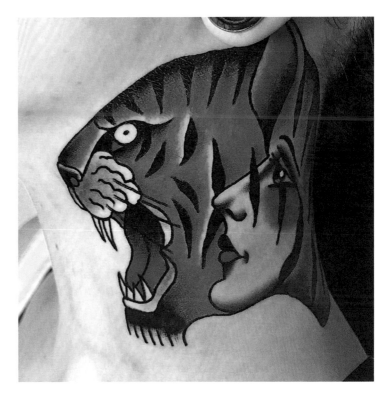

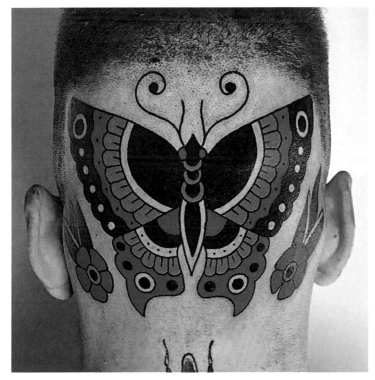

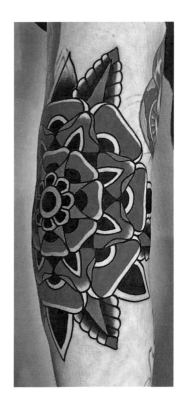

NORM

@LOVELETTERS_TATTOO
LOS ANGELES, CALIFORNIA, USA

Based in Hollywood, in Los Angeles, Norm draws his influences and his artistic foundations from the street. He is inspired by the imagery, tones, and wonders he has seen on streets all over the world. His passions have become his life, and Norm has evolved by thinking ever bigger.

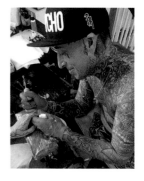

Norm uses tools from the graffiti world, and transforms his love of urban culture into art, excelling in that domain. Most of his work is lettering, done freehand, before being inked. It looks incredible. His patience, and his desire to constantly set new goals, drives and guides him ever further. Norm is always seeking to learn more and to evolve as an artist, creating his own style and building his own identity. Meticulous and precise, Norm has also branched out into the design of tattooing machines that are used by big-name tattooists throughout the world. Although he travels a lot, Norm returns home, to his Hollywood studio, whenever he can, immersing himself totally in that which enables him to fulfill himself artistically: the street and street art.

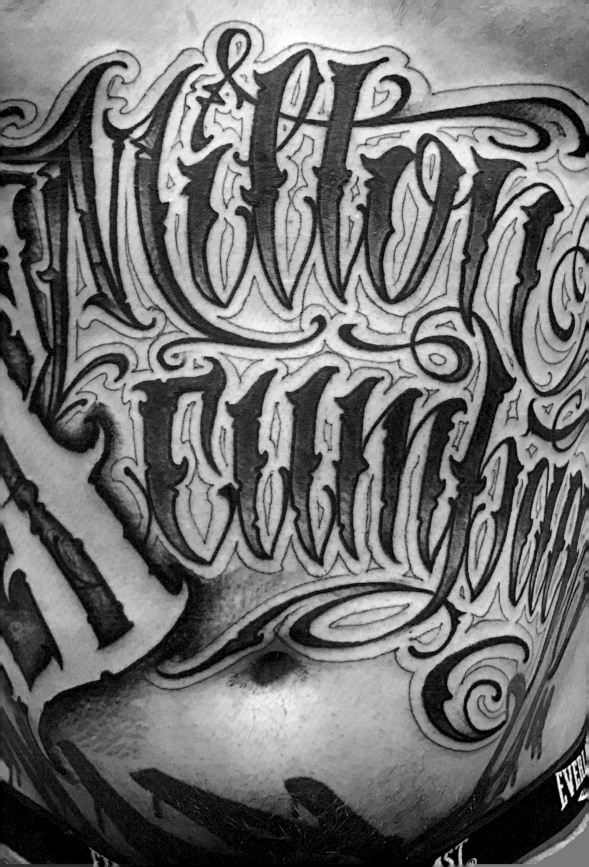

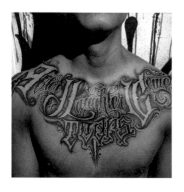
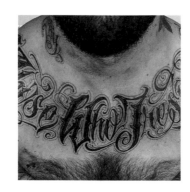
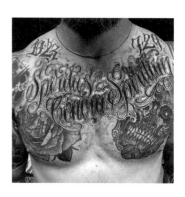
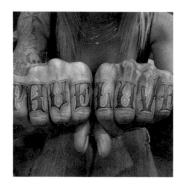
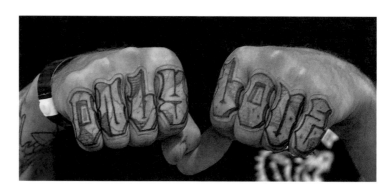
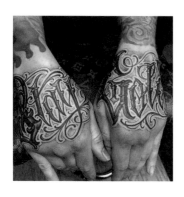
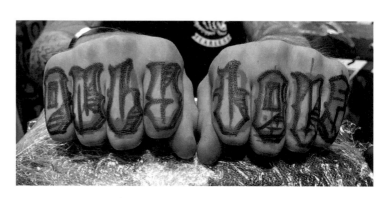
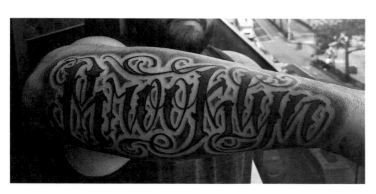
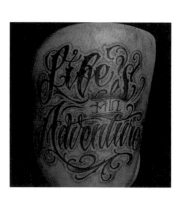

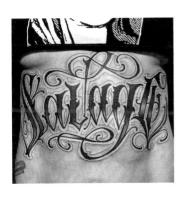

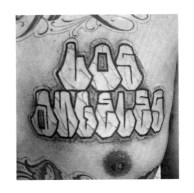

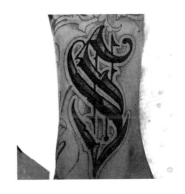

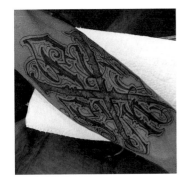

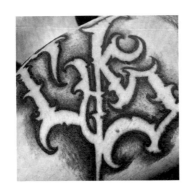

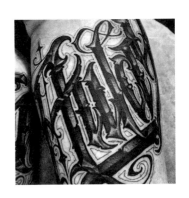

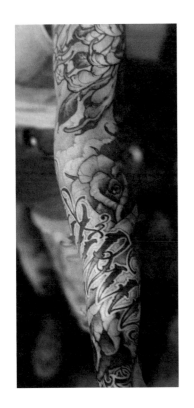

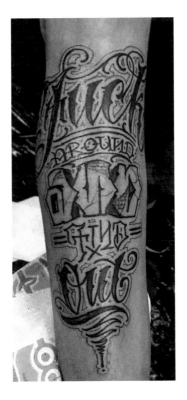

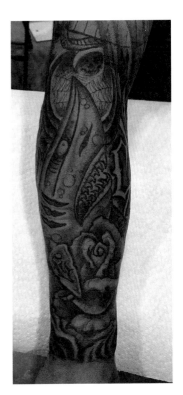

NAM
@NAMATSANHUGI
PARIS, FRANCE

Nam specializes in the neotraditional Japanese style, working in black and gray, and drawing inspiration from mythology–mainly Asian, but also Western.

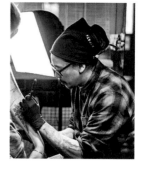

Nam is a resident tattooist at Sanhugi Tatouage, the Paris studio known for its large pieces depicting striking symbols from Asian tattoo art. From early on in his career, Nam has strived to transpose works by the great traditional Japanese painters to our own era. He attaches particular importance to creating bespoke, personalized motifs for every tattoo he makes.
His influences stretch from the grand masters of heroic fantasy to Art Nouveau, by way of the Japanese painters of the ukiyo-e movement. This unique design concept reaches its height when Nam places it on what he considers to be the finest medium: the skin. The artist loves to work on large pieces with a bold impact, and he is dedicated to continuous improvement. Nam constantly reassesses himself in order to make all of his pieces timeless.

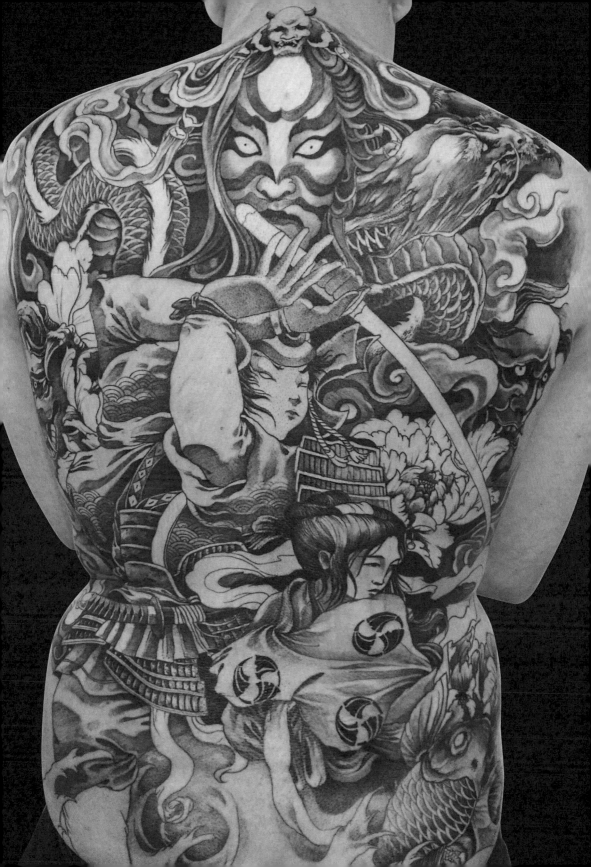

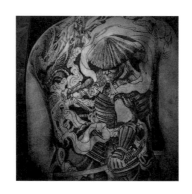

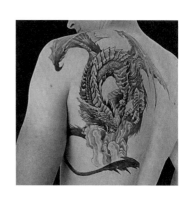

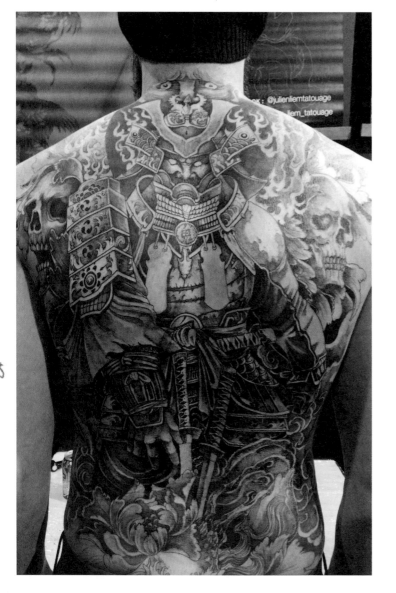

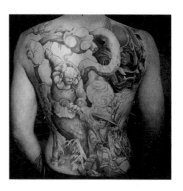

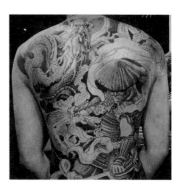

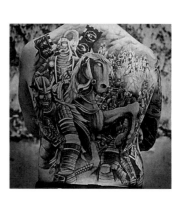

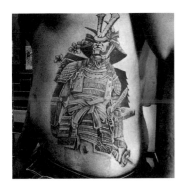
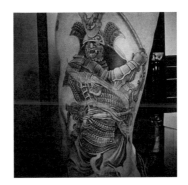
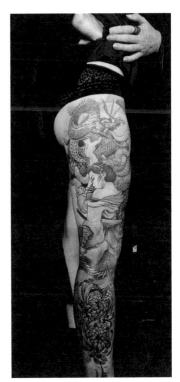
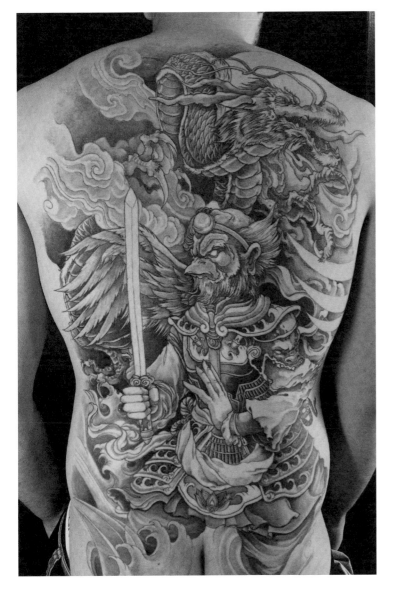
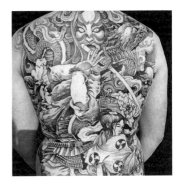
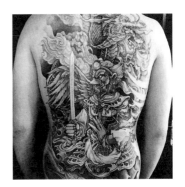

SADHU LE SERBE

Sadhu le Serbe has been honing his so-called "Serbitude" technique–doing a lot with relatively little–for a long time. It's a classic approach for this artist who, despite a spell studying fine art, developed his craft in the underground movement of the 1990s.

Born in Perpignan, France, Sadhu is a tattooist whose style, which is close to engraving, is immediately recognizable. Before becoming a tattoo artist, he was strongly influenced by photography, graphic design, and, above all, stenciling. Indeed, stenciling is how he began to make a name for himself, even before he first laid hands on a tattoo machine. His work was very quickly noticed, which led to him participating in Bansky's The Cans Festival, held in the famous Leake Street tunnel below Waterloo Station in London. After earning his stripes as a tattooist at Art Corpus, in Paris, under the benevolent guidance of Roberto Dardini, he returned to his native region and opened his own studio, the OldSerb Tattoo Club.

Sadhu has an incredible sense of detail and precision. He works mainly in black and white, sometimes adding the odd touch of red. The result is simple, effective, diabolically precise, and dreamlike, with a certain Eastern European influence evocative of Ivan Drago's shorts from *Rocky IV*.

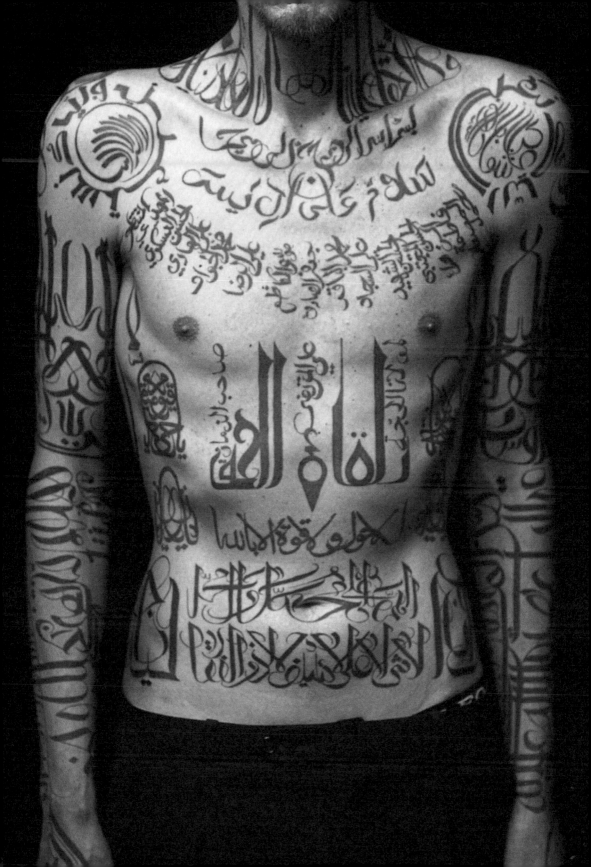

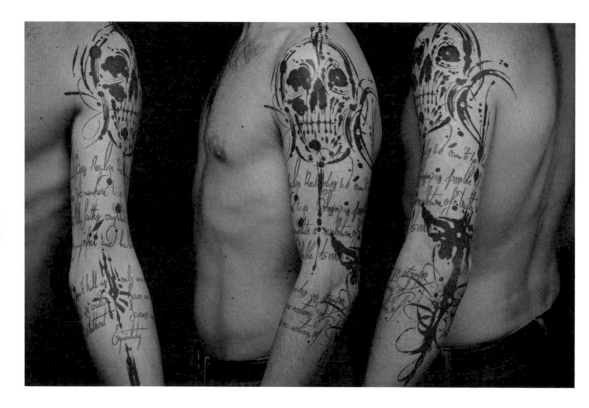
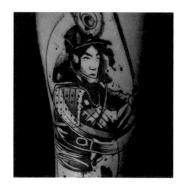
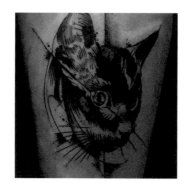
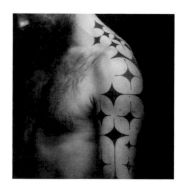

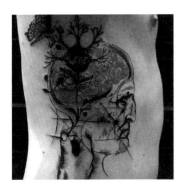

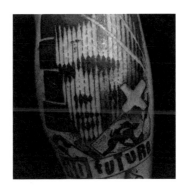

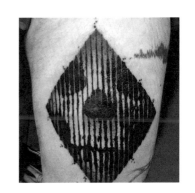

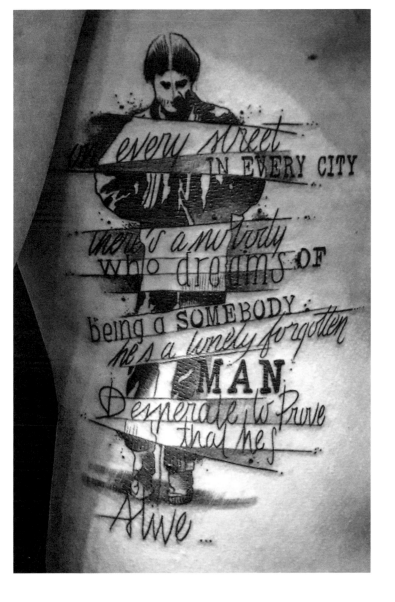

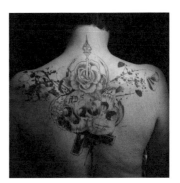

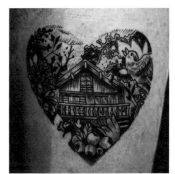

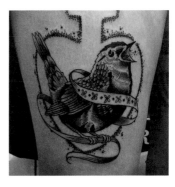

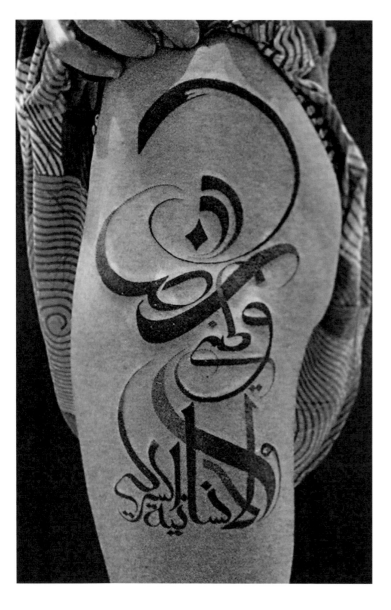

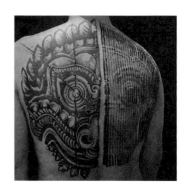

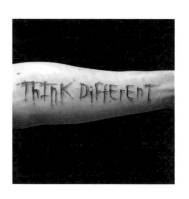

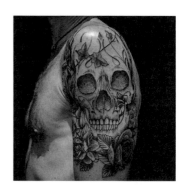

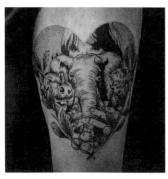

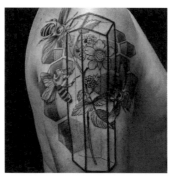

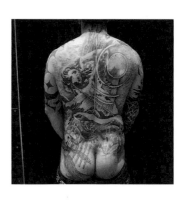

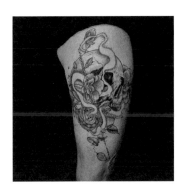

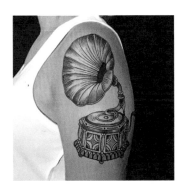

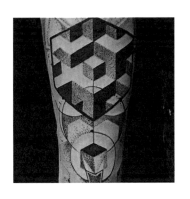

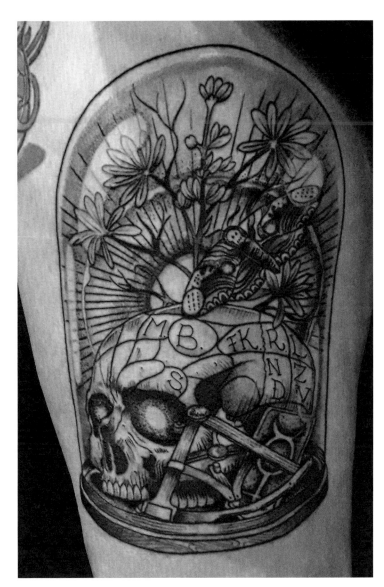

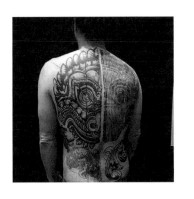

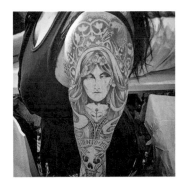

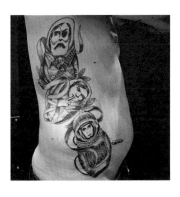

ARNO SCHULTZ

@ARNOSTATTOOS
MONTREAL, QUEBEC, CANADA

With twenty-one years of tattooing behind him, Arno Schultz is old school, a devotee of traditional American tattooing. As he says, he prefers to create ink pieces that look like tattoos.

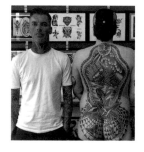

Arno Schultz lives and works in Montreal. He started out at a time when tattooists made their own needles. Arno recognizes how fortunate he was to rub shoulders with some incredible tattoo artists who helped and inspired him in his artistic and ethical development. He also considers himself lucky when it comes to his clientele—they are real enthusiasts who allow Arno to do pretty much anything—and he has created an aesthetic that is very much his own, based on a highly traditionalist approach. Tattooing has enabled him to lead a life he never would have been able to imagine had he stayed in school. Arno enjoys returning the favor through his work.

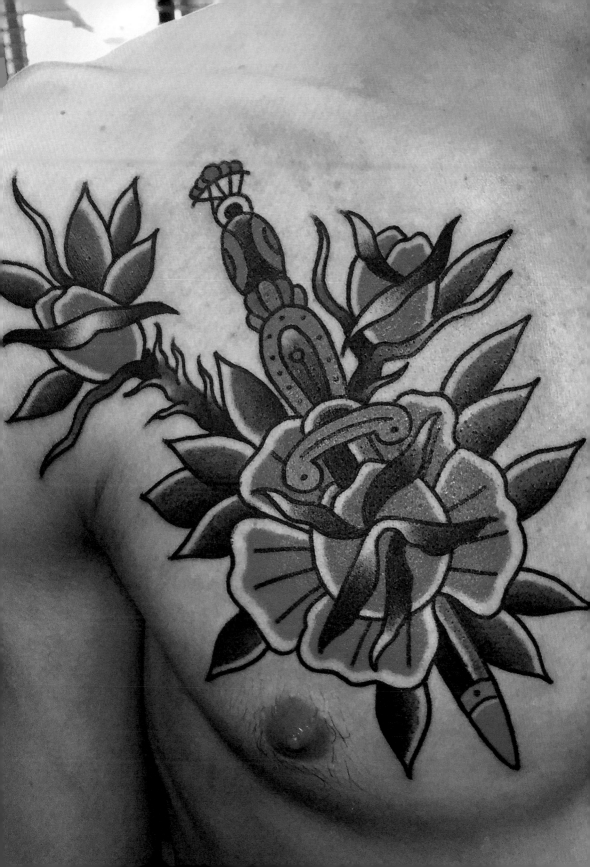

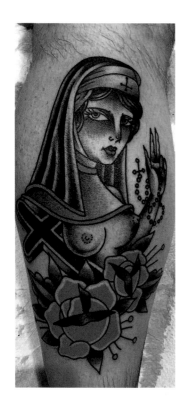

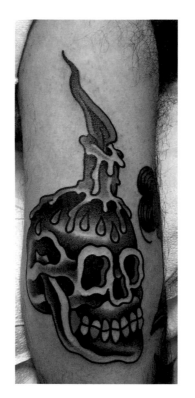

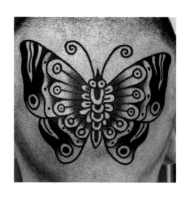

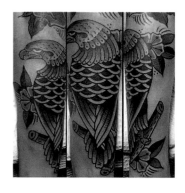

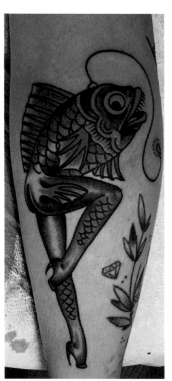

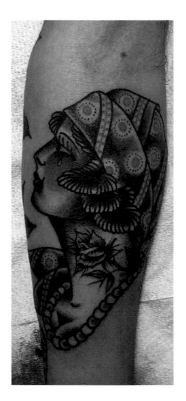

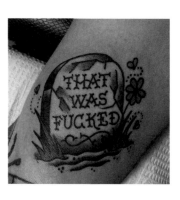

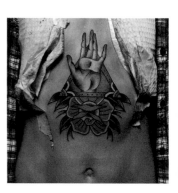

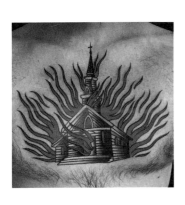

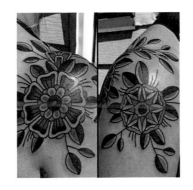

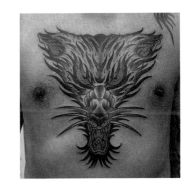

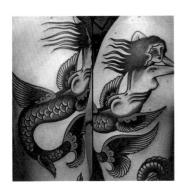

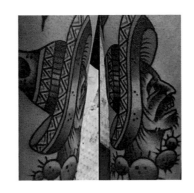

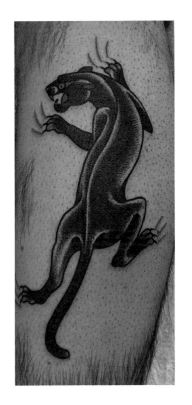

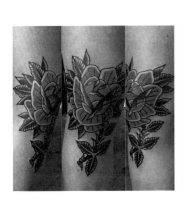

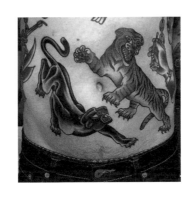

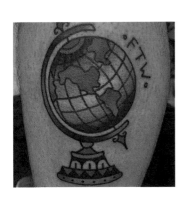

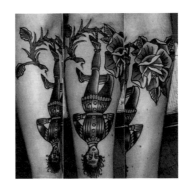

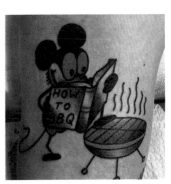

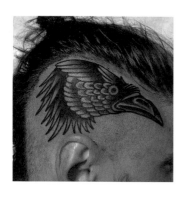

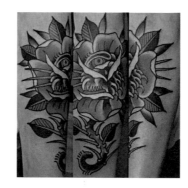

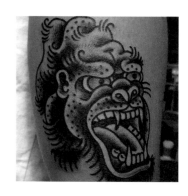

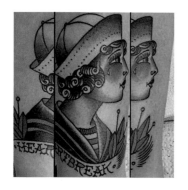

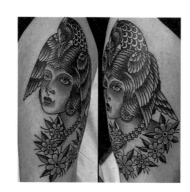

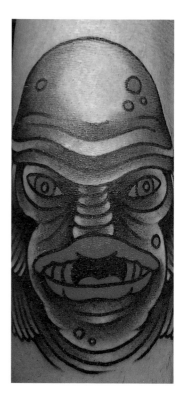

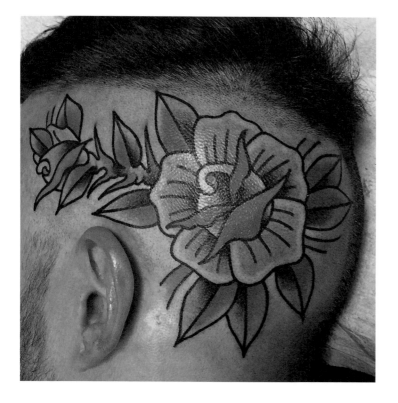

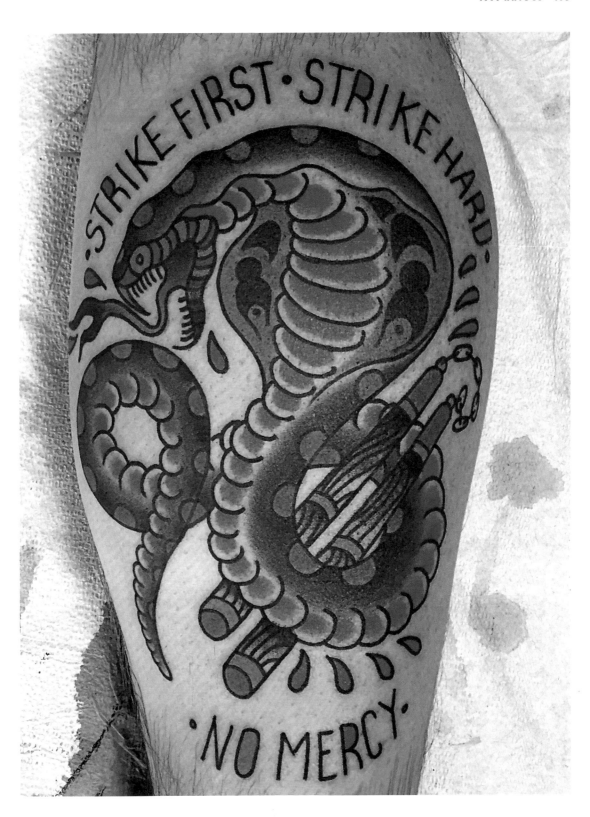

JEYKILL
@JEYKILL_BLEUNOIR
BIARRITZ, FRANCE

By turn meticulous and spontaneous, inspired by the ocean, the sky, and human nature, Jeykill creates a complex world between the illustrative and the abstract, often tinged with dreamlike elements.

Born in the Paris suburbs in 1974, Jeykill is a well-rounded artist. He trained as a graphic designer before joining the famous 9ème Concept collective in 1997, where he learned the ropes, frequenting artists from different but complementary worlds. The early 2000s marked a turning point for Jeykill, as the tattooist's calling found him. Often working freehand, he places a premium on simple yet effective pieces. In 2010, Jeykill opened Bleu Noir tattoo studio in Paris with Veenom, another artist who shares the same philosophy. It was an instant hit, thanks to the refreshing wave that the studio brought to the Paris scene, where tattooing had remained very traditional in its approach, its semantics, and its graphic influences. Other major artists of the French street-art scene, notably SupaKitch, began working at his studio. In 2016, this little crew, who grew up on skate/surf videos, launched the Bleu Noir Biarritz tattoo studio.

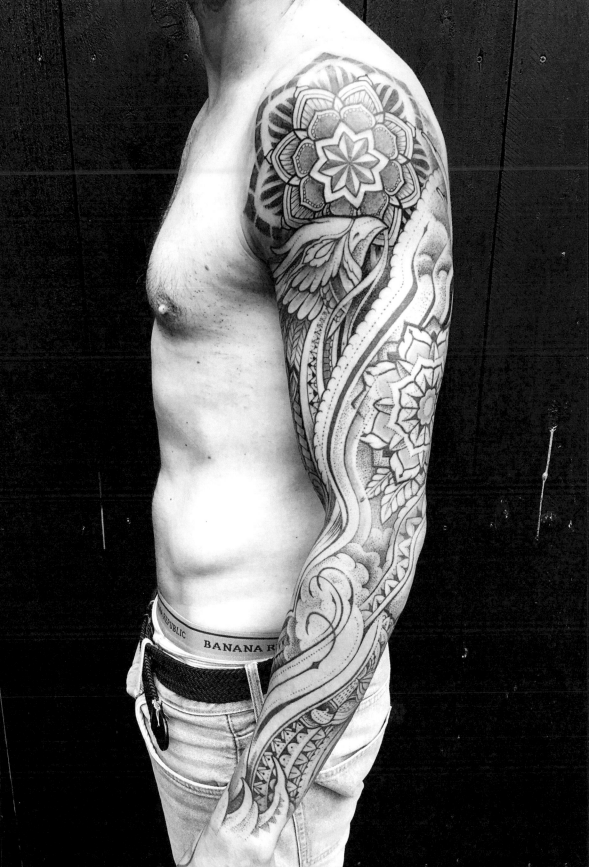

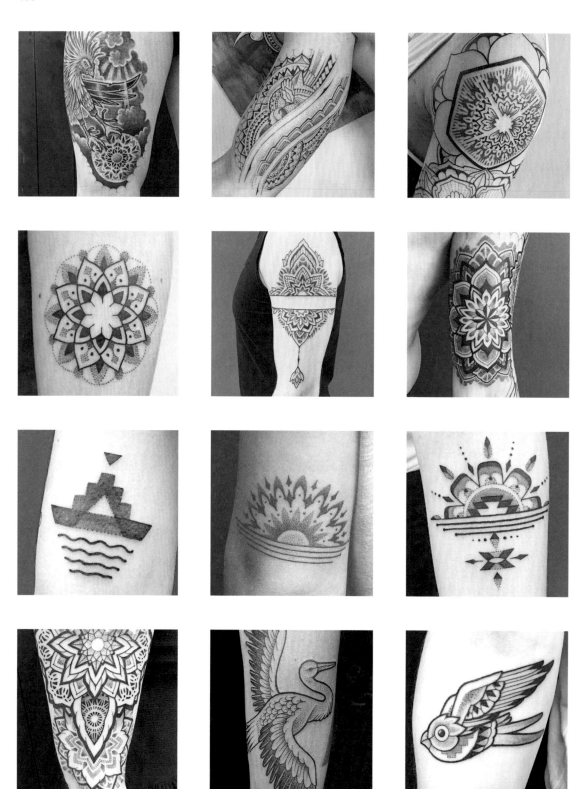

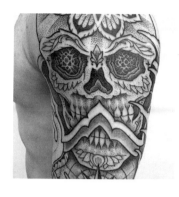

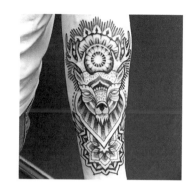

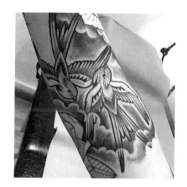

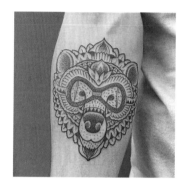

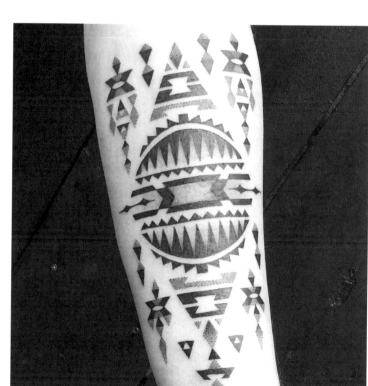

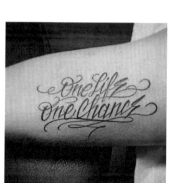

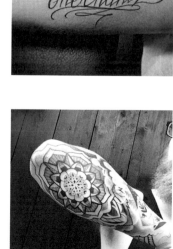

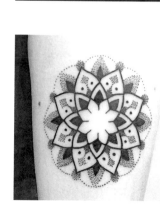

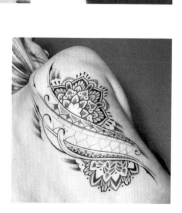

LISA ORTH
@LISAORTH
LOS ANGELES, CALIFORNIA, USA

Lisa Orth only tattoos pieces that she herself has created, and only in her own particular style of linework. They are originals, often imitated, never equaled. If you're after a tattoo that's not in a similar vein to what she's offering, you'd better look elsewhere.

Lisa began her career in Seattle, as a graphic designer for clients such as the local music magazine *The Rocket* and Sub Pop Records, for whom she designed the sleeve for Nirvana's first album, *Bleach*, as well as their now iconic logo. In the late 1990s, Lisa started her own record label to showcase unknown local grunge acts, played guitar and sang in a number of bands, and was active in Seattle's queer scene. She became interested in tattooing as a young girl, undertaking her first stick-and-poke tattoos on her sister. Once she reached the legal age, she got her first tattoo and discovered the world of traditional studios. In 2007, Owen Connell offered her an apprenticeship and encouraged her to develop her artistic vision. Lisa considers herself lucky to have been able to enter the tattoo world so late in life, at a time when the mentalities and the global scene had changed to be more open to new artists and fresh graphic styles. Since then, Lisa has acquired a fine reputation and her work has received a number of awards.

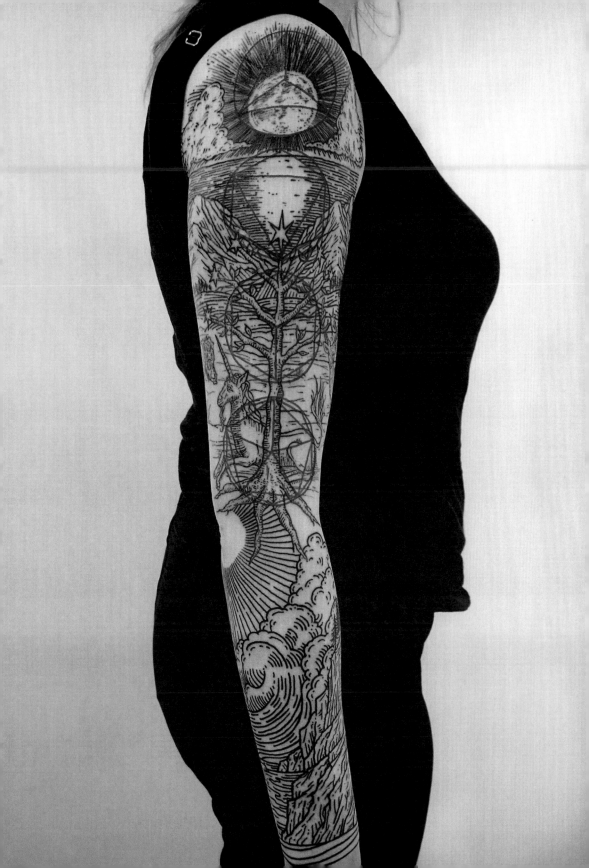

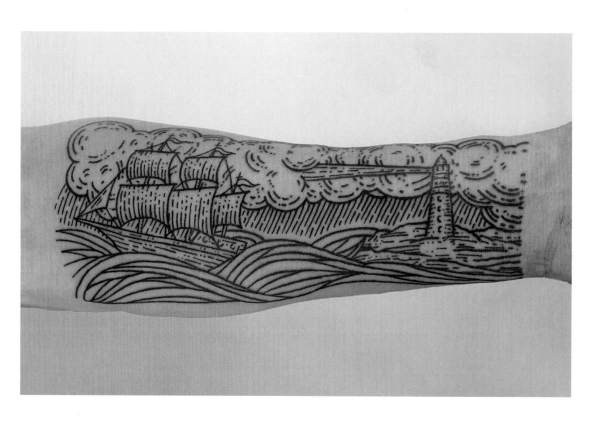

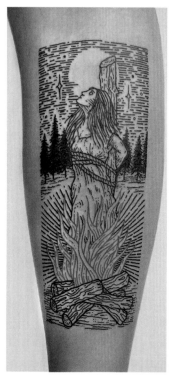

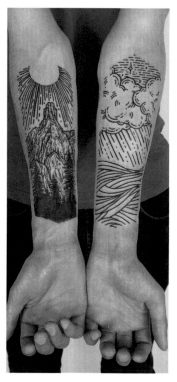

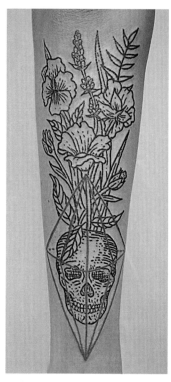

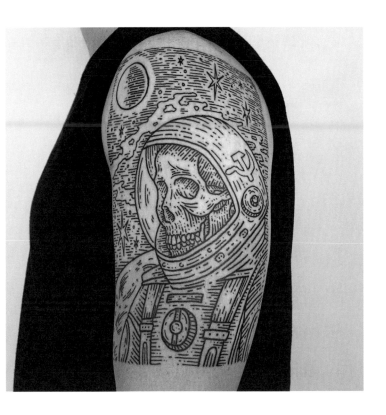

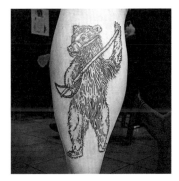

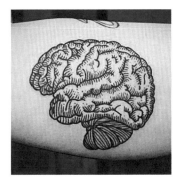

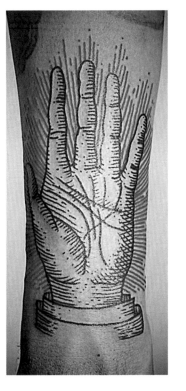

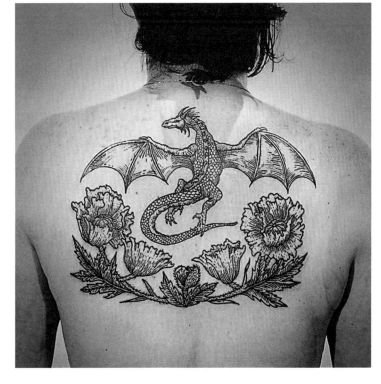

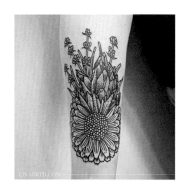

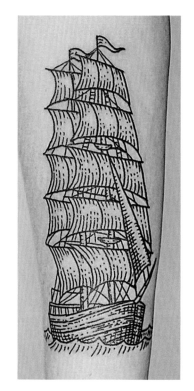

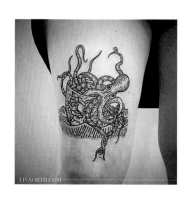

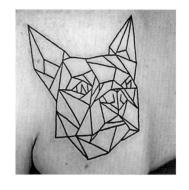

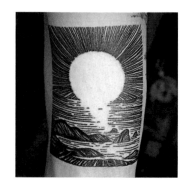

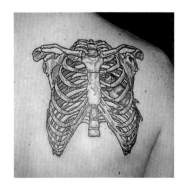

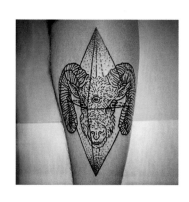

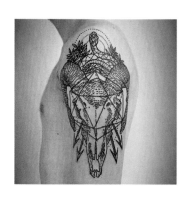

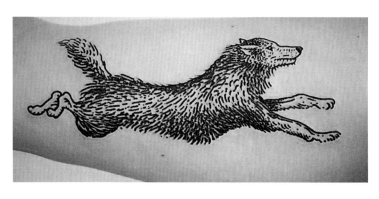

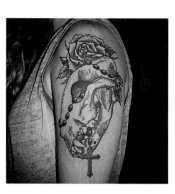

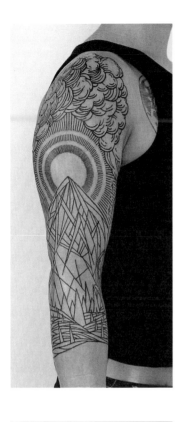

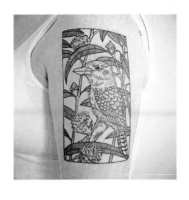

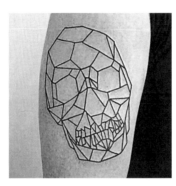

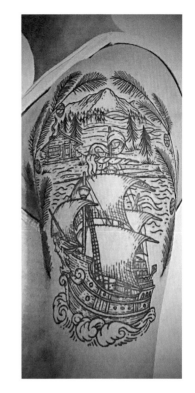

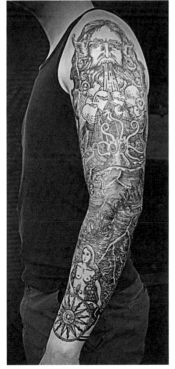

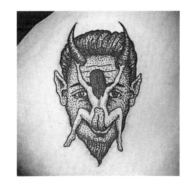

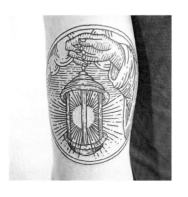

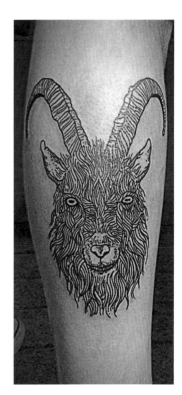

LESHA LAUZ
@LESHALAUZ
MOSCOW, RUSSIA

Alexey Lauz, aka Lesha Lauz, is a Russian tattoo artist and painter from Moscow. His highly personal style is colorful and makes use of pixels, dots, and the brushstroke technique.

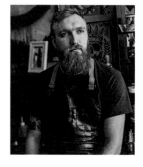

Lesha began drawing when he was just a boy, under the influence of his father, who was an amateur artist. He developed his style and technique by following an artistic curriculum at university. Lesha started tattooing in 2007, but he still tries to draw something new every day, to explore new ideas, shapes, and compositions. Over time, he has developed a combinatorial style that makes heavy use of pixels, digital effects, and a technique close to that of the paintbrush, all used to create realistic images. This mix makes his tattoos unique and textured, and full of energy. In some respects, Lesha's style is close to that of Sasha Unisex. When he began focusing on what he calls his "pixel works" or "pixel and glitch," his first flashes were quickly snapped up. Lesha's website has several tutorials to encourage other artists to explore his unique style.

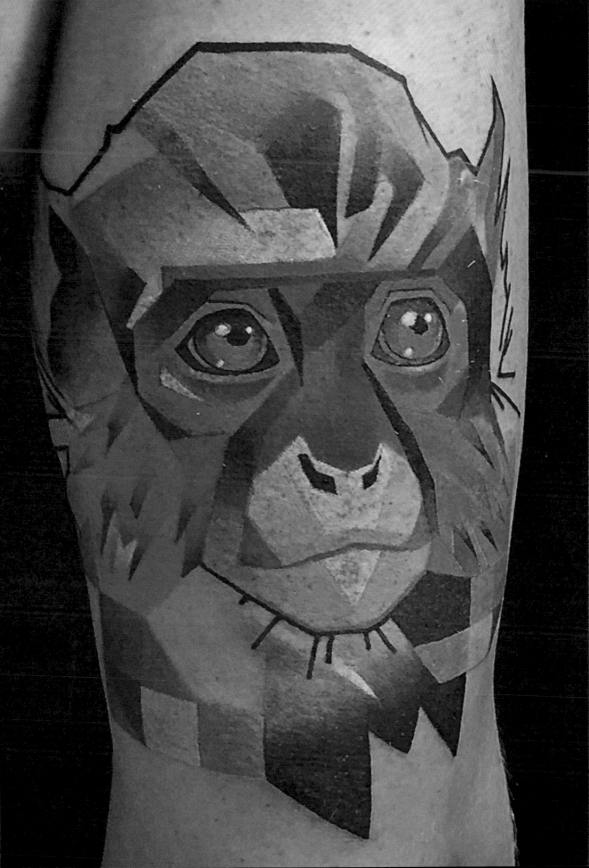

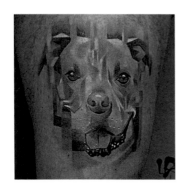

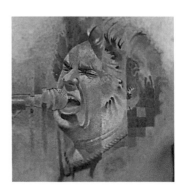

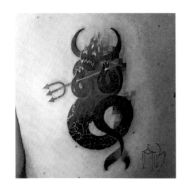

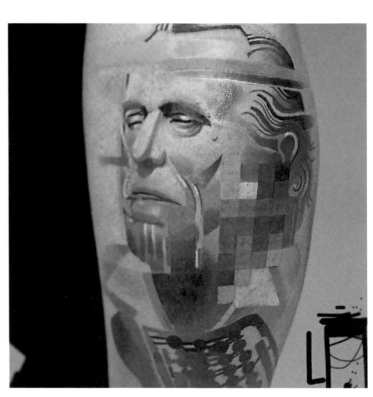

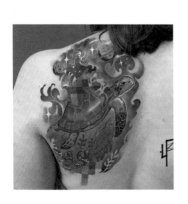

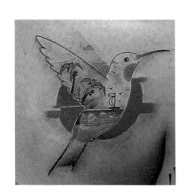

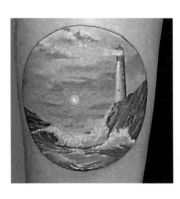

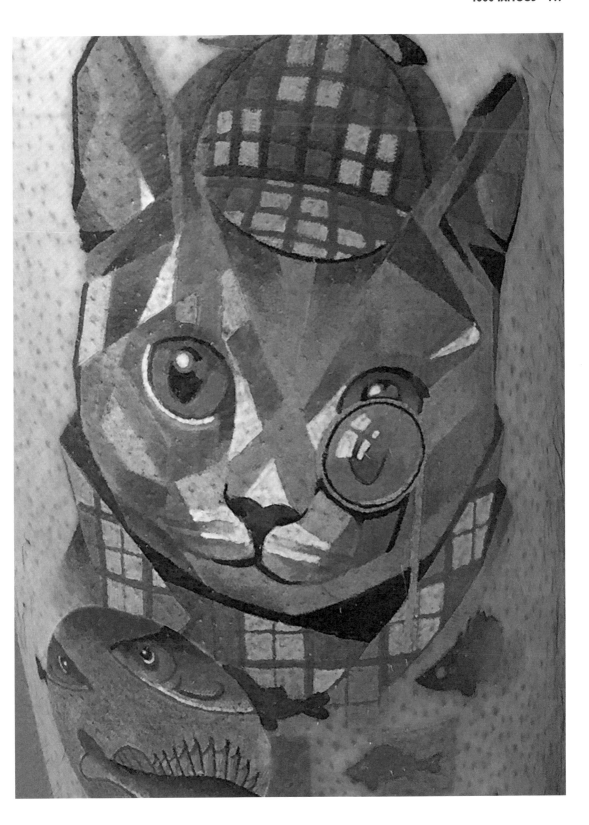

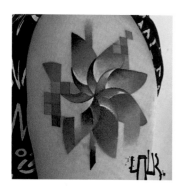

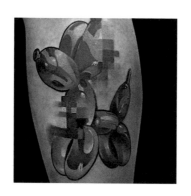

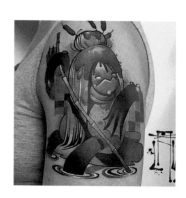

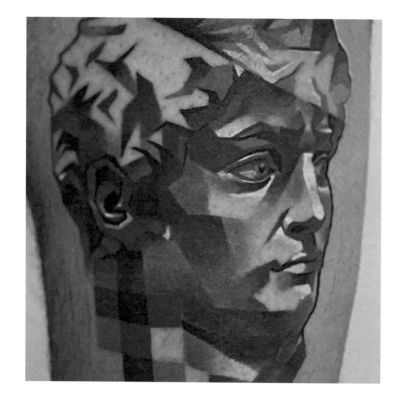

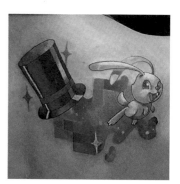

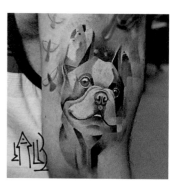

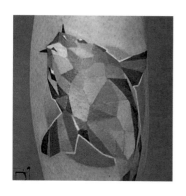

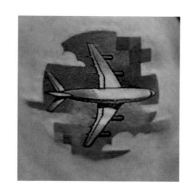

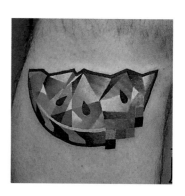

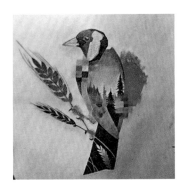

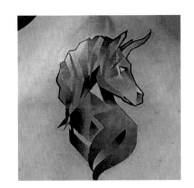

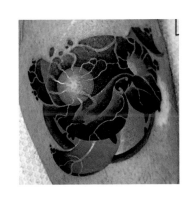

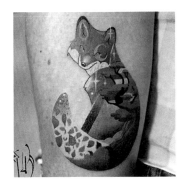

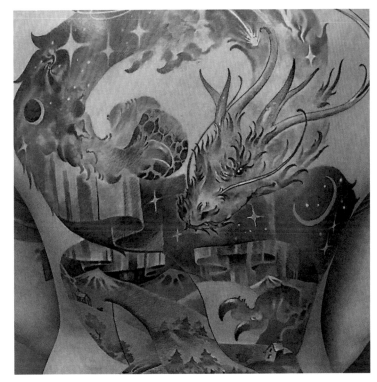

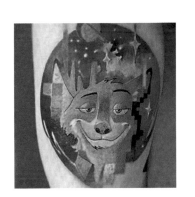

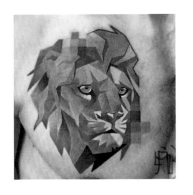

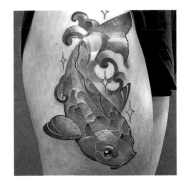

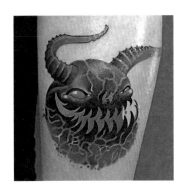

LA BARBE TATTOO

@LABARBETATTOO
NANTES, FRANCE

The style of La Barbe Tattoo evokes the cover art of Van Halen's second greatest hits album, *The Best of Both Worlds*: traditional linework influenced by the TV series or video games of the moment. The results are pretty intense.

The artist known as La Barbe Tattoo (real name: Hugo Delart) comes from the city of Amiens, in northern France. After completing his studies in graphic design, he spent six chaotic months as a freelance graphic designer in Nantes, France, where Rudy, the owner of Mud Tattoo, took him under his wing as an apprentice. Drawing is in Hugo's blood; his older brother, Simon Delart, is a talented poster artist. He also had the support of his parents in his chosen vocation, a factor too rare not to mention. Hugo draws his inspirations from music, heavy metal, comics, video games, TV series, and movies. He's definitely from the Marvel/Netflix/Playstation generation!

Hugo has been showing his work at Paris Games Week since 2016, and he is one of the artists who designed custom controllers for the one-year anniversary of the game *Overwatch*.

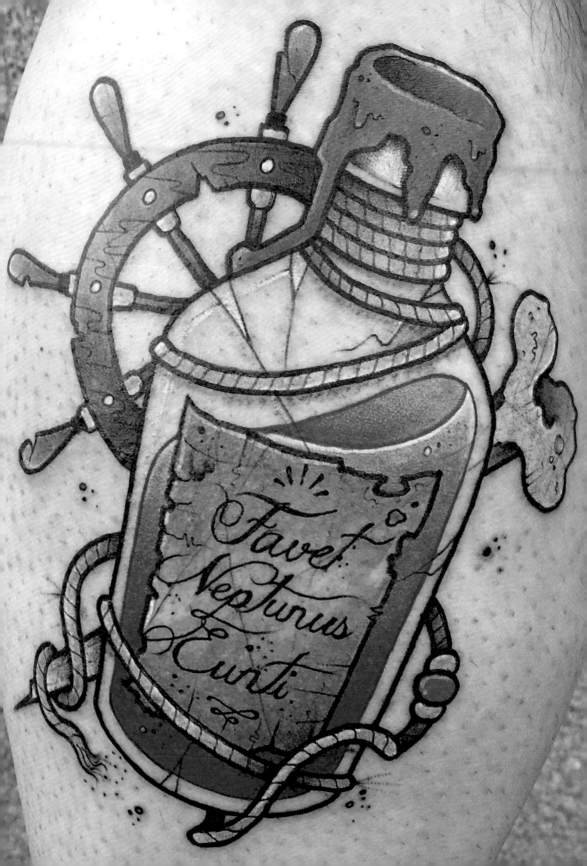

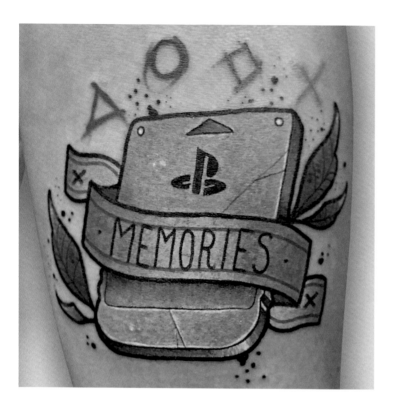

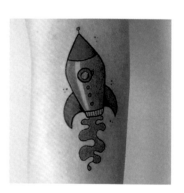

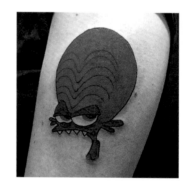

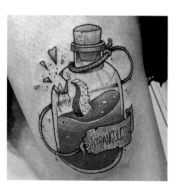

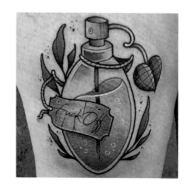

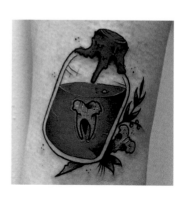

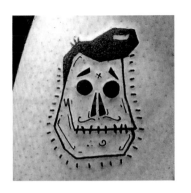

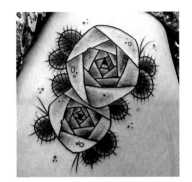

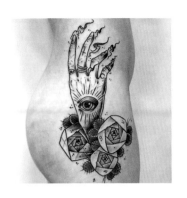

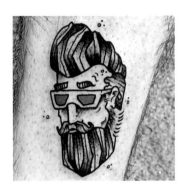

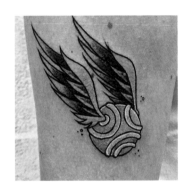

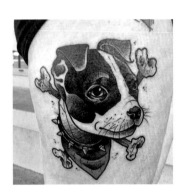

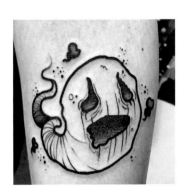

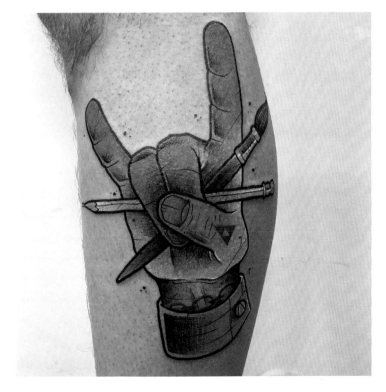

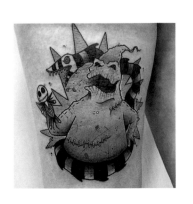

VOLKO & SIMONE

@BUENAVISTATATTOOCLUB
WÜRZBURG, GERMANY

Volko Merschky and Simone Pfaff are the incredible duo behind the Buena Vista Tattoo Club, and they are responsible for the tattoo style they call "Trash Polka." They have over fifteen years of tattooing behind them.

Volko and Simone have an immensely original approach, both in life and in tattooing. They cooperate, share, discuss, and collaborate. The resulting pieces are a mix of dark, tortured realism, with an emphasis on pure graphic design and lettering. Their aesthetic and iconography are informed by punk culture, urban art, typography, geometry, and photography; it's an exciting, borderless melting pot. These two all-rounders do it with panache, stretching the limits of modern tattooing a little further: large expanses of black flat-tint, outrageous amounts of gray, and the use of bloodred hues, skulls, and written messages. The hybrid, graphic tattoos created by these two clever minds and four nimble hands are truly unique.

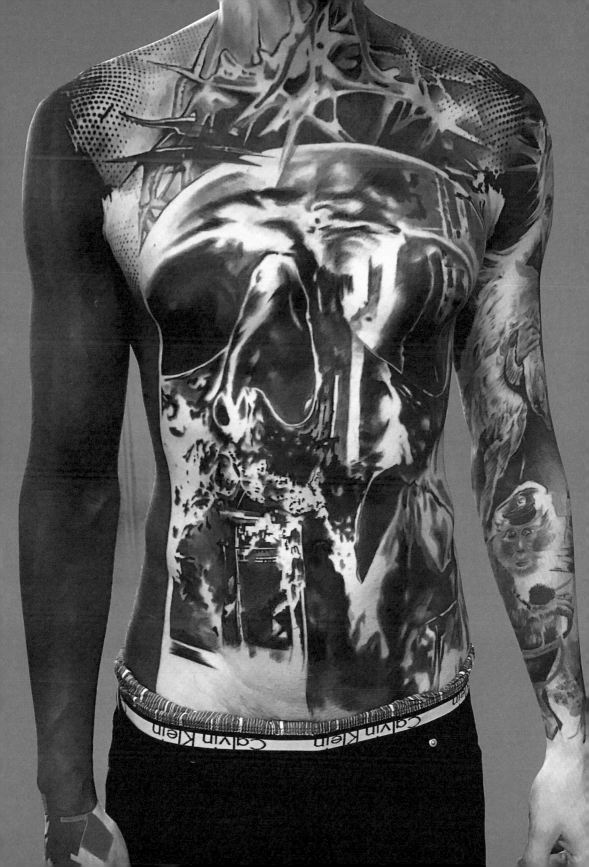

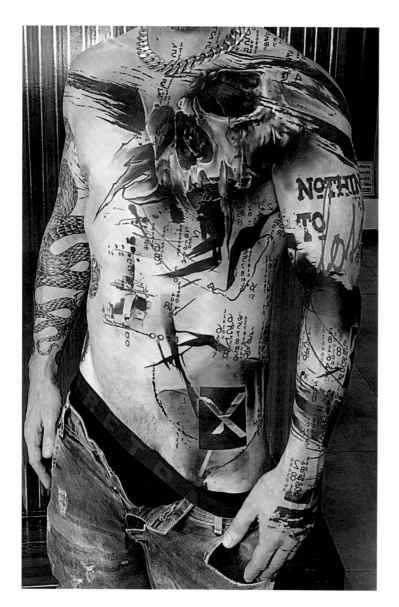

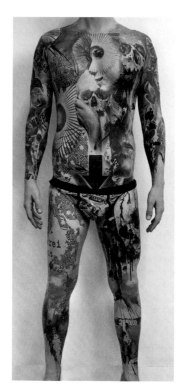

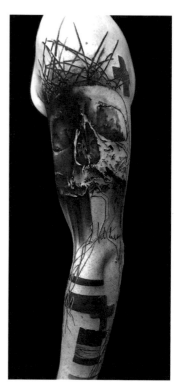

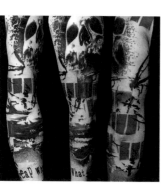

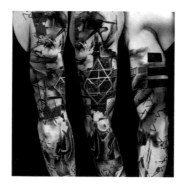

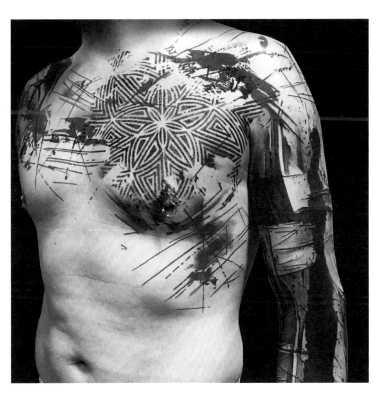

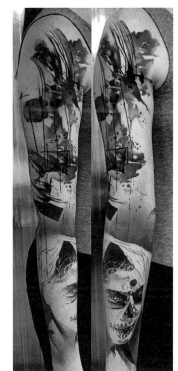

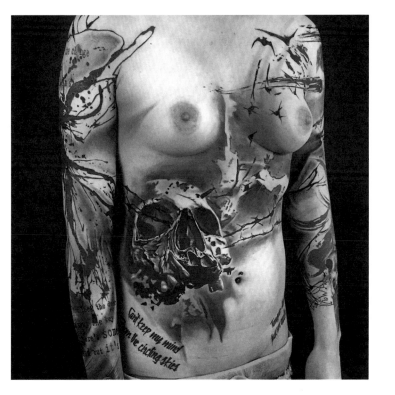

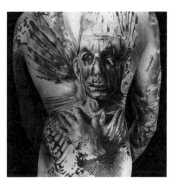

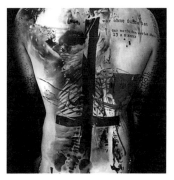

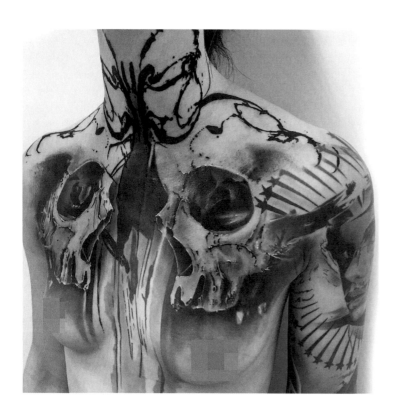

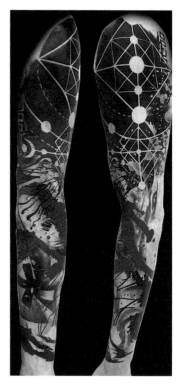

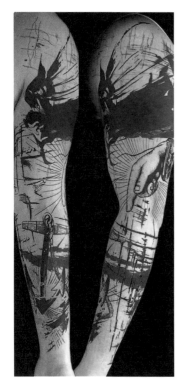

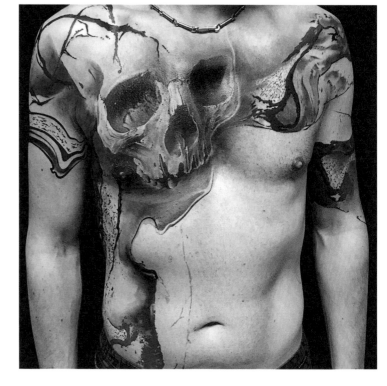

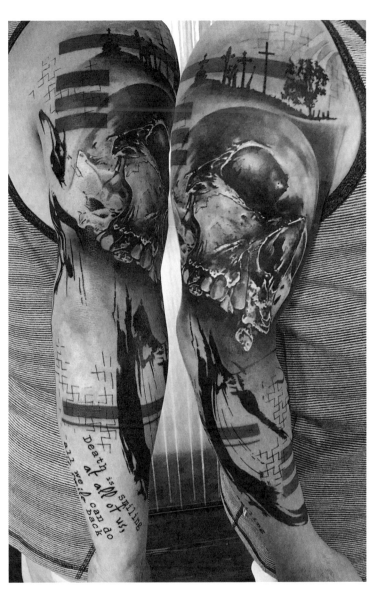

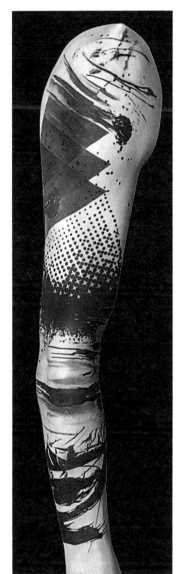

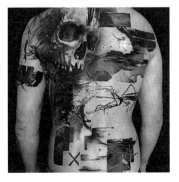

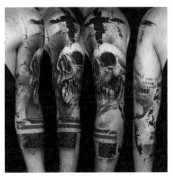

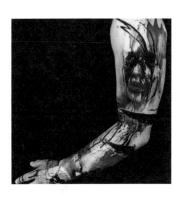

SANYA YOUALLI
@SANYAYOUALLI
PALENQUE, CHIAPAS, MEXICO

Sanya Youalli was born in Slovenia, where she also spent her childhood, in the late 1970s. Having arrived in Mexico in early 2002, she formed a strong connection to ancestral Mexican culture, forging close relationships with the guardians of the traditions.

Sanya has learned about Mexican culture and arts in-depth. Self-taught, she makes her own tattooing tools and has established her private studio in the middle of the jungle. Sanya considers the body to be a temple and tattooing the holiest of paintings, where the intention behind the act of tattooing is as important as the design. She also practices therapeutic tattooing according to the needs of her clientele; it's a communion, an expression of, and connection with, the sacred and the spiritual. Sanya has been invited to numerous conventions in Europe, Asia, and North America. She has tattooed at the prestigious Amsterdam Tattoo Museum, established by Hanky Panky, and has participated in events such as the Traditional Tattoo & World Culture Festival in Ireland and the Traditional Tattoo Camp in Indonesia. Sanya is one of those pioneers who are reviving and preserving ancient tattooing practices and cultures. She lives and works in a national park close to an archaeological site in Palenque, Chiapas, Mexico.

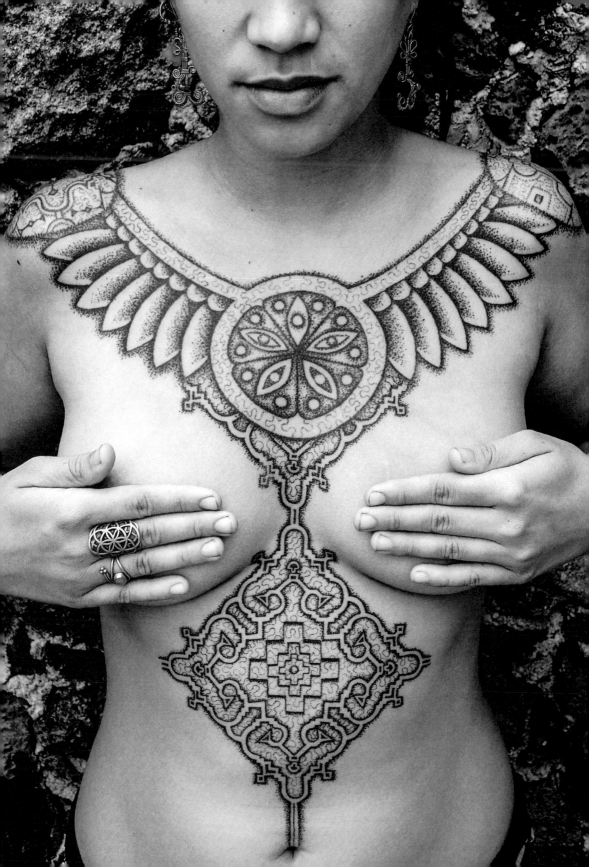

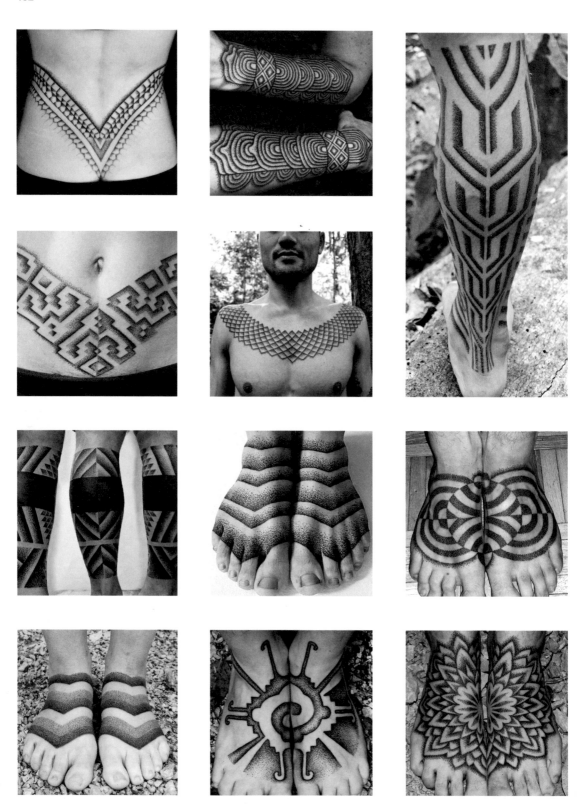

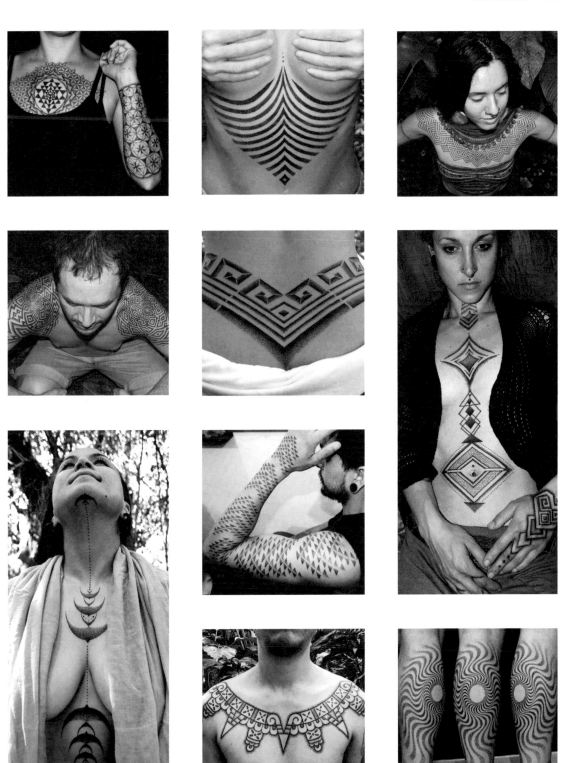

LORENZO ANZINI

@LOREPROD
CATTOLICA, EMILIA-ROMAGNA, ITALY

Lorenzo Anzini creates unimaginable, unique tattoos, like nothing you've ever seen before. They are often colored, not without humor, even cynicism, and carry strong meanings.

Lorenzo Anzini, alias Loreprod, is a young tattoo artist born in Rimini, Italy, who lives and works in the small town of Cattolica, a little way down the coast. As a child, he was struck by the sight of a tattooed Austrian biker and began drawing on his friends' arms. A few years later Lorenzo made tattooing his profession, after studying traditional graphic design—including time at the Istituto D'Arte Federico Fellini—and training under Alex De Pase. This star of the Italian tattoo scene took full note of his apprentice's skills and encouraged him to develop his own personal style. Loreprod finds his inspiration in literature, architecture, cinema, and illustration and merges all of these elements to breathe life into his ideas. To give free rein to his passion, he opened his own concept store in Cattolica: Nero Di Seppia, which comprises a tattoo studio and an exhibition space.

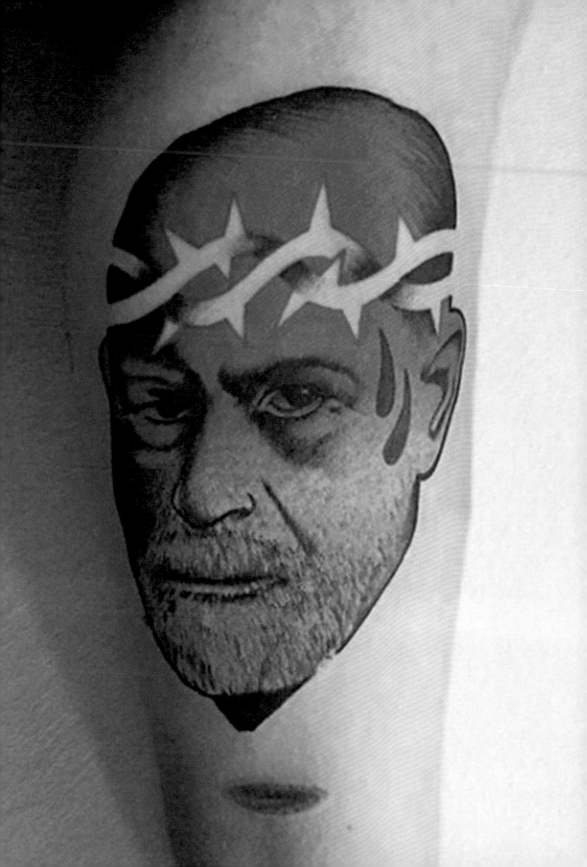

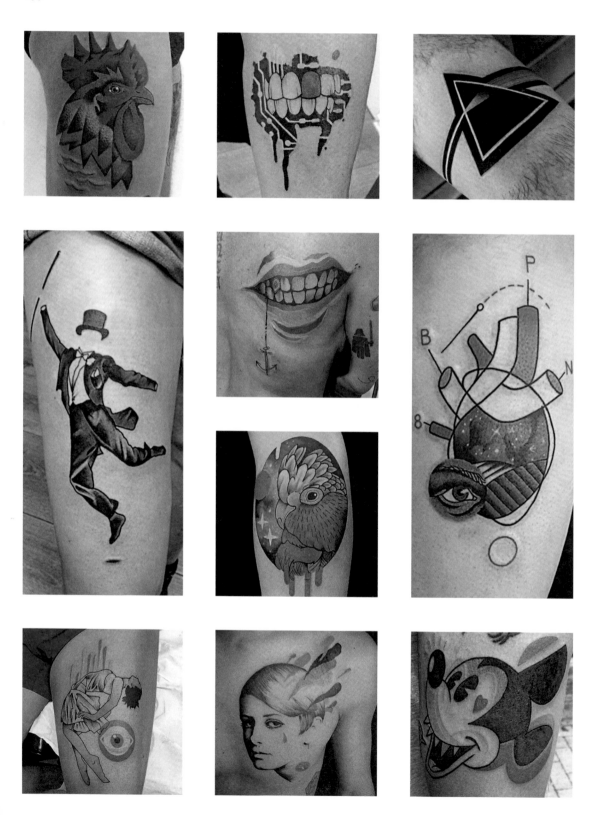

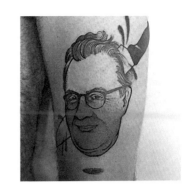

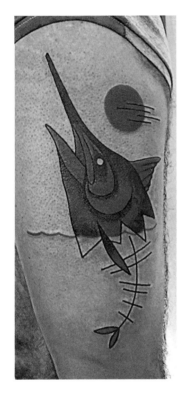
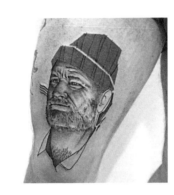
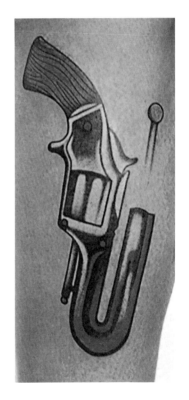

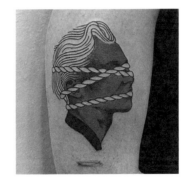

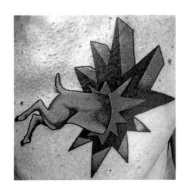
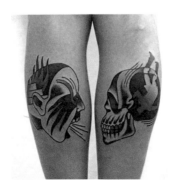
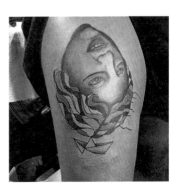

AMIRAL TATTOO

@AMIRAL_TATTOO
PARIS, FRANCE / BERLIN, GERMANY

Are you a lover of adventures on the high seas, old-school navigation, and voyaging? If so, you should explore the work of Amiral Tattoo.

Following studies in fine art, Amiral Tattoo tried his hand at various media, including painting and street art, and participated in a number of collective projects. Then he discovered tattooing: a revelation. He learned the ropes in a street shop—a difficult and restrictive experience, but one that taught him a lot and enabled him to develop the versatility he needed to fulfill his potential. Amiral then took to the road, driven by a need to travel, to discover other shops, to get out of his comfort zone, and to meet other artists. It was a process similar to the apprenticeships of olden days, when aspiring craftsmen would travel around France to learn from the masters, before going on to produce their own masterpieces—very apposite for those who consider tattooing to be as much a craft as it is an art. Amiral's next challenge? Sculpture, in which he would like to explore the parallels between tattooing and the 3-D body.

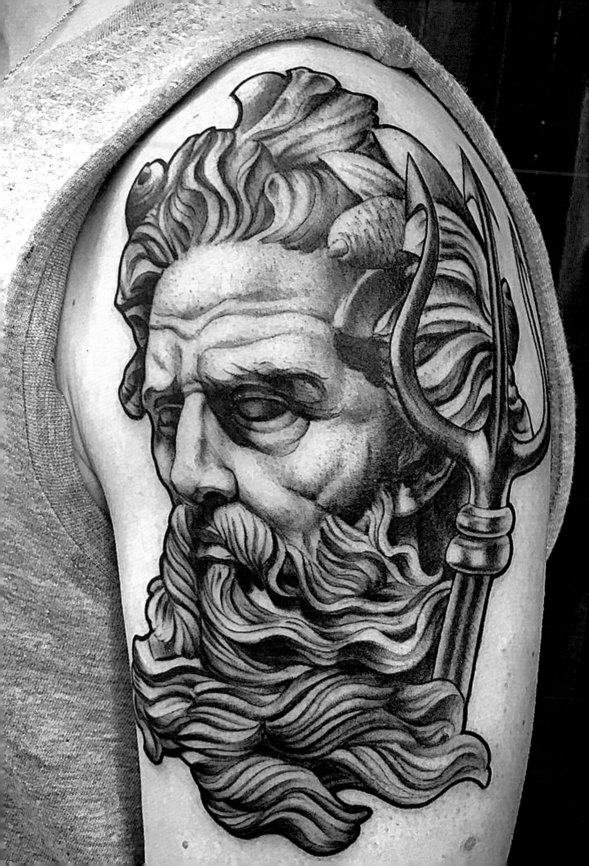

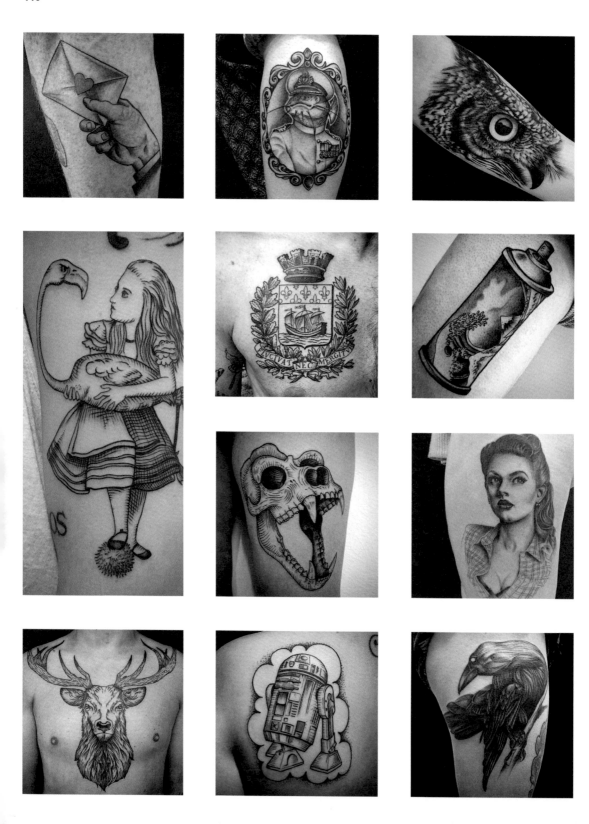

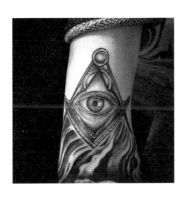

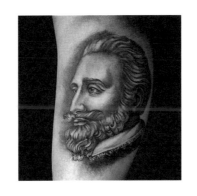

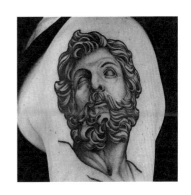

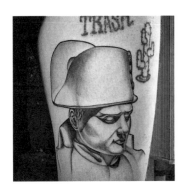

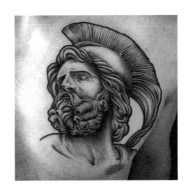

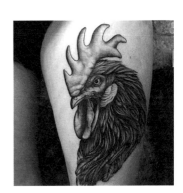

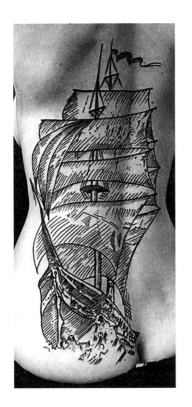

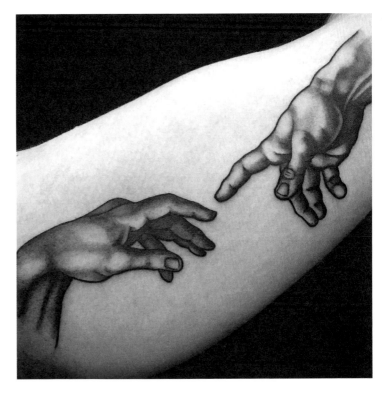

JÜRG
@JURGPOULYCROCK
BRUSSELS, BELGIUM

Brought up on "potatoes and beer" in the countryside of his native Belgium in the 1970s, Jürg moved to Brussels to study comic book art. His tattoo aesthetic lies at the crossroads of comics, barroom humor, and Z movies. It's pure lowbrow art with a sprinkling of trash.

Brussels, 1995. With his diploma in the bag, Jürg was eager to do something and to make connections, so he cofounded an independent comics publisher. He created comics, fanzines, and experimental/underground magazines, and collaborated with writers for several publishers, dividing his time between writing, painting, and putting on exhibitions. Jürg then went to work with Mister P—who ran the Tendre Furie tattoo studio in Brussels—before switching to the nearby La Boucherie Moderne studio, and, recently, the Bonne Fortune studio, also in Brussels. Jürg retains some strong influences from his initial studies: Bernie Wrightson, Charles Burns, Jordi Bernet, and EC Comics, the filmmakers Fritz Lang and Robert Aldrich, and of course all those horror/trash/weird movies that are "so bad they're good"—as dark and bizarre as they are funny. It's a rich aesthetic world, one that comes through strongly in all his tattoos.

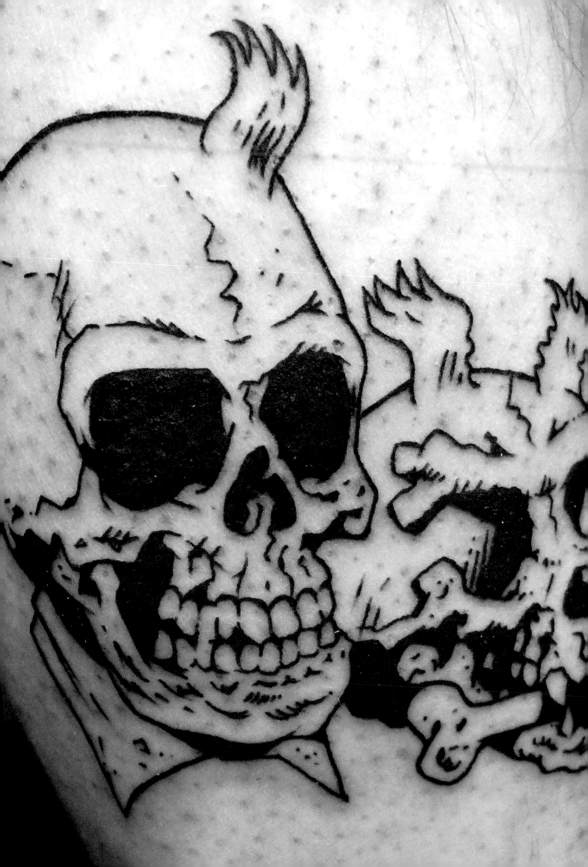

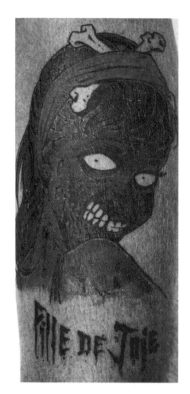

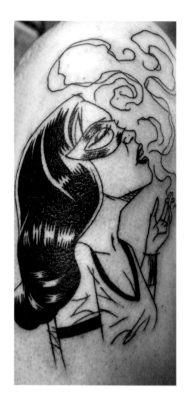

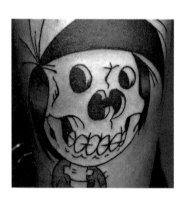

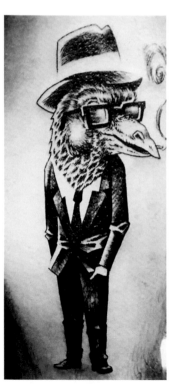

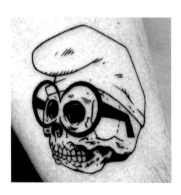

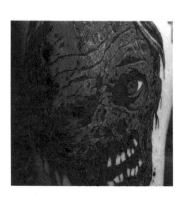

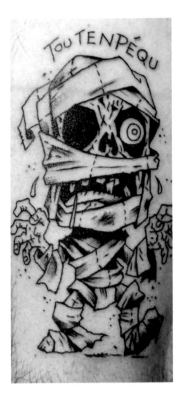

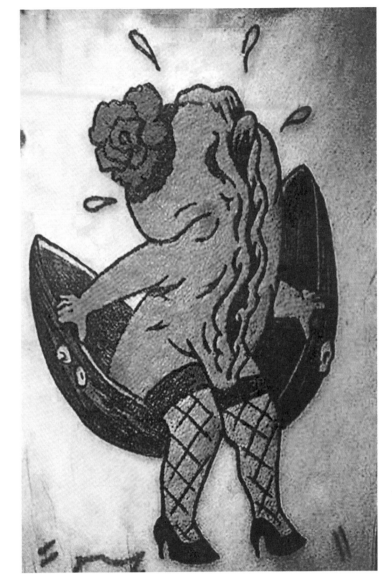

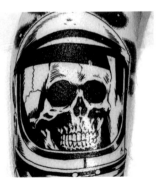

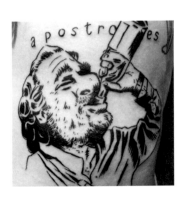

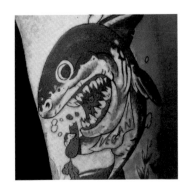

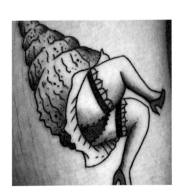

NAOKI
@TNS_NAOKIDZ
OSAKA, JAPAN

For fans of the lowbrow art movement, the sweet-and-sour world of Naoki is a wonderful burst of color.

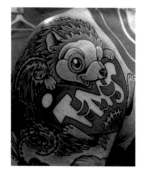

At the crossroads of manga, *kawaii* (the culture of "cuteness"), and the universe of Mark Ryden (American artist whose characters have exaggerated, large eyes), Naoki's aesthetic is an off-the-wall world, where creatures—some quite delicious with an innocent gaze, others dangerously attractive—share the billing with charming animals, real and imaginary. You also come across icons from specifically Japanese popular art, such as the *kokeshi* and Daruma dolls, as well as various *maneki-neko* (those famous beckoning-cat figurines, which are supposed to bring good luck). Naoki holds court in his own studio in Osaka: TNS (Tattoo Naoki Studio). Like a Wizard of Oz tripping out in the world of Lewis Carroll, but behind the mirror, Naoki portrays an enchanted world inhabited by creatures that really aren't that cute at all: a sweet and totally addictive graphic nightmare.

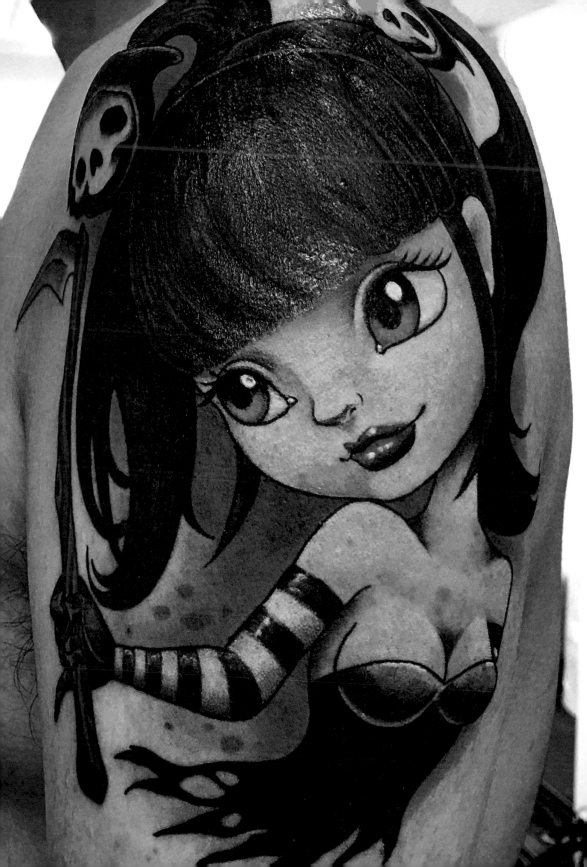

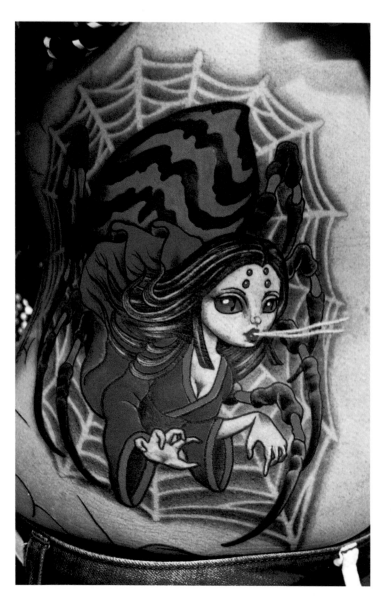

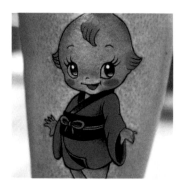

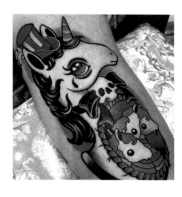

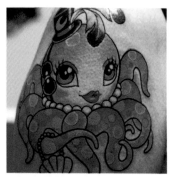

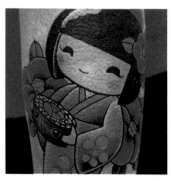

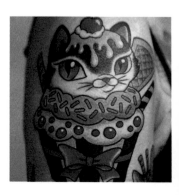

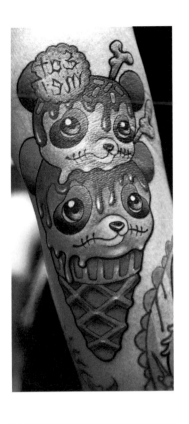

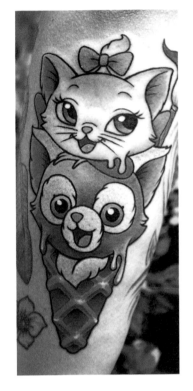

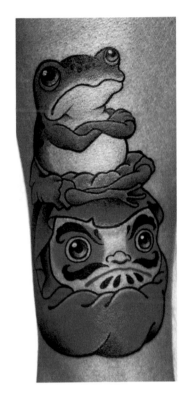

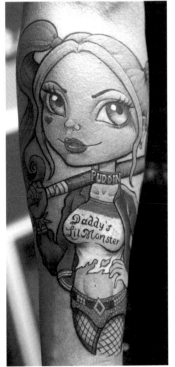

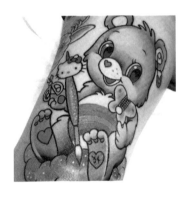

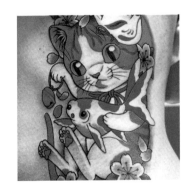

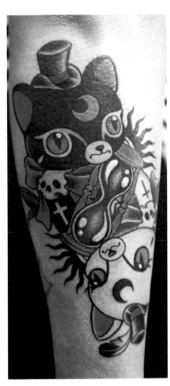

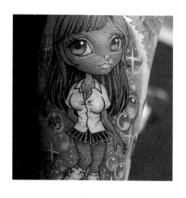

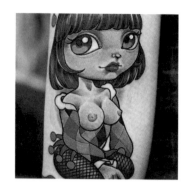

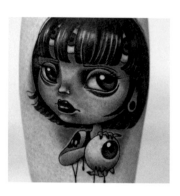

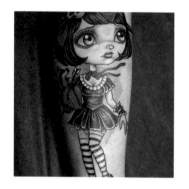

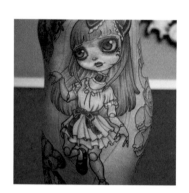

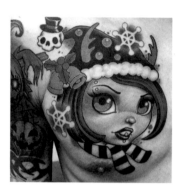

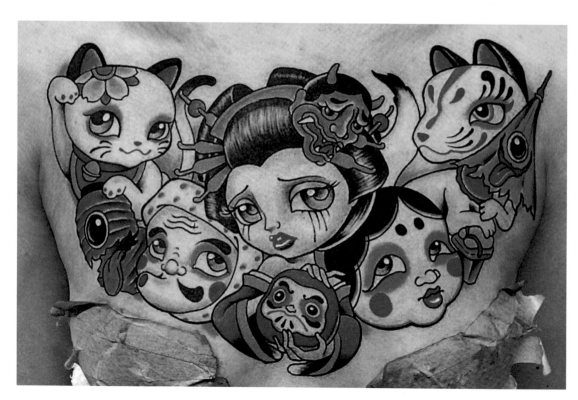

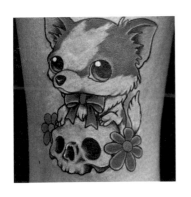

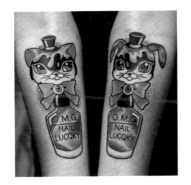

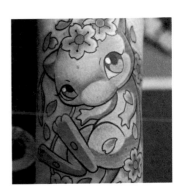

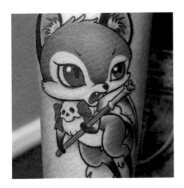

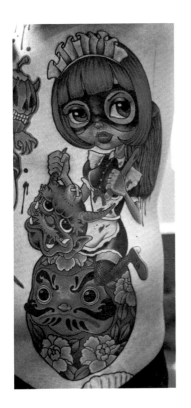

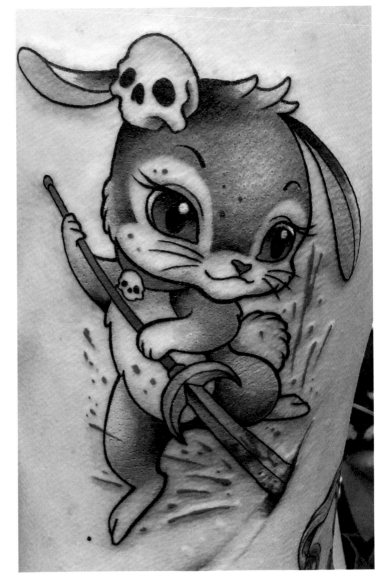

ROMA & NICK BROSLAVSKIY

@ROMA_BROSLAVSKIY & @BROSLAVSKIY
KIEV, UKRAINE

These talented Ukrainian twins work together in Kiev, in a single tattoo studio housing two styles, two worlds that collide and complement each other. One twin favors a curious mix of engraving and color, while the other prefers blackness and humor. Welcome to the realm of the Broslavskiy brothers.

Good grades were not sufficient for either Nikita, aka Nick Broslavskiy, or his twin brother, Roman (Roma), to gain admission to the art school in their hometown. Roma joined the army, while Nick stayed with their parents, continuing to draw while looking for any branch of the art world where he might find a place. So he started to paint clothes and sometimes did portraits to order. Since sales of his custom designs and objects were few and far between, he also worked at construction sites. Using the little money he managed to save, Nikita bought his first tattoo machines. He trained on the job, tattooing his friends and himself, with his graphics being influenced by Alexander Grim, Ien Levin, Thomas Hooper, and Guy Le Tatooer. Once he had acquired a little experience, Nikita went to Moscow, before settling in Kiev, where he opened his first studio. Six months later his brother, Roman, joined him, and they began collaborating.

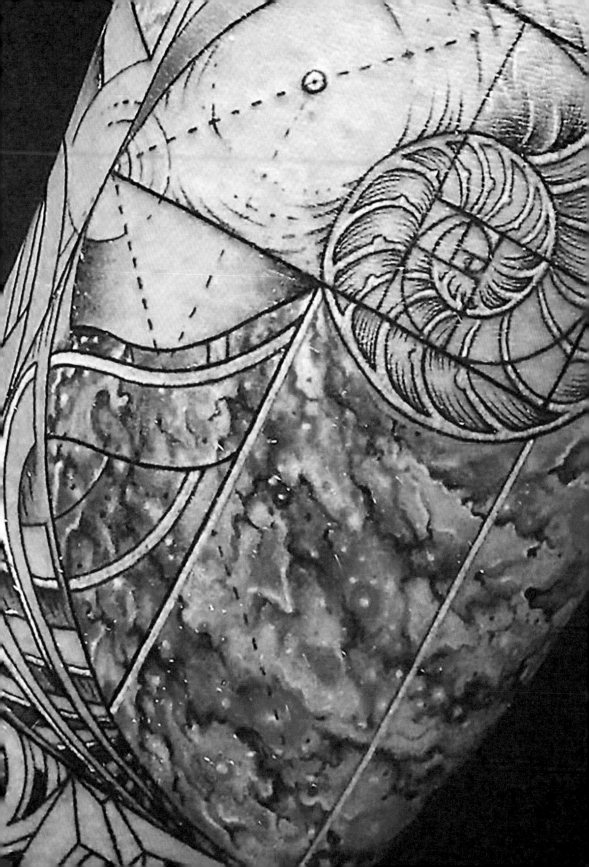

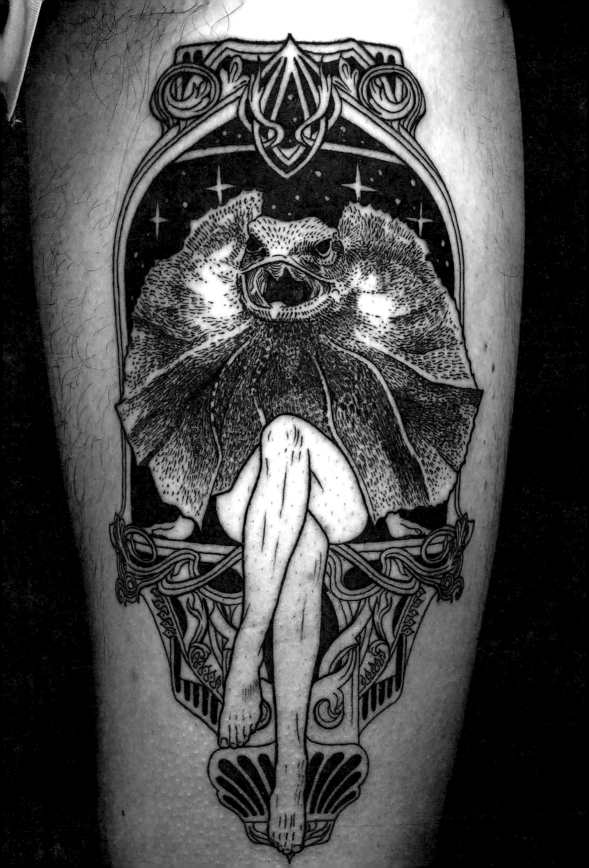

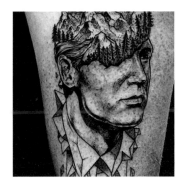 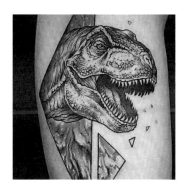

The pair have created a mysterious universe of great depth, in which engraving is of phenomenal importance. Their shared appetite for this pictorial art allows them to work side by side and to build bridges between their respective creative ideas. Although Nikita's pieces are most recognizable by their inspirations drawn from architecture and surrealist religious art, they are also marked by the colors that he likes to use—cosmic hues, which are inserted into drawings that are highly classical in style, with fine, powerful lines, close to old engravings.

Roma, who is more into conceptual blackwork, shares his twin's taste for weirdness, love, esotericism, romantic decadence, and disturbing, subversive images. To this he adds a dose of black humor and cynical tonality, making his work flamboyant and charismatic.

Where the worlds of the two brothers meet, unique pieces arise, the fruit of considerable dedication and aesthetic care.

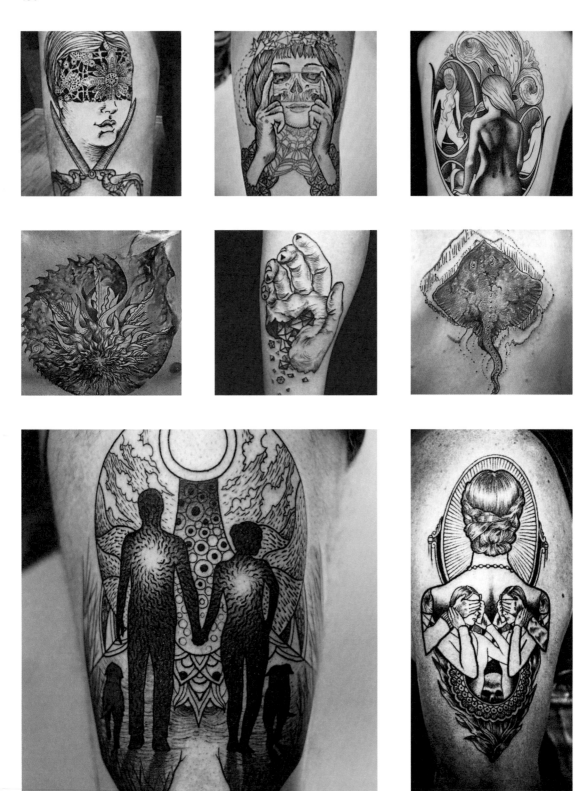

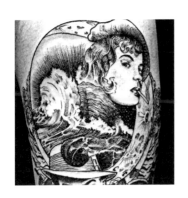
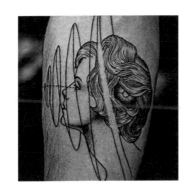
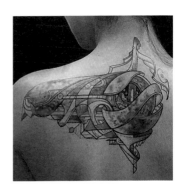
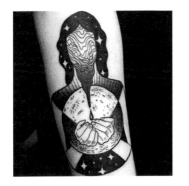
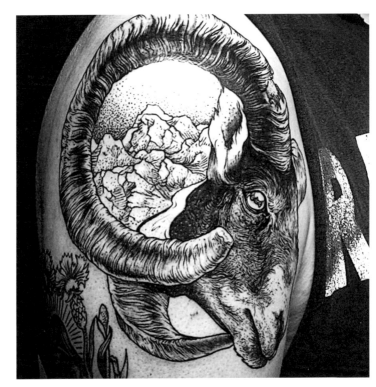
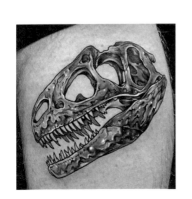
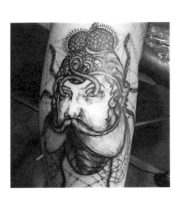
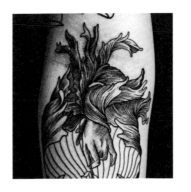
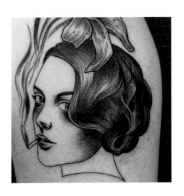

DIMITRIS CHATZIS
@DIMITRISCHATZIS_NTC
ATHENS, GREECE

Dimitris lives and works in Athens. He studied at the Coventry School of Art & Design (UK) and has forged a career in the worlds of street art, graphic design, and illustration, always with a surrealistic approach.

Dimitris Chatzis began tattooing in 2007. Two years later, he joined the Nico Tattoo Crew, in Athens, where he still works. Dimitris has been highly influenced by the neotraditional and neo-Japanese styles, which form a large part of his work. Indeed he sometimes blends the two styles to create something quite distinctive. With clear, solid lines combined with finer ones, and a wide palette of colors, his tattoos evoke Romanticism, from the Victorian period to Art Nouveau—of which Dimitris confesses to being a great fan. He is always trying out different techniques—an aspect of tattooing that interests him greatly; his adventures are not restricted simply to graphic experiments. Dimitris draws inspiration from his travels, as well as music. Art is all around us.

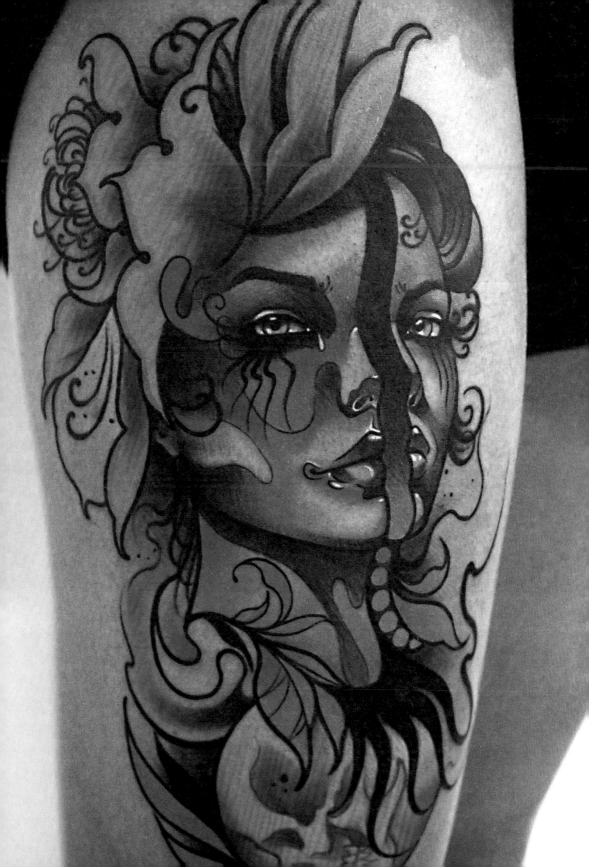

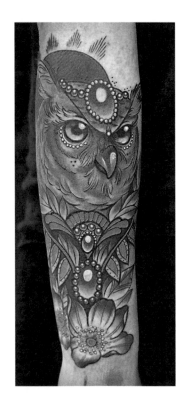

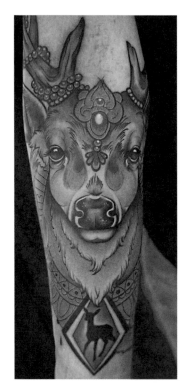

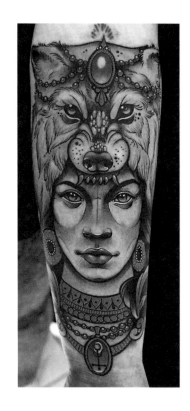

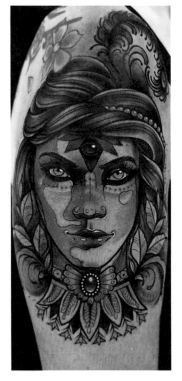

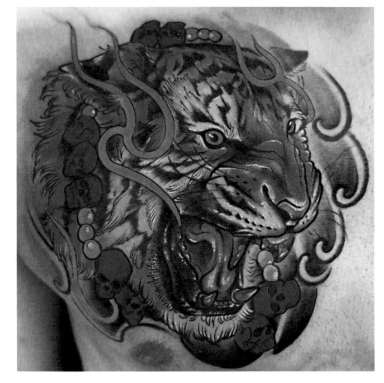

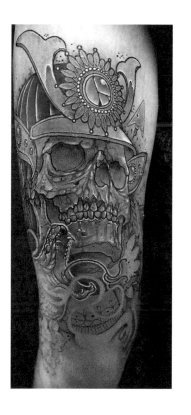

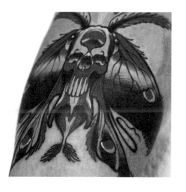

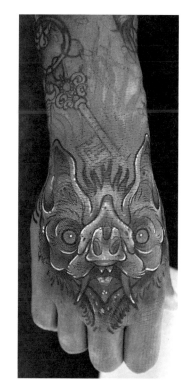

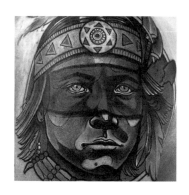

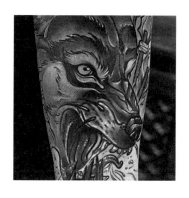

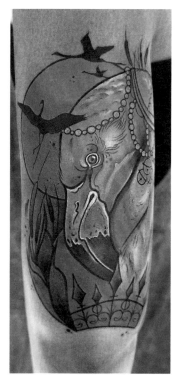

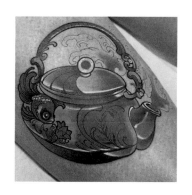

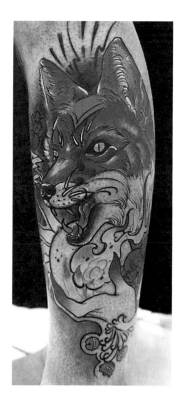

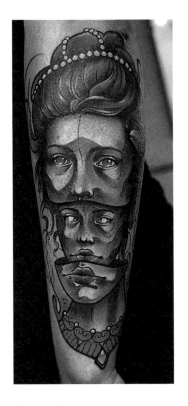

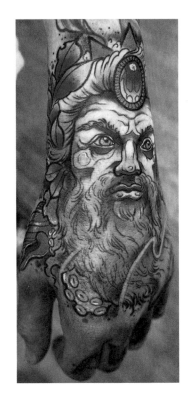

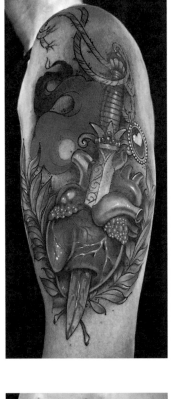

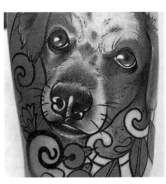

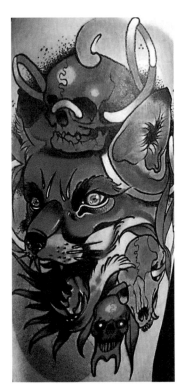

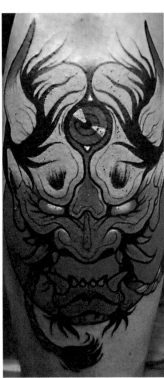

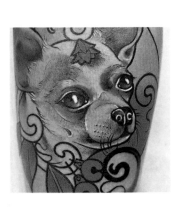

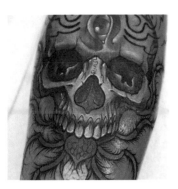

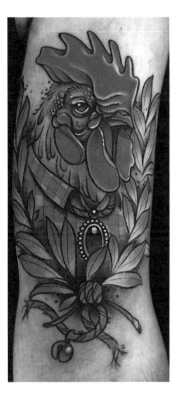

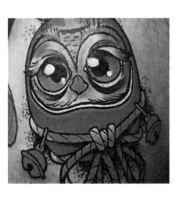

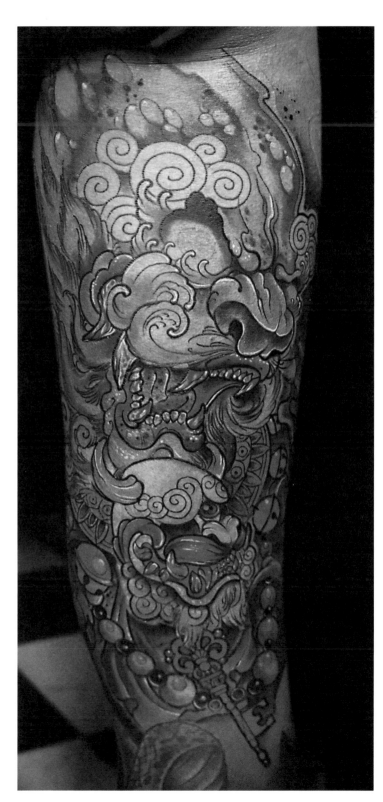

LAURA SATANA

**@LAURASATANA
PARIS, FRANCE**

This Parisian artist has developed her own style—a mix of drawing, painting, and calligraphy, with influences from rock music. Laura Satana's renown extends beyond France's borders. Her tattooing has taken her to Mexico, London, São Paulo, Los Angeles, and New York. That's some recognition!

Born in 1977, the year of punk's heyday, Laura hung out in the Paris underground scene with various fringe rock bands. Her passion for drawing made it a natural step for her to commence an apprenticeship as a tattoo artist at the age of nineteen. In 2003, she opened her own shop, EXXXOTIC TATTOOS, in east Paris.

Laura has an affection for strong images, such as gangster tattoos, to which she adds her own blend of somberly glamorous romanticism. During her trips through the southern United States and Latin America, she was "adopted" by Chicano tattooists, who taught her their own particular art and craft of inking skin. Laura has made this graphic style her own, incorporating it in her portraits, her lettering, and a whole set of imagery derived from Latino gang culture. Laura's fame and influence grew further when celebrities from the world of rap, such as Booba, became interested in her work and had themselves tattooed by her.

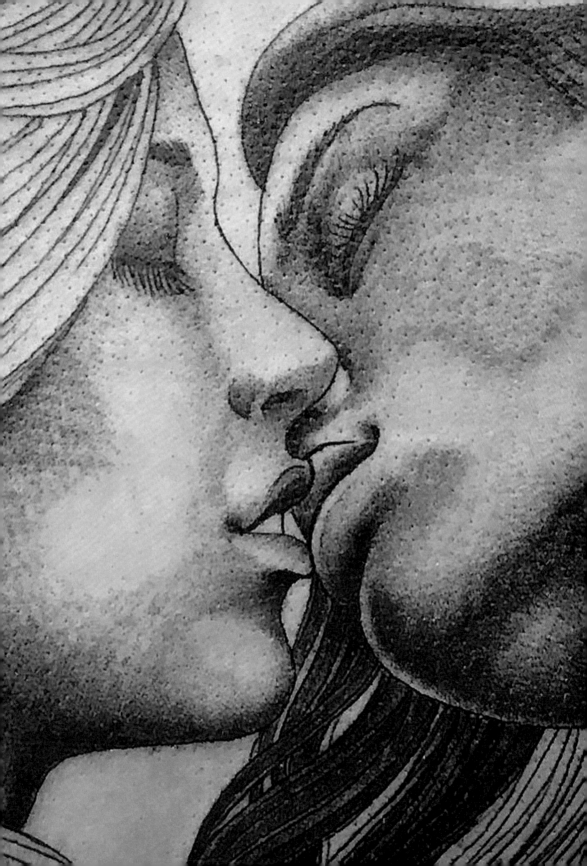

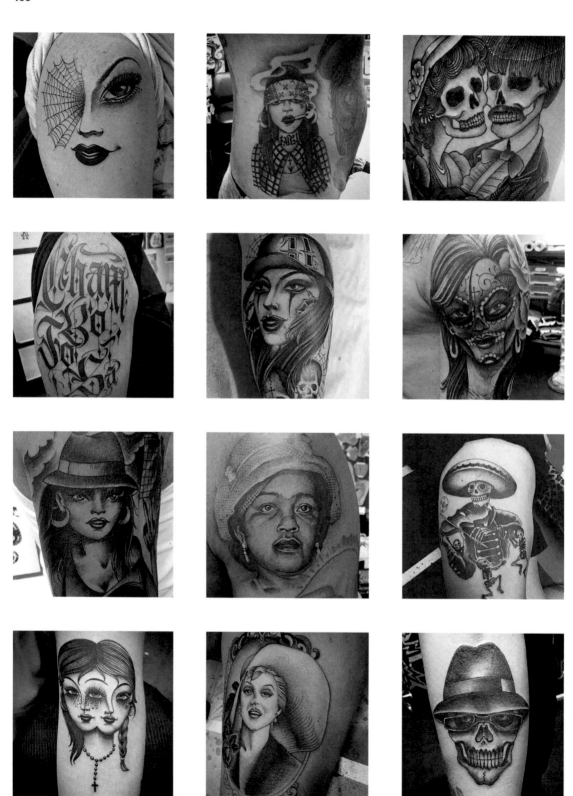

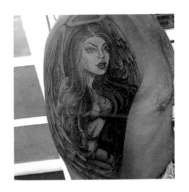

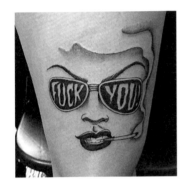

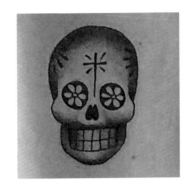

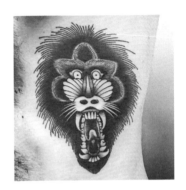

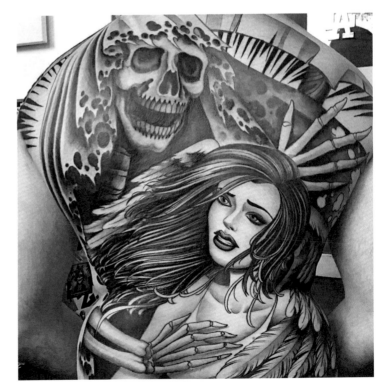

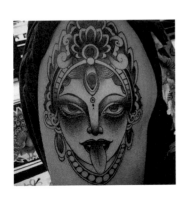

AGA MLOTKOWSKA

@AGAMLOTKOWSKA
PARIS, FRANCE & WARSAW, POLAND

Aga Mlotkowska creates a world where colors are often absent. Her strong, dreamlike style, with subtle fills, is what sets her apart.

Aga grew up in Poland during the 1970s, and earned a degree in engraving from the Institute of Fine Arts at the University of Zielona Góra. In her creative process, she takes inspiration from Constructivist art and the traditions of Zen Buddhism. Given that the art of inking includes all of these influences, it was quite natural for her to turn toward tattooing several years after graduating. In 2006, she opened her first studio in Wroclaw, and in 2011, she launched an artistic space, Kollectiv Tattoo, in Warsaw with her tattooist colleague Ania Jalosinska. The following four years were filled with travel, conventions, and wonderful encounters, including with the team of Art Corpus, in Paris, which Aga visited several times as a guest tattooer before taking the plunge in 2015 and joining them. Her approach, which is closer to a spiritual and aesthetic quest, fits no particular style; she describes it as "off-piste."
Aga identifies with this proverb from the Iban people of Borneo: "A nontattooed body is invisible to the gods."

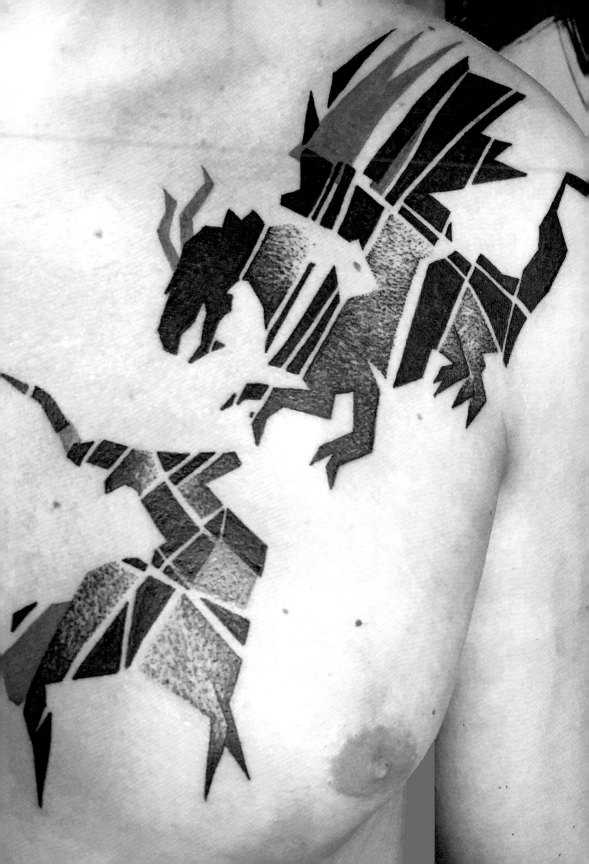

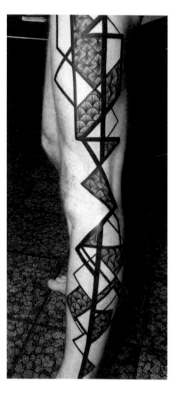

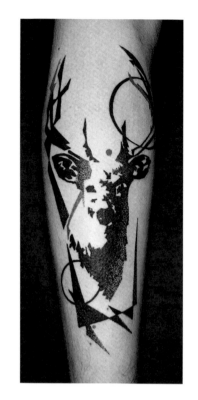

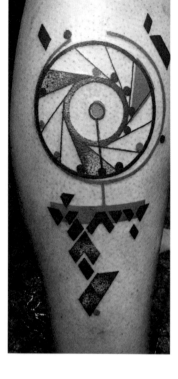

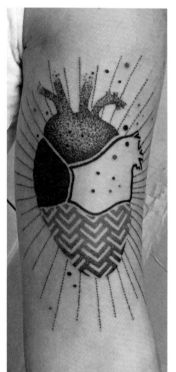

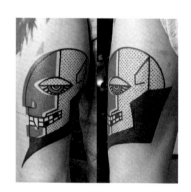

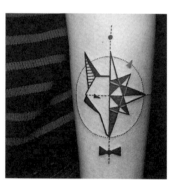

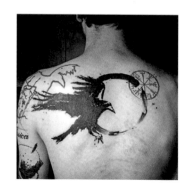

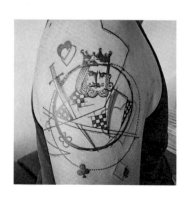

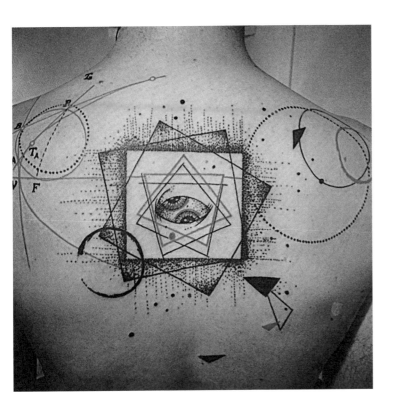

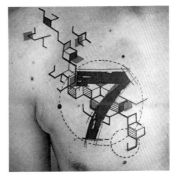

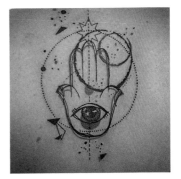

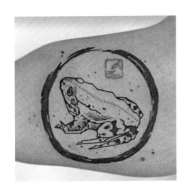

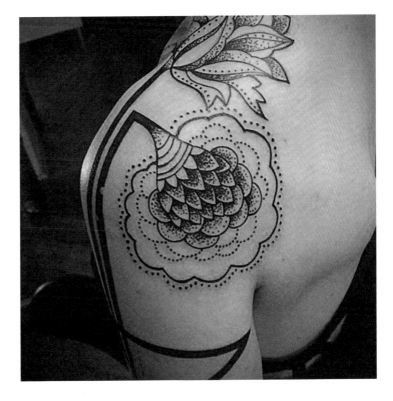

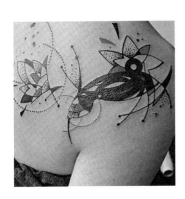

MARK WAKEFIELD

**@MARK_TATTOOS
TUNBRIDGE WELLS, KENT, UK**

Always improvise and improve: that's the credo of Mark Wakefield. And the man is well on the way–his tattoos speak for themselves.

Mark was born and works in Kent, in the United Kingdom. He has been tattooing for seven years and his love for this art is visible through his work. He adores the freedom that tattooing gives him, as well as the people he meets, particularly the tattooists he has learned from. His travels have given him a taste for sharing and observation; he is always on the lookout for new sources of inspiration, of which he distills the substance before reworking it into his compositions. His tattoo aesthetic is realism, in black and gray. He gives his tattoos as much detail as possible, driven by a desire to attain aesthetic and technical perfection. Mark would like to travel more in the not-too-distant future, but is currently focusing fully on his passion. He has consciously chosen to steer clear of the mainstream media, rejecting the "brainwashing" of the small screen in favor of old movies and skateboarding videos.

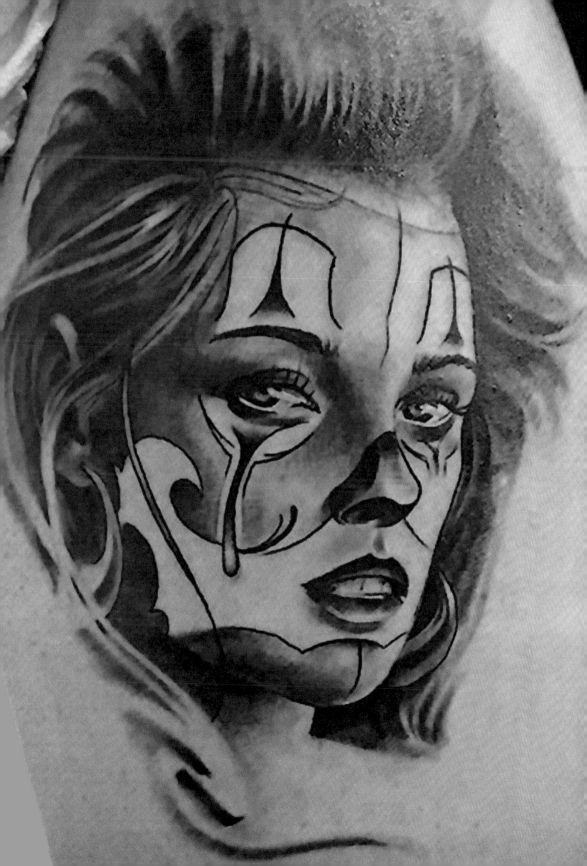

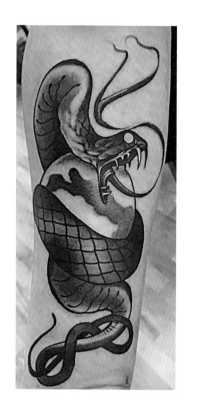

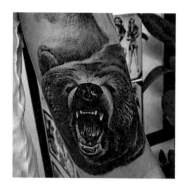

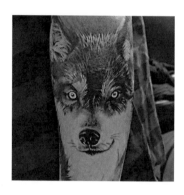

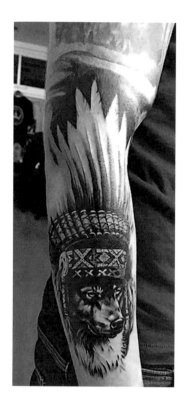

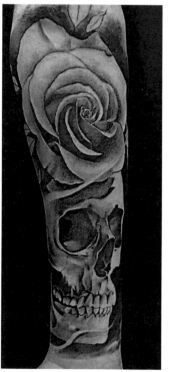

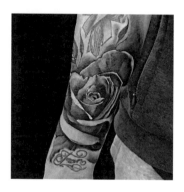

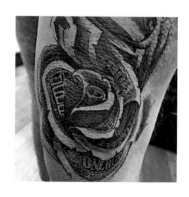

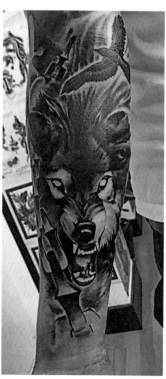

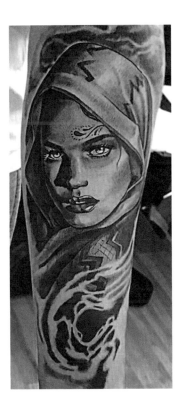

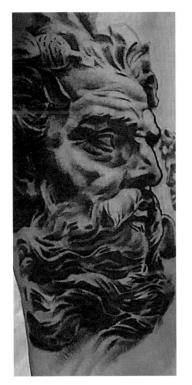

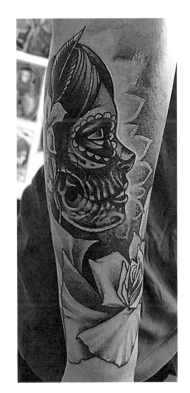

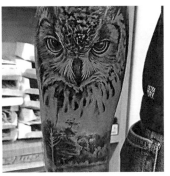

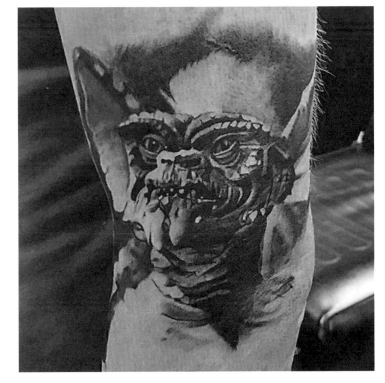

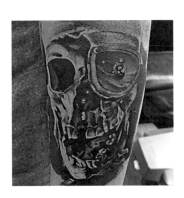

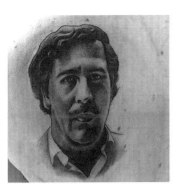

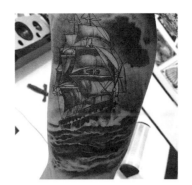

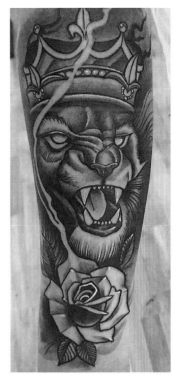

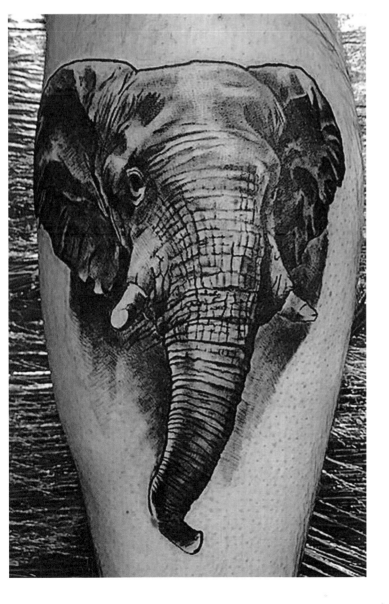

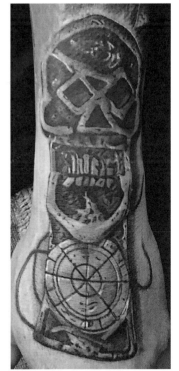

JOHN MA
@JOHN.MA
KATHMANDU, NEPAL

John Ma, real name John Maharjan, is a Nepalese tattooist who lives and works in Lalitpur, Nepal. John is from the Newar people, the original inhabitants of the Kathmandu Valley.

In 2000, John built his own tattoo machine. This was the start of his love affair with the art of inking. At that time there were only two tattoo studios in Kathmandu. From 2002 to 2003 John worked full-time as a tattooer, before opening his own studio, Jads Tattoo, in 2007. Here John collaborated with Eek Glass Pani—under the moniker EekMa—on large pieces, particularly those covering the back. John doesn't claim to follow any particular style; in fact, his motto is No Style Is My Style. John simply loves tattooing, whether traditional motifs—related to Nepalese culture and folklore—or not. The culture and traditions in which he has been immersed since birth inspire him as much as nature or spirituality. John enriches his range and his technique through the people he meets, becoming energized by the work of other tattoo artists he encounters when they visit his studio or at conventions held in Kathmandu.

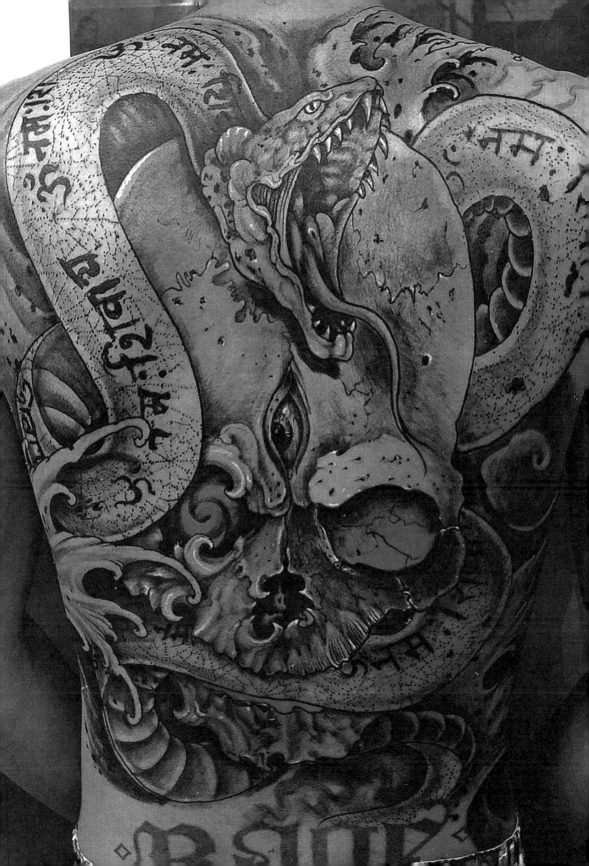

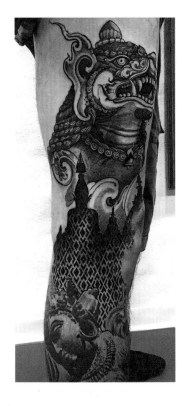

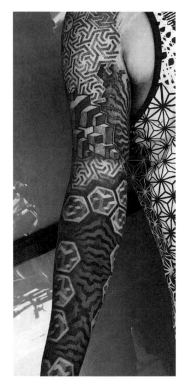

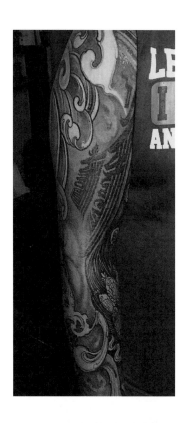

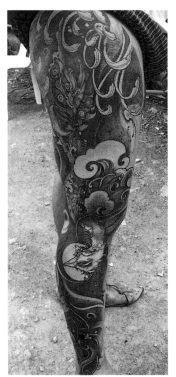

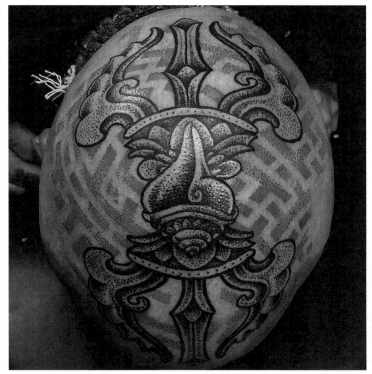

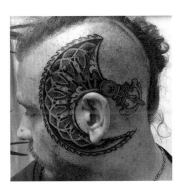
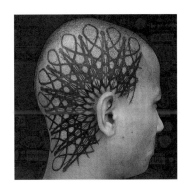
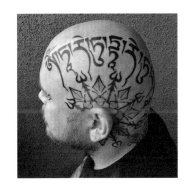
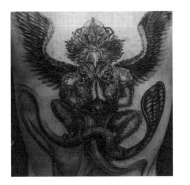
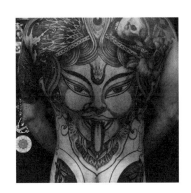
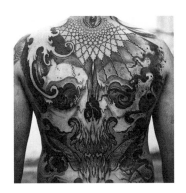
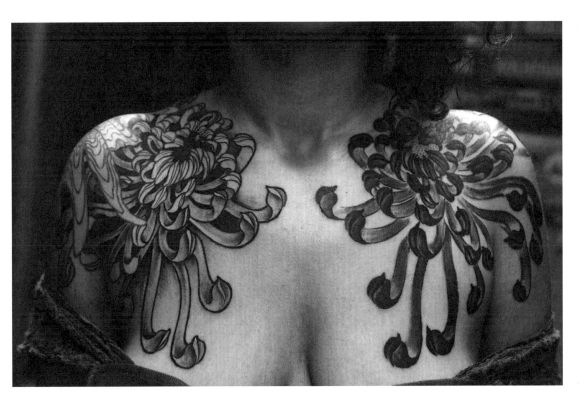

COLIN DALE
@COLINDALETATTOO
COPENHAGEN, DENMARK

Colin Dale lives and works in Copenhagen, Denmark. A specialist of the neo-Nordic style, Colin is inspired by Scandinavian bronzes and Viking art. He also works entirely using the hand-poke technique.

Born in Saskatoon, Saskatchewan, Canada, Colin Dale has been tattooing for twenty-two years. Steeped in "native" cultures, the whole of his output is imbued with his singular graphic style. From experimental archaeology to the development of tools, Colin uses techniques and materials to reproduce bygone ages through tattoos. His challenge is to reconcile traditional manual tools, design, and current hygienic procedures. Colin's influences derive mainly from prehistoric cultures, from Paleolithic art to the European Bronze Age, Native American and Inuit cultures, and traditional tattooing from the four corners of the globe. Colin also draws inspiration from the art and painting of the Vikings, the Haida, and the Inuit, as well as the work of artists such as Bill Reid, Norval Morrisseau, and Kenojuak Ashevak.

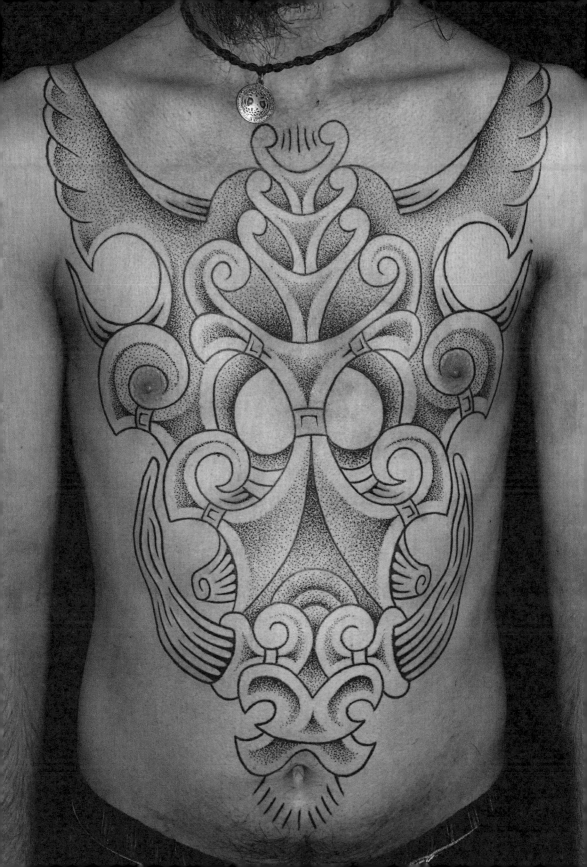

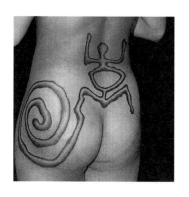

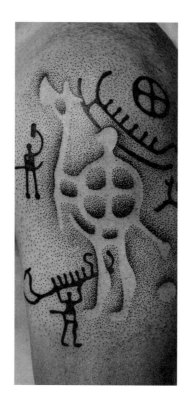

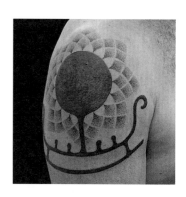

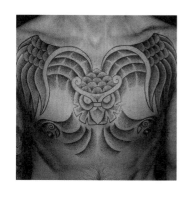

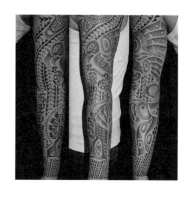

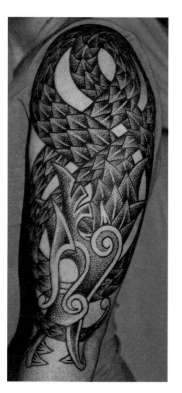

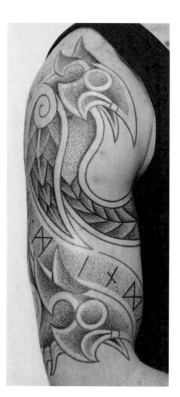

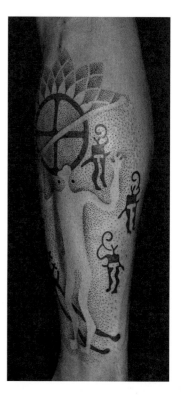

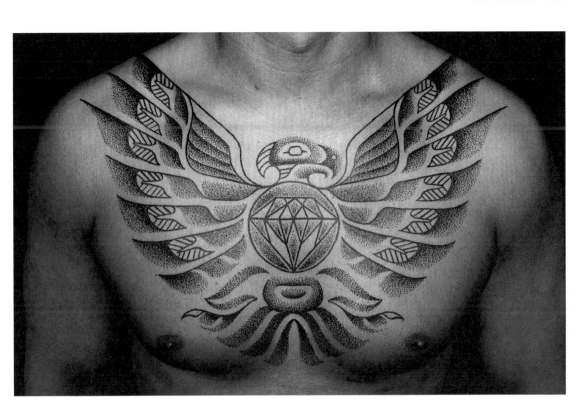

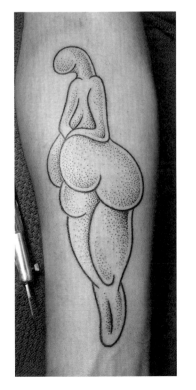

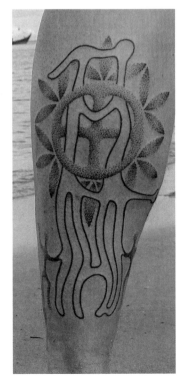

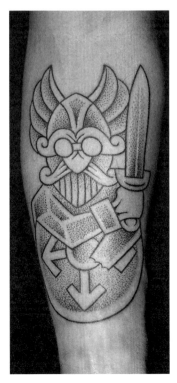

DARUMANU

@DARUMANU
PARIS, FRANCE

Darumanu's pieces are influenced by *irezumi*, a traditional style of Japanese tattooing, which is recognized for its elegance and visual impact, virtues that have allowed it to transcend eras.

Originally from Corsica, Darumanu and his parents spent much of their life abroad. They returned to France at a pivotal age for Darumanu: adolescence. The young man started tattooing during his military service, when he was with the 13th Parachute Dragoon Regiment. After leaving the army, he moved to the Pigalle neighborhood in Paris, where he discovered the studio of the first French professional tattooist, Monsieur Bruno (Bruno Cuzzicoli)—an institution! Darumanu's passion for inking grew; he collected magazines—very influential at the time—and quickly became fascinated with irezumi. Darumanu is now a resident tattooist at Art Corpus, after spending ten or so years on the road. At Art Corpus, he works in the traditional Japanese style of *horimono*, a timeless tattooing technique that covers the body with patterns. It's an extremely precise graphic approach where every detail counts. Darumanu draws his inspiration from the artists of the ukiyo-e movement, such as Kawanabe Kyōsai, Utagawa Kuniyoshi, and Katsushika Hokusai. The artist himself is as fascinating to discover as his art.

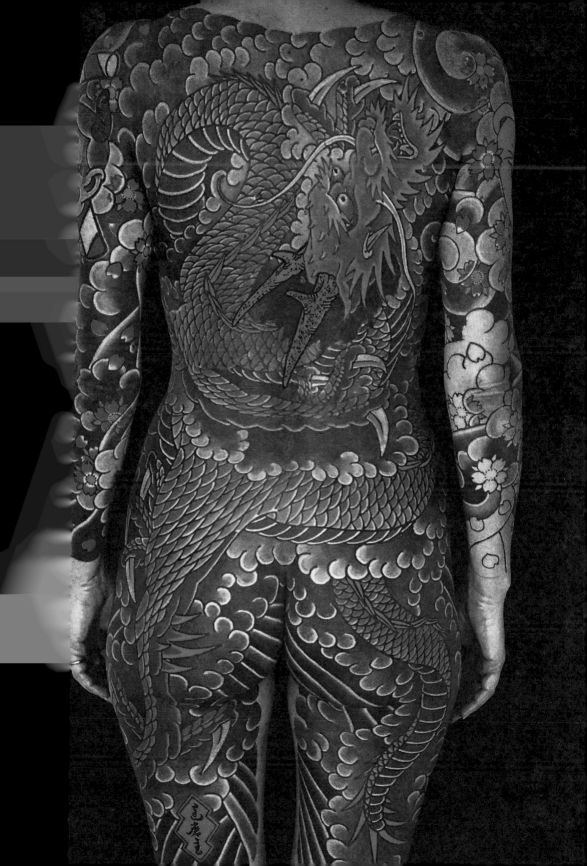

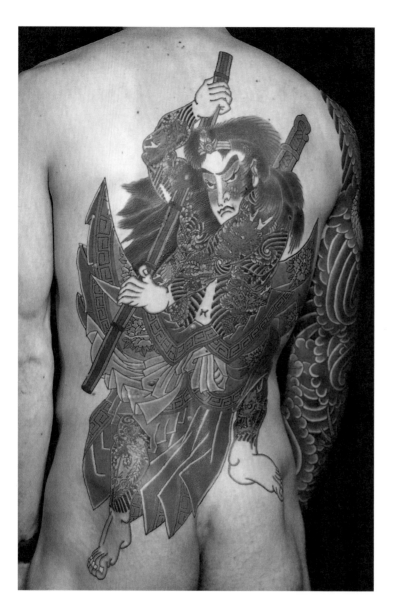
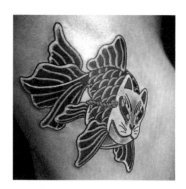
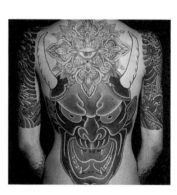
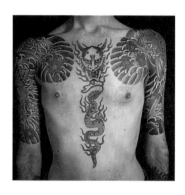
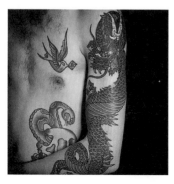
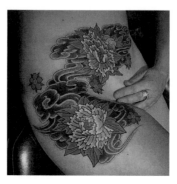
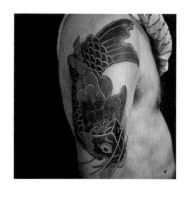

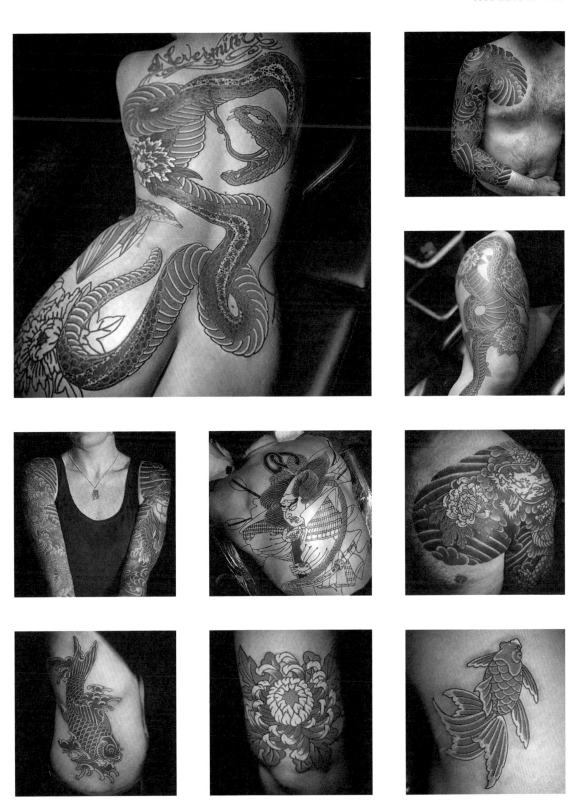

SERGEY MURDOC

@SERGEYMURDOC
ST. PETERSBURG, RUSSIA

Sergey Murdoc's story has all of the attributes of a perfect crime novel or a road movie–Russian style. Yet the artist behind it is much more complex; his world is full of finesse and detail.

Sergey was born and grew up in Saint Petersburg, Russia's cultural capital. As a young boy, he discovered the art of inking from his grandfather. At age fifteen, he undertook his first tattooing, using a homemade machine comprising the motor from a cassette player, a pen, a guitar string, and some ink. This incredible object became his best friend. The passage from adolescence to adulthood was not without pitfalls for Sergey; it was a complicated time, filled with experiences off the beaten track or even totally at the margins of society. But the young man got back in the saddle, met the love of his life, and began studying psychology with the aim of exploring human nature.

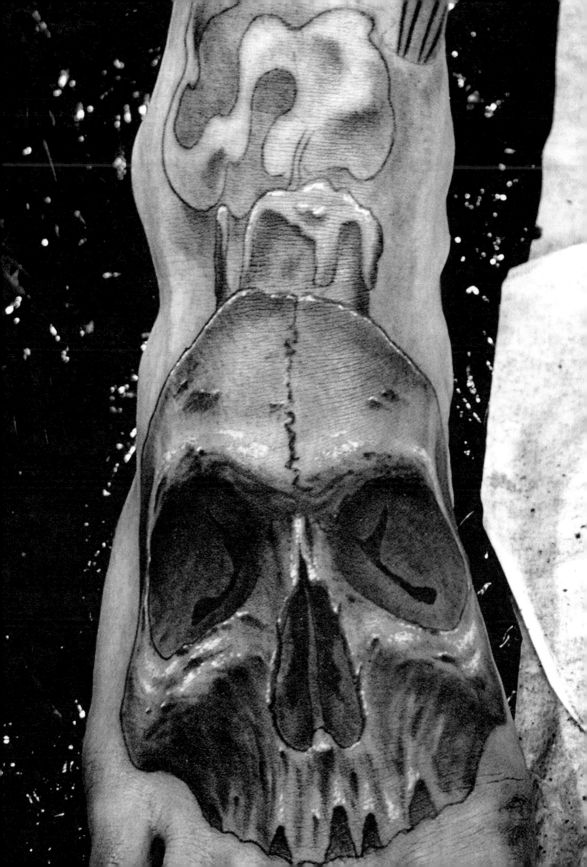

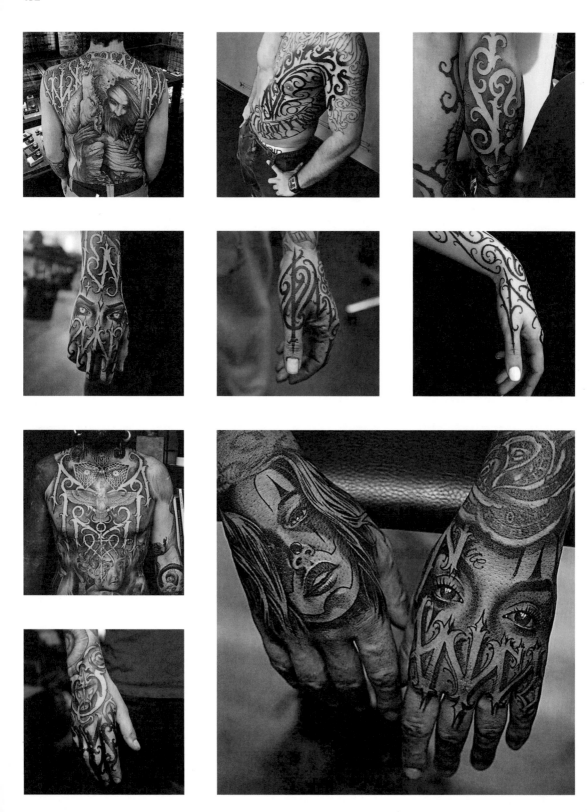

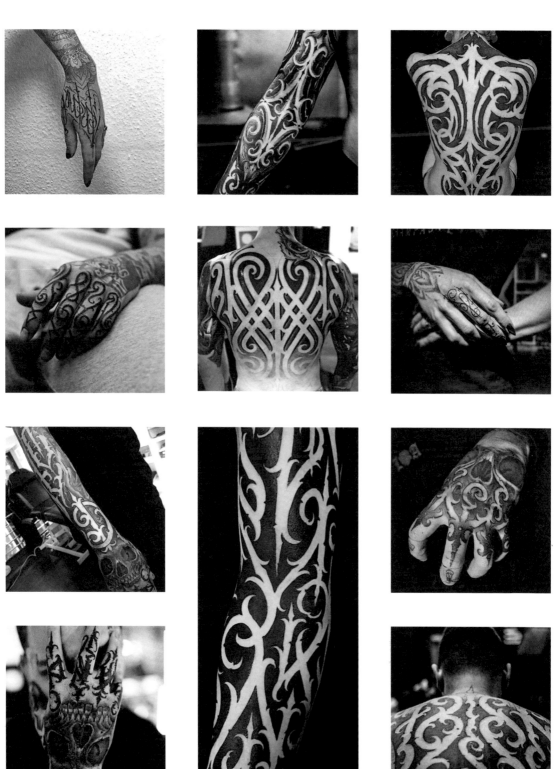

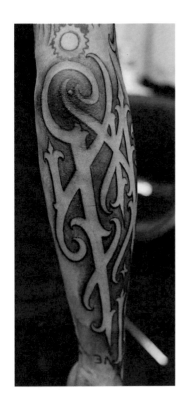

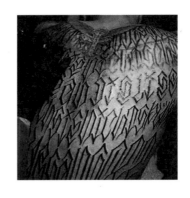

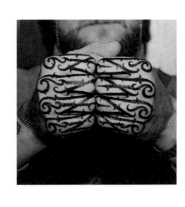

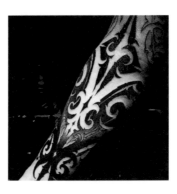

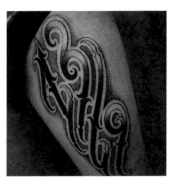

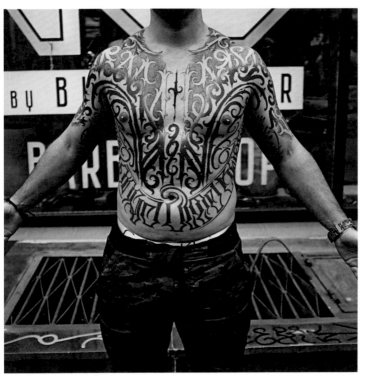

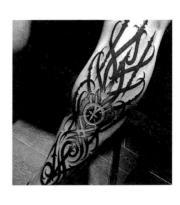

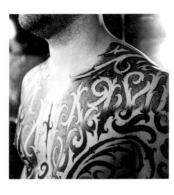

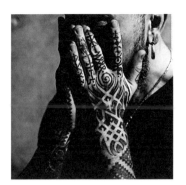

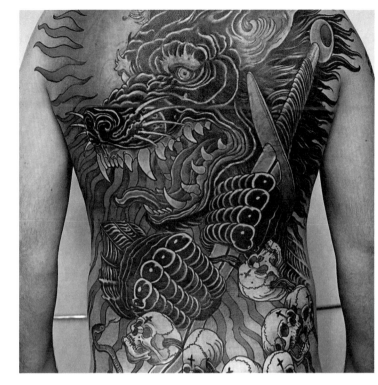

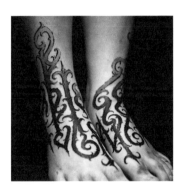

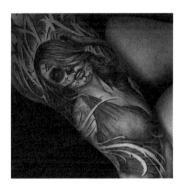

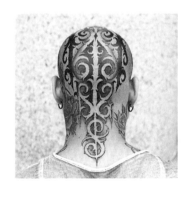

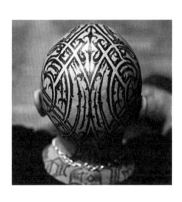

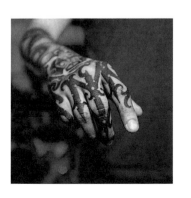

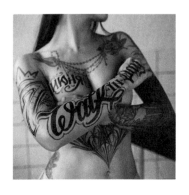

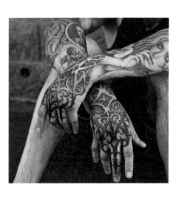

EL PATMAN
@ELPATMAN
PARIS, FRANCE

El Patman was born in Orléans, France, in the early 1970s. He has been tattooing for fifteen years and is a dotwork specialist. El Patman started out at a time when this now widespread technique was being practiced in France and other French-speaking countries only by Alexis Calvié (in the Var region) and Sky (in Brussels).

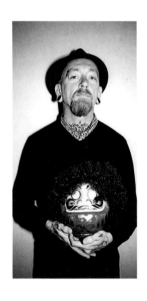

The work of Xed Lehead and the tattoo artists of the London studio Into You—established by Alex Binnie—have brought this technique back into fashion and made it an art in its own right. It's the nonfigurative aspect of this tattooing style that attracts El Patman, for whom the act of tattooing itself is what matters. Being a tattooist means embracing a life of passion, patience, encounters, talents, and challenges.

El Patman has worked in several studios in Paris and Brussels: Tribal Act, EXXXOTIC TATTOOS, Mystery Tattoo Club, La Boucherie Moderne, and Art Corpus. His work is influenced by many things: everyday life, architecture, the motifs and patterns visible all around him, sculptures, museums, books, and, of course, the tattoo world. What El Patman likes about tattooing is that you can include anything, whatever the style, because inspiration comes from everywhere. As Frank Zappa said: "A mind is like a parachute. It doesn't work if it is not open."

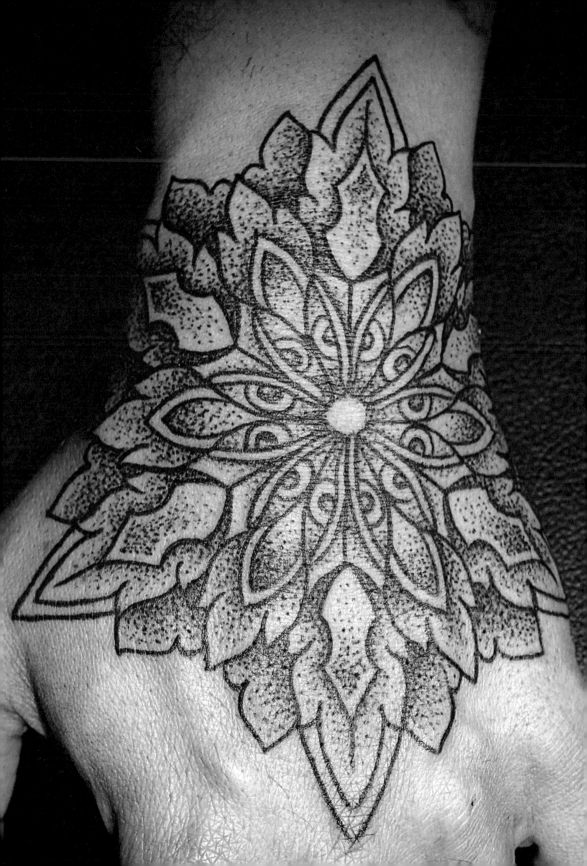

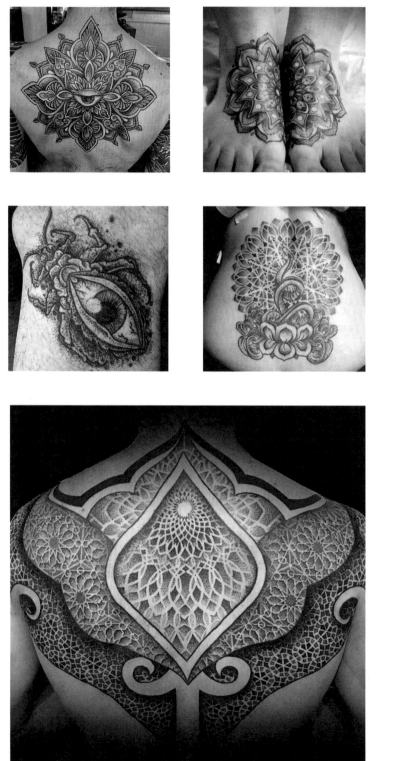

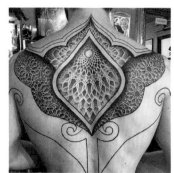

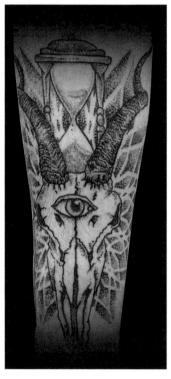

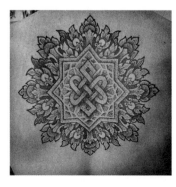

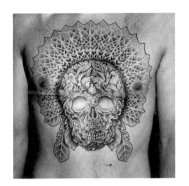

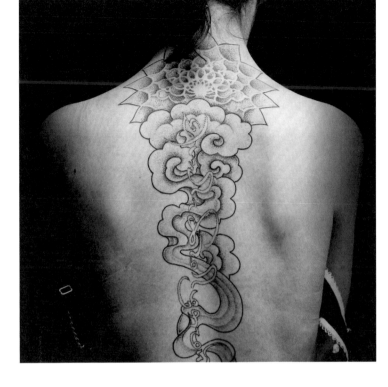

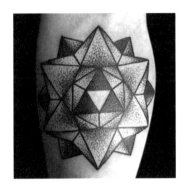

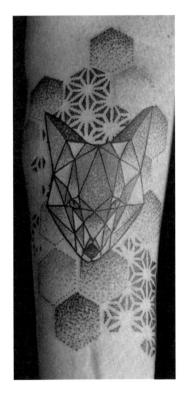

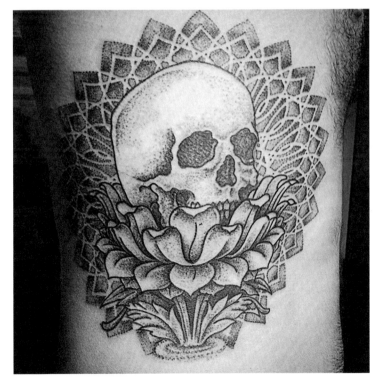

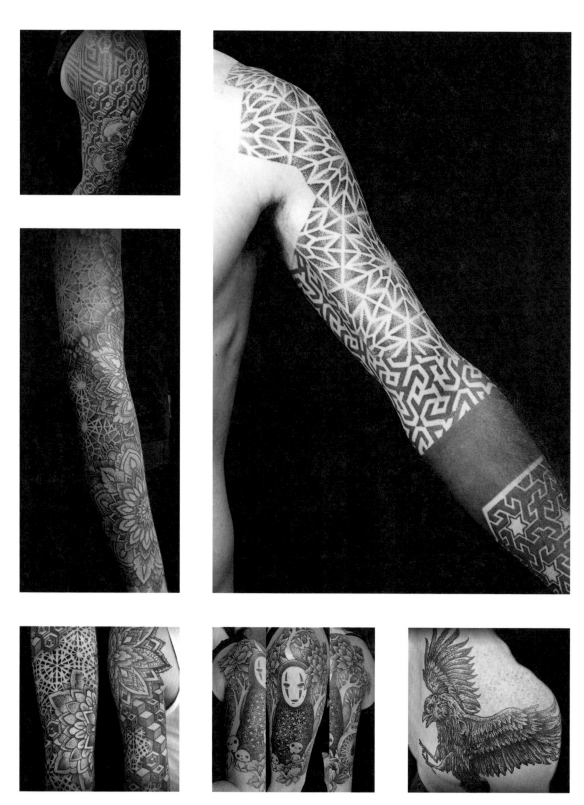

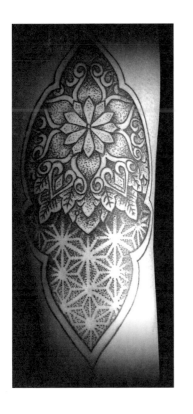

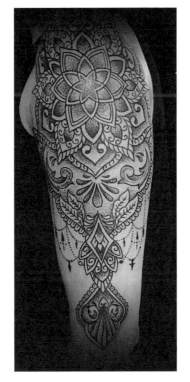

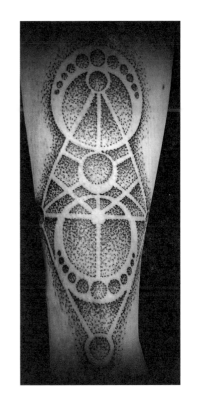

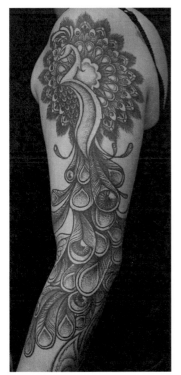

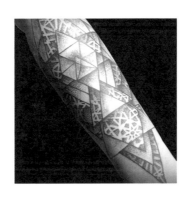

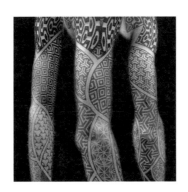

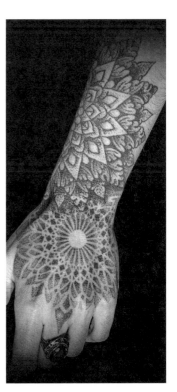

CHRISTIAN NGUYEN

@INKVADERS
GENEVA & SION, SWITZERLAND

Christian Nguyen is a prolific tattooist whose work extends beyond tattooing to music, snowboarding, design, and illustration. This array of interests constantly opens new doors for him.

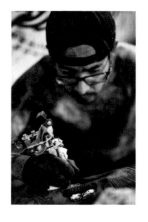

Born in Geneva in 1975, Christian fell into tattooing at an early age. His professional career began in 1992, while travel and encounters took him to Denmark, the Netherlands, France, Japan, and the United States. When he returned home he opened his own studio, Inkvaders, in Geneva, Switzerland— followed by a second one in Sion, sixty miles from Geneva— where he deploys his black-and-gray style to striking effect. Christian is very active in the snowboarding scene, where he tattoos professional riders. He also works for brands such as Apo, Burton, Imperium, Ninthward, Tns Industries, and Vans. He is something of a hit in the music world—both for his tattoos and his album cover design—with clients including Ceekay (La Coka Nostra, Skam Dust), John Otto (Limp Bizkit), Trouble Andrew, House of Pain, and The Vendetta. Christian also designs for the clothing brands Black Market, Nothing Changed Wear, and Sullen Clothing and has his own label, Inkvaders Wear. The man is a jack-of-all-trades inspired by the combined cultures of tattooing, hip-hop, hardcore, extreme sports, and graffiti.

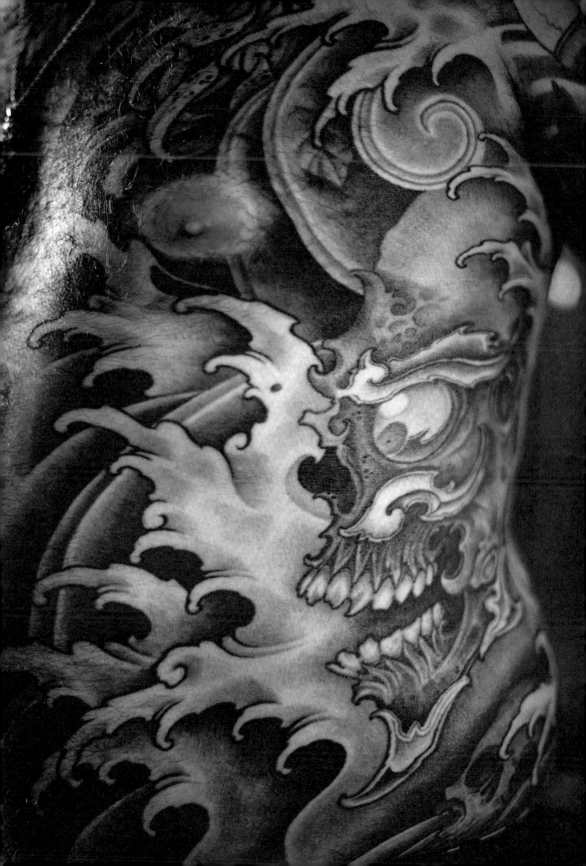

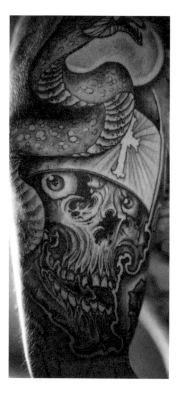

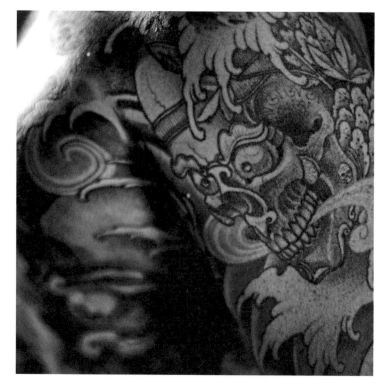

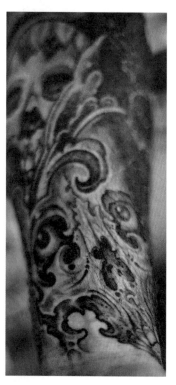

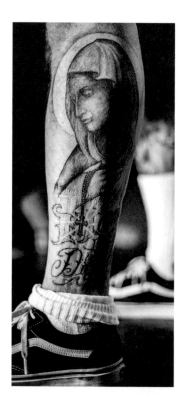

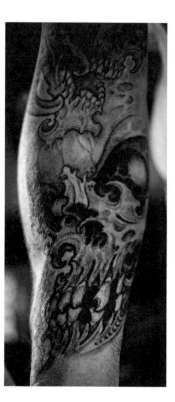

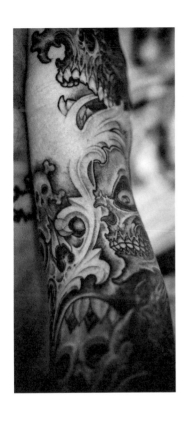
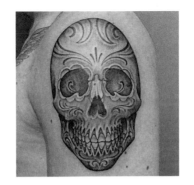
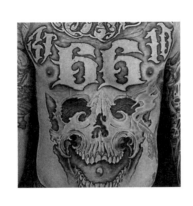
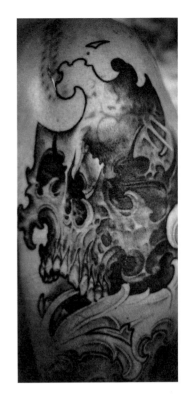
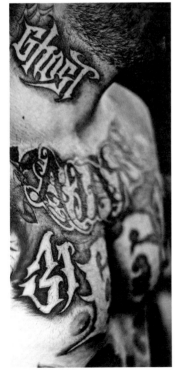
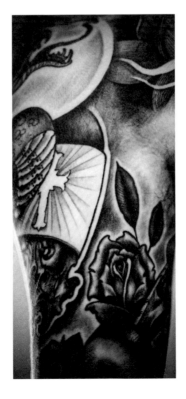
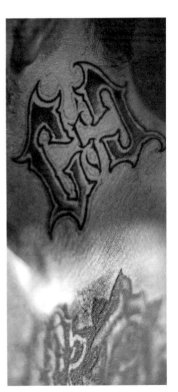

ROB WEISS
@ROBTATTZ
ON THE ROAD

The German tattooist Rob Weiss is a traveling tattooer. He crisscrosses Germany and other parts of Europe, working here and there, learning from every encounter and every voyage.

Rob Weiss is a relatively new tattooer who has been working professionally since 2013. He completed his apprenticeship with Bernd Broghammer, at the Tätowierstudio Hautnah in Landau, in early 2017. Since then, Rob has been dropping his bags and setting up his gear wherever his feet take him. He loves to travel and to meet people. He continues his apprenticeship as a guest in various studios, and he likes attending conventions, whether as a tattooer or just a visitor. His artistic preferences are focused eastward, to Japan, and he likes black-and-white and lettering. Rob doesn't see himself as a tattoo artist but rather as a tattooer. He appreciates what the profession can give him, the people he can meet and learn from, the ways he can evolve, and the work he can undertake. The right mindset and a love of tattooing are the necessary foundations to become one of the greats.

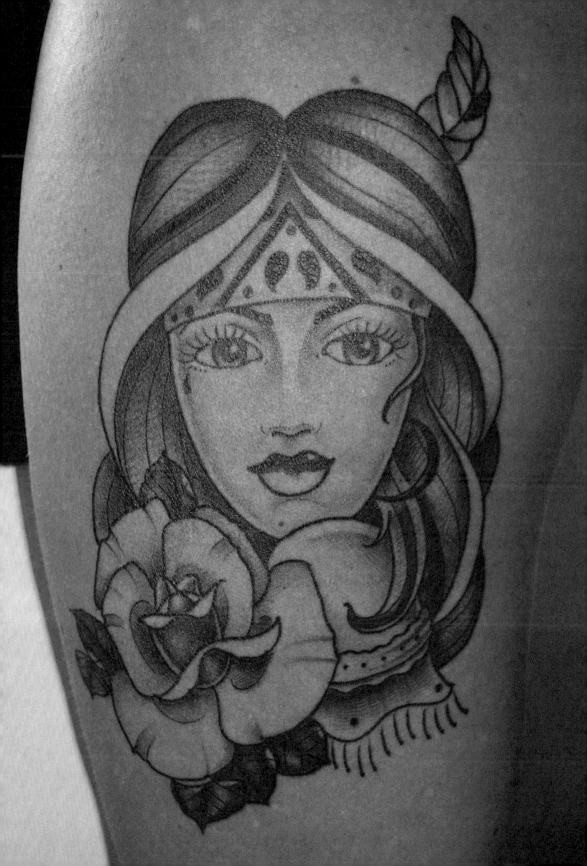

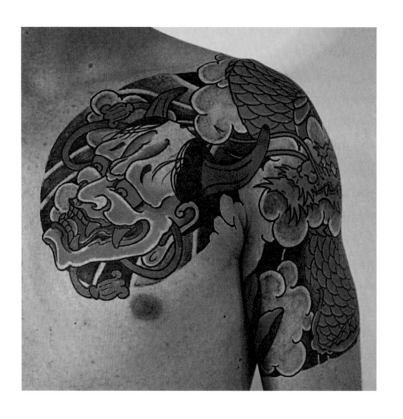

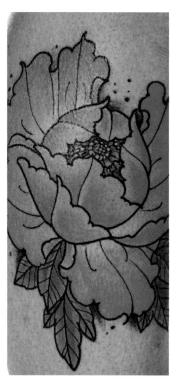

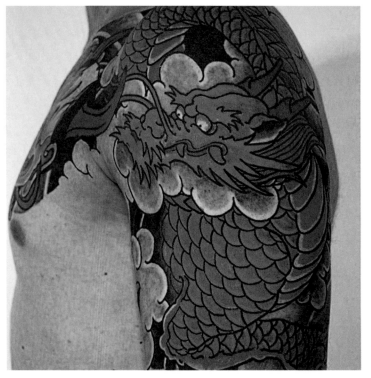

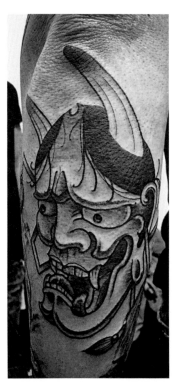

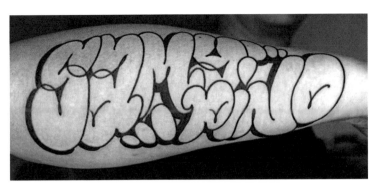

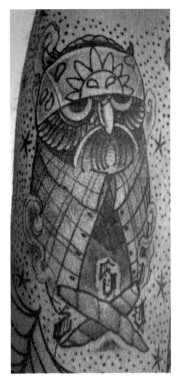

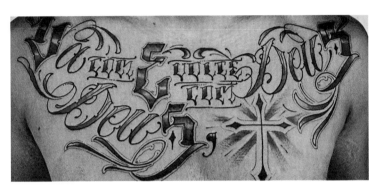

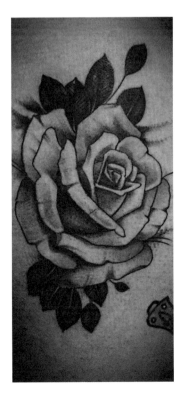

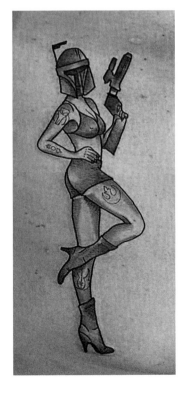

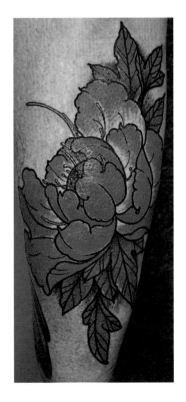

KAROLINA CZAJA

@PRIMITIVETATTOO_POLAND
WARSAW, POLAND

Karolina Czaja is passionate about art and folklore, particularly the characteristic decorative elements of the five continents. She specializes in a wide range of ethnic tattooing using the hand-poke technique.

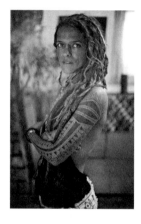

The Primitive Tattoo studio has a unique atmosphere—it is located in a tranquil, wooded suburb of Warsaw—and it is where Karolina lives and works. She schedules just one client each day. This young woman studied at the small University of Malopolska in the Polish mountains. Her first years in the world of tattooing were hard, being a young mother and self-taught, and without a mentor, but Karolina stuck with it. She specializes in dotwork and ethnic motifs, and although she hasn't completely rejected the tattoo machine, she does most of her work using the hand-poke technique. For Karolina, tattooing the traditional way, without a machine, gives her a unique contact with her clients. She loves the sound of the needles as they prick the skin. Karolina gives a part of herself, as she tattoos sacred geometric patterns, and magical and spiritual symbols, while the client gains much in return, since this style of tattooing is a real exchange of human energies.

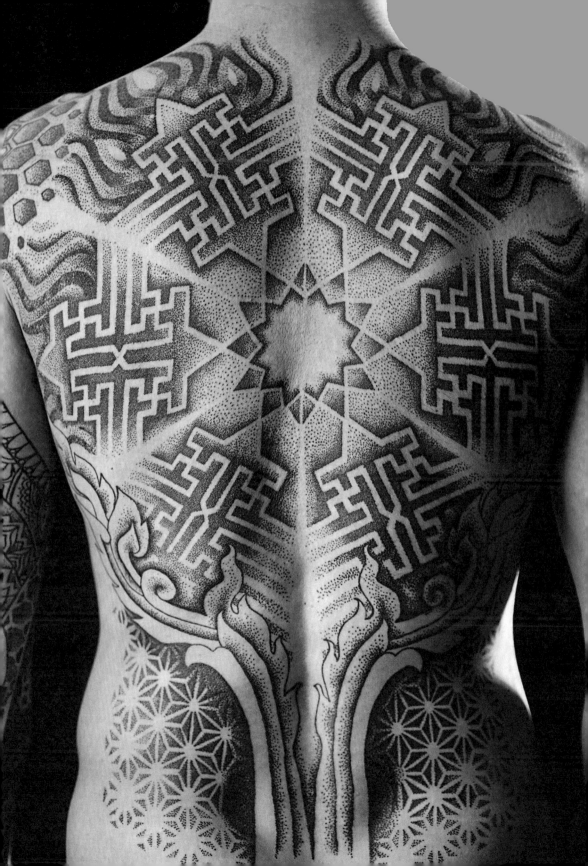

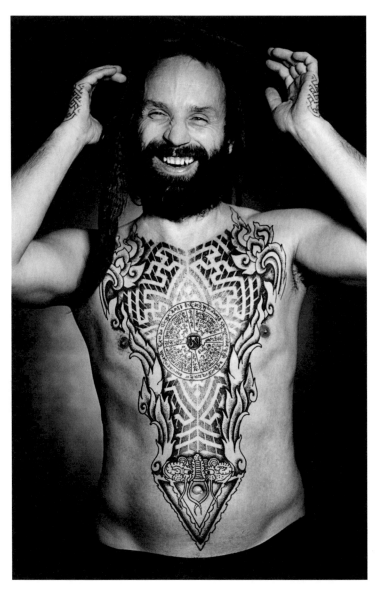

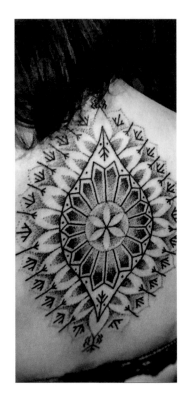

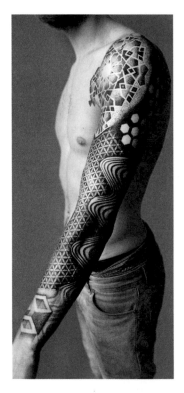

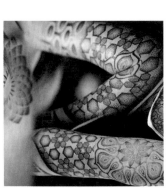

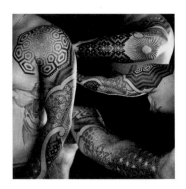

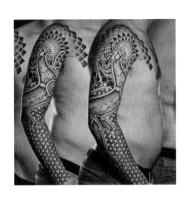
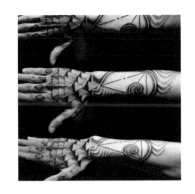
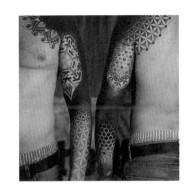
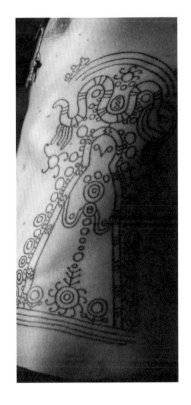
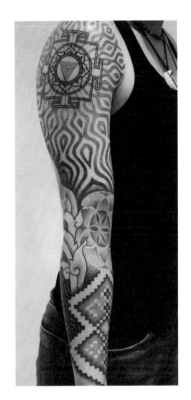
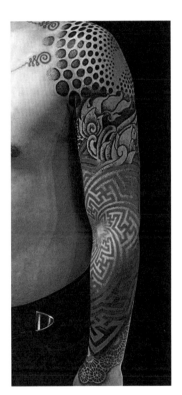
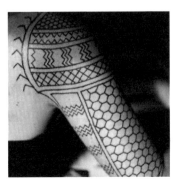
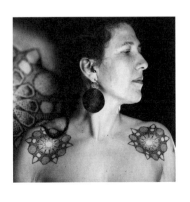
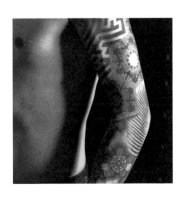

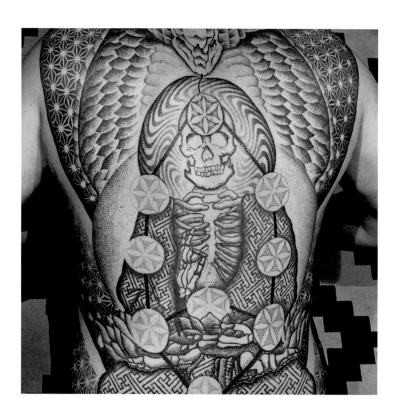

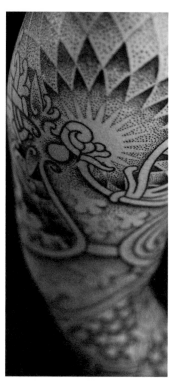

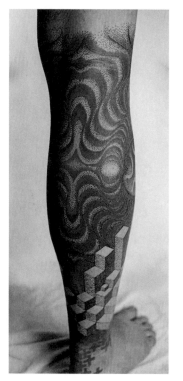

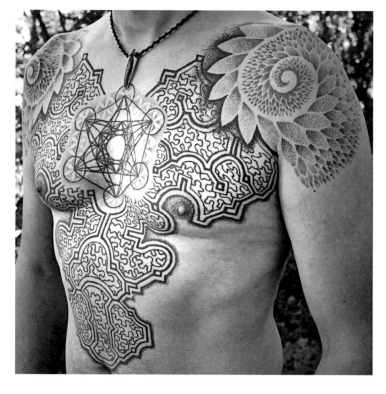

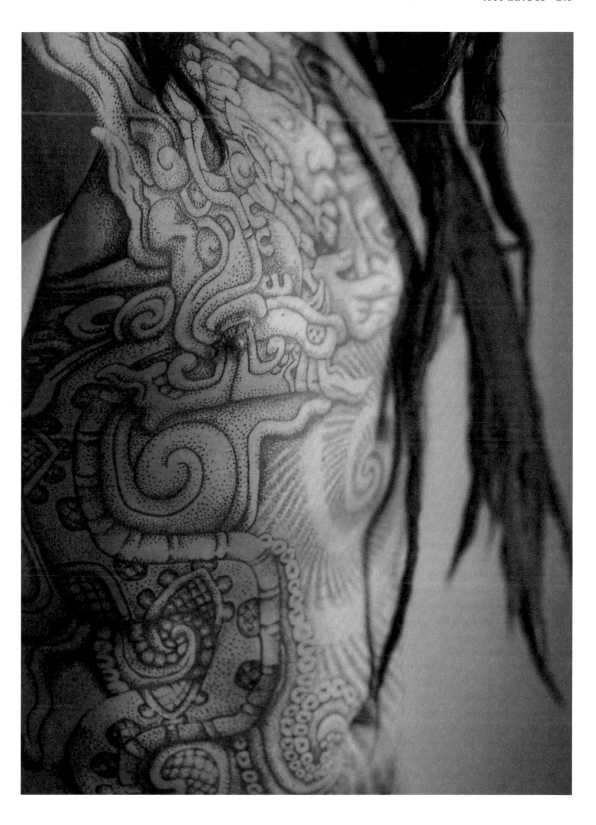

OTE HONO

@OTE_HONO
ON THE ROAD

Teiva is a native of Hiva Oa, the second largest of the Marquesas Islands, in the South Pacific. He tattoos under the name Ote Hono, and he specializes in his own take on the Polynesian tattoo form. Teiva's practice of this ancestral art allows him to preserve a connection to his origins.

Teiva has been passionate about tattooing since childhood, and has been a tattooist for more than ten years. He always works freehand, combining this Polynesian base with his various artistic aspirations—ancient Polynesian cultures, cubism, geometry, music—as well as his clients' desires.

Teiva draws inspiration from travel, life, and encounters with the people he tattoos, as well as from other tattoo artists. Thanks to the support of his Hiva Oa family, his friends, and those who encourage and advise him—people such as Chime, Vatea Labbeyi, Mike, Tomasi, and Pahuru—Teiva is on the road, both literally (he travels a lot) and figuratively (his tattooing is constantly evolving). Recently, Teiva has been learning from Tomasi Sulu'ape, a master of traditional Samoan tattooing.

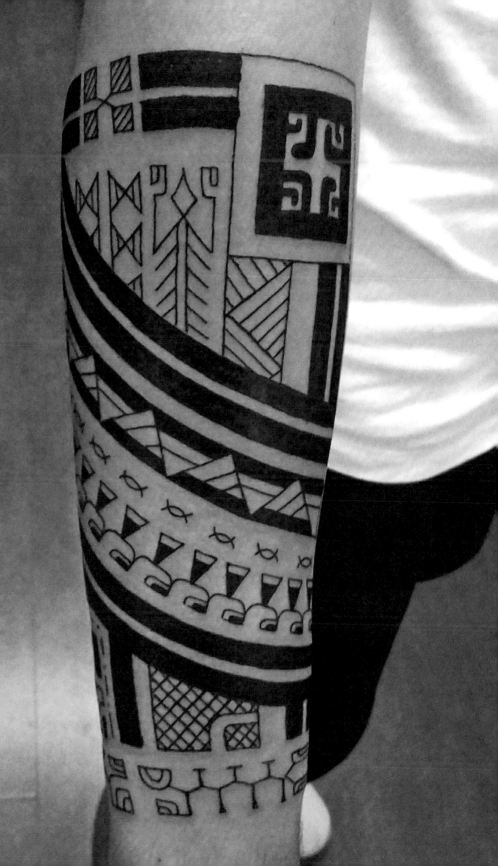

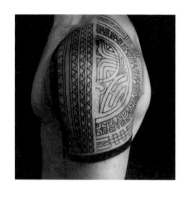
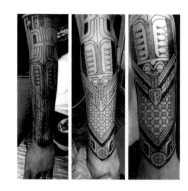
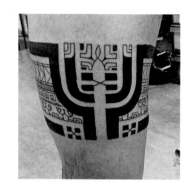
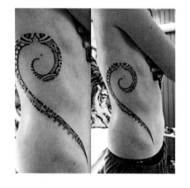
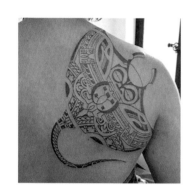
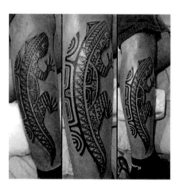
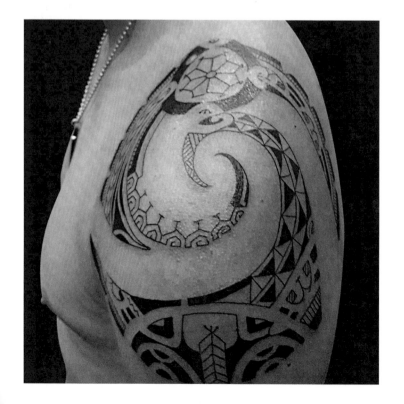
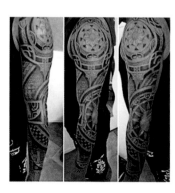

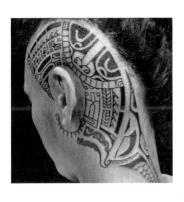
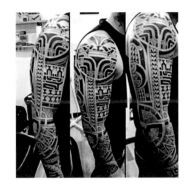
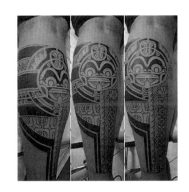
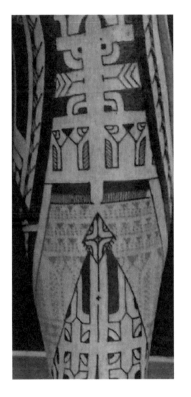
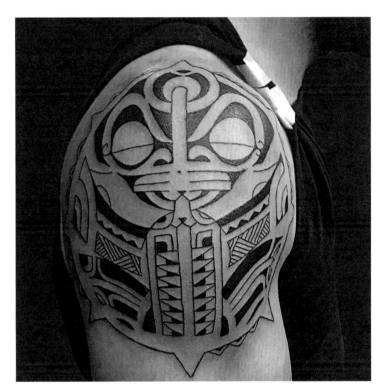
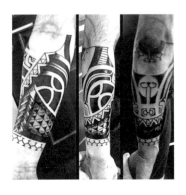
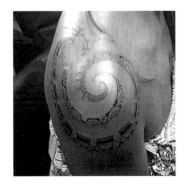
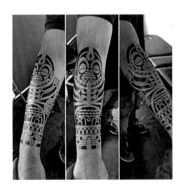

SANDRA MASSA

@SANDRA_GRAPHINK_TATTOO
SAINT-MAXIMIN-LA-SAINTE-BAUME, FRANCE

Sandra Massa developed her aesthetic in a graphic and multicultural context. And while her head may be in the clouds, she is very much rooted in the natural world. Born to an Egyptian mother and a French father, this tattooist was surrounded by art from an early age.

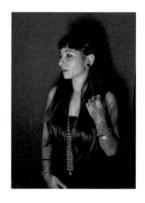

Sandra is a devotee of the ancestral tattooing from which she draws her inspiration, and she considers herself a "messenger of the soul." She wants her body art to reflect the soul of the person wearing it: "The tattoo must look as if it has always existed, there on the skin. A tattooist must remain humble and remember that they are merely the instrument of the materialization of the soul on the body. A tattooist exists only through the trust clients place in them to adorn their temple." Sandra believes that the craft of tattooing is a true gift from god and is constantly looking for a closer connection "between the soul and the body." These days, she has her own private studio, among nature, close to the Verdon Gorge, in southeastern France, which she runs with her partner. La Mauvaise Herbe is an alternative studio set in 2½ acres of forest, where clients come to get tattooed and recharge their batteries. Mother to a little girl, Sandra divides her time between La Mauvaise Herbe, guest spots, conventions, travel, and her family.

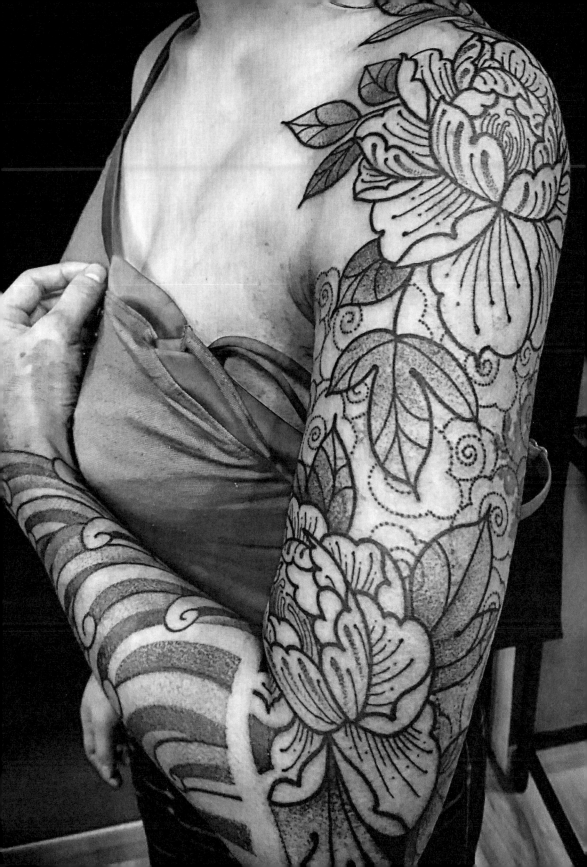

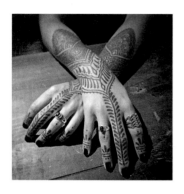

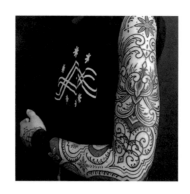

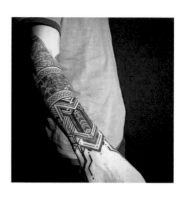

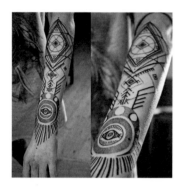

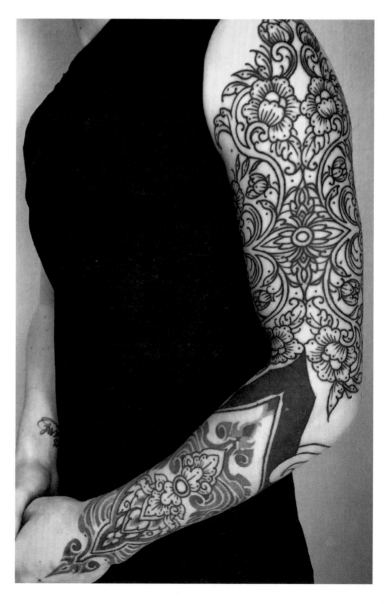

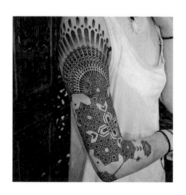

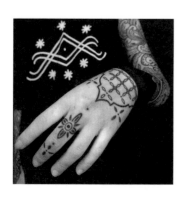

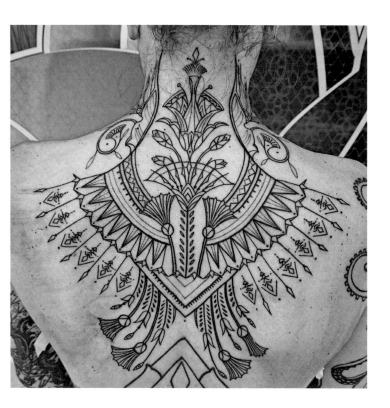
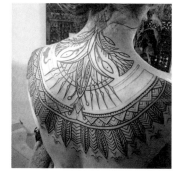
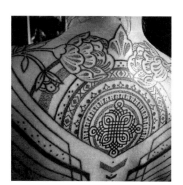
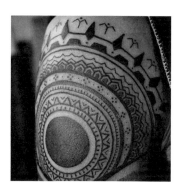
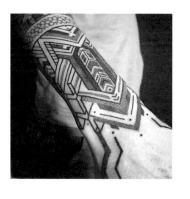
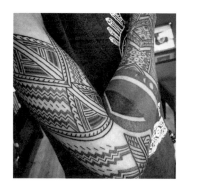
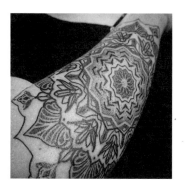
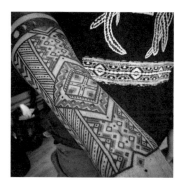
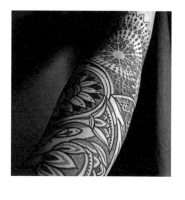

JAVI CASTAÑO

@JCASTANO666
BARCELONA, SPAIN

Javi Castaño lives and works in Barcelona, Spain. His tattoos are all executed with a highly distinctive touch, a striking line, and bright colors!

Javi has many arrows in his quiver, but he has a preference for playing with powerful styles such as Japanese horror, psychedelic horror, and biomechanical tattoos. The horror, however, is offset by a certain offbeat humor. Javi likes blown-out colors, bizarreness, and exaggeration. It's like a revised and corrected Japanese style, tinged with weird fantasy art, and an old-school, custom-tattoo vibe that's straight out of the 1990s. Javi doesn't do things halfway; his pieces are excessive and funny, playing against context and subject. He draws his inspiration from the imagery he finds in his collection of movies, magazines, and horror comics, taking us on a voyage through the unconscionable and the outrageous. It's a delight.

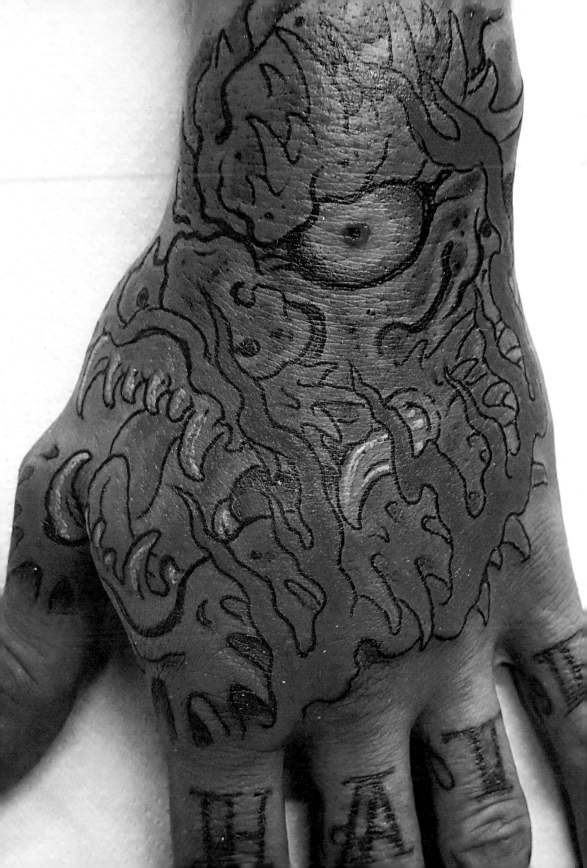

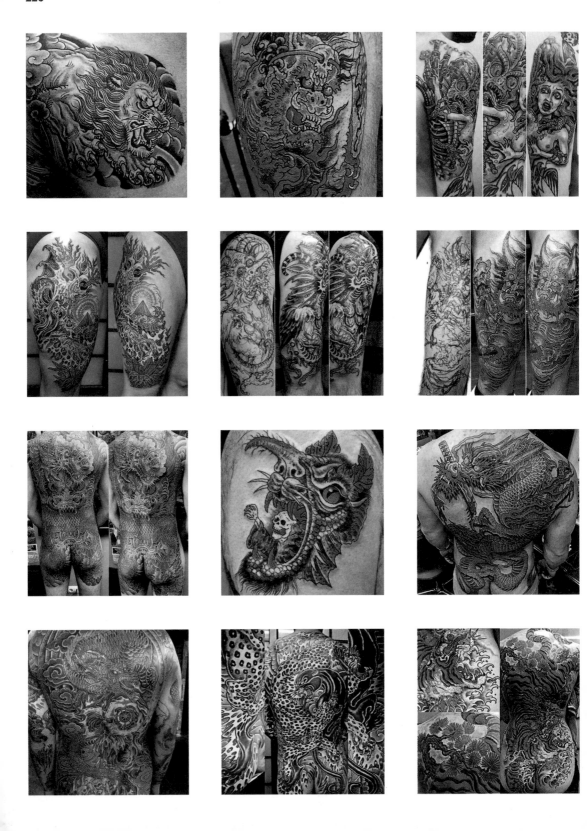

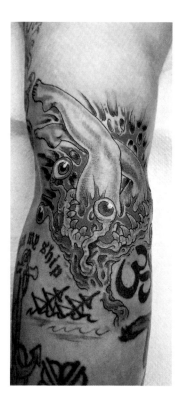
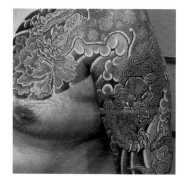
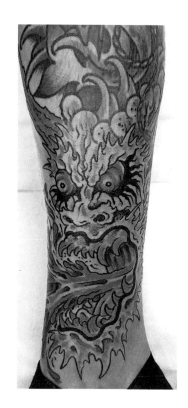
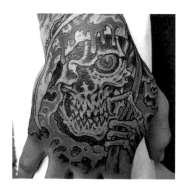
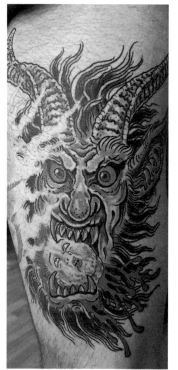
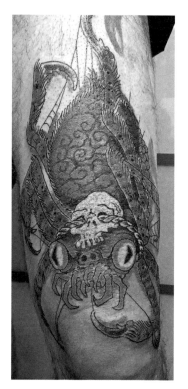
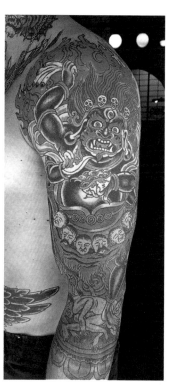

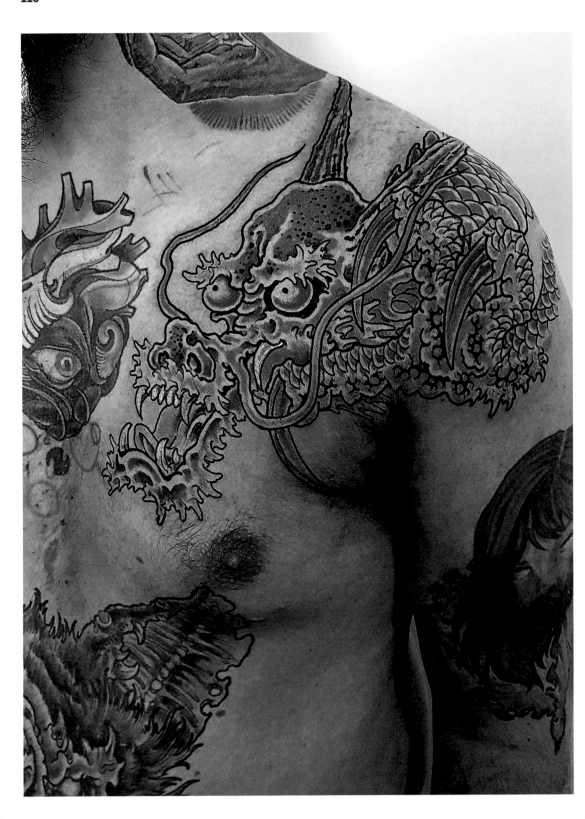

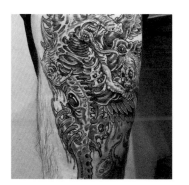

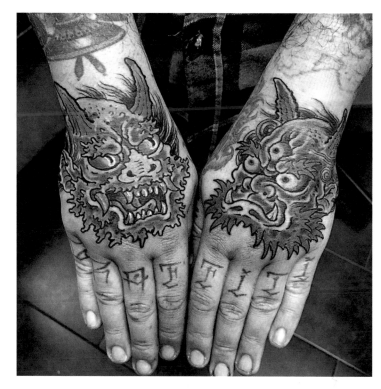

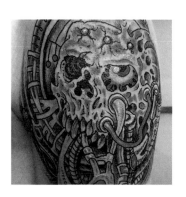

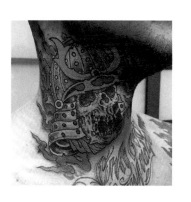

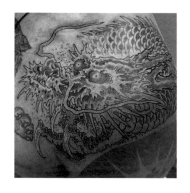

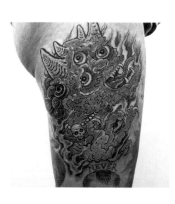

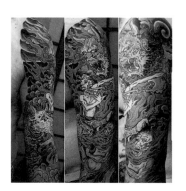

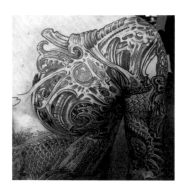

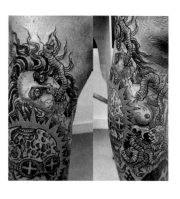

ENDHOVIAN OVO
@ENDHOVIAN_TATTOO
PARIS, FRANCE/ARMENIA/RUSSIA

Born in Armenia, Endhovian Ovo grew up in Moscow before packing his bags for France. He has never set foot in an art school, but taught himself the craft and developed an incredible style. Hats off!

Endhovian says of his career path, "I never went to art school. I don't know if that's an asset or a deficiency, but I do know that it has allowed me to develop my own technique, a personal way of doing things. Not having had to undergo that influence, I have been able to maintain complete freedom. That said, it no doubt took me longer to learn to draw all by myself."

Endhovian readily takes inspiration from the great artists—particularly the works of Leonardo da Vinci—to improve his line. Yet he quickly realized that "art for art's sake" didn't suit him; every piece must carry its own significance, in his view. That is why in 2011 he turned to tattooing. It wasn't easy to learn a new trade, and the road toward a professional career was littered with hazards; but Endhovian persevered, happy to give meaning to his existence. Every piece is unique, created with the love of a true craftsman, in black and gray, and blackwork.

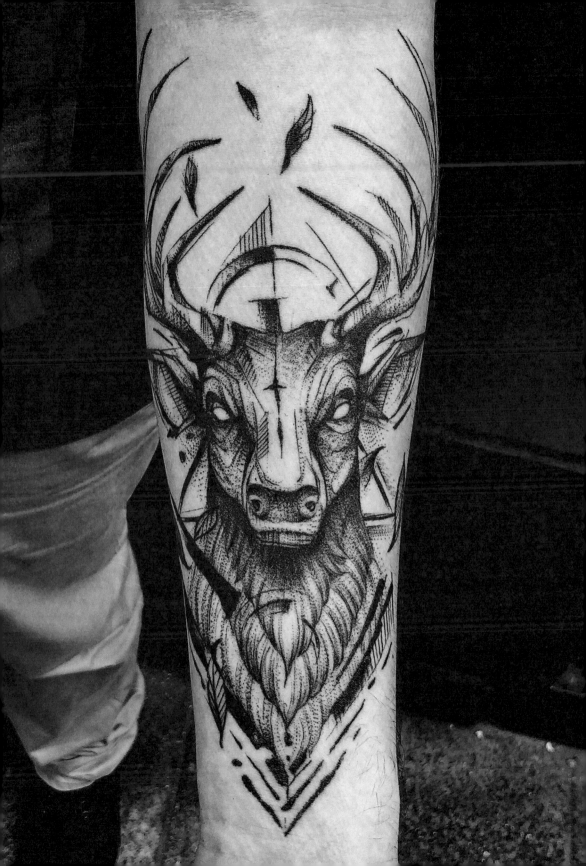

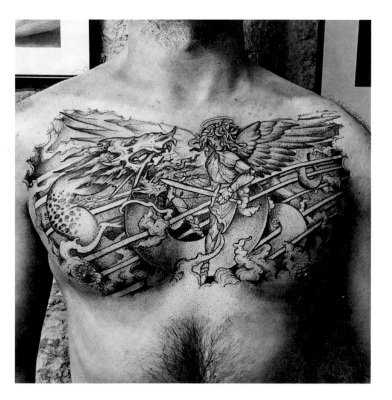

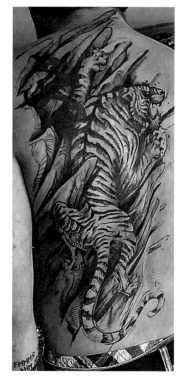

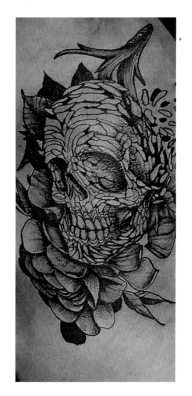

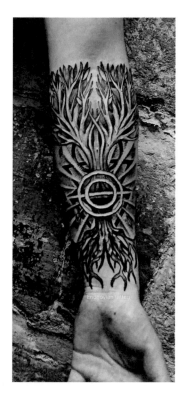

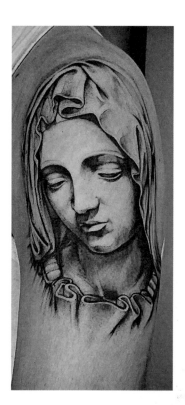

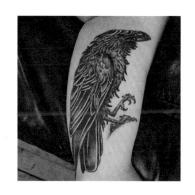

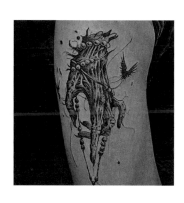

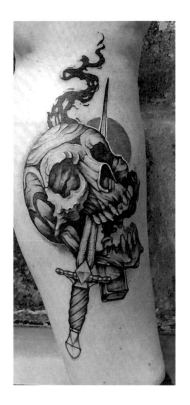

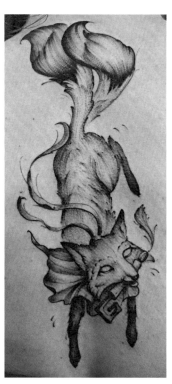

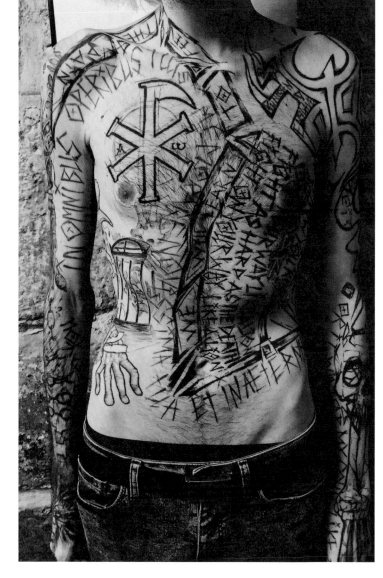

DAVID MORRISON

@DAVID_MORRISON_TATTOO
AIX-EN-PROVENCE, FRANCE

Looking a little like a punk John Belushi out of the Tattoo Brothers, David Morrison is a charismatic artist. Precision dotwork is his signature style; all of it in color, what else?

When David was a teenager, he discovered drawing and punk rock: a music style that he adores and which he would go on to play. The step into tattooing was, therefore, a natural one. His friendship with Eddy, the son of Alain Meyer of the famous Prestige Tattoo studio in Plessis-Trévise (his hometown, just outside Paris), also had something to do with his chosen vocation. David soon became part of Roberto Dardini's "dream team" at Art Corpus. He spent eleven years at the studio, before leaving Paris for the south of France with his wife and child. Although David has now joined the Fisherman Tattoo Club, he remains very close to his mentor—whom he visits once a month as a guest tattooer in his new Paris studio, Les Derniers Trappeurs. David is very attached to the craft aspect of his trade, and he loves to take an "old-school" approach to his work. Despite his preference for dotwork, David doesn't tie himself down to any particular style, aiming to satisfy his clients' requests above all. With his track record, he is clearly on a mission from god!

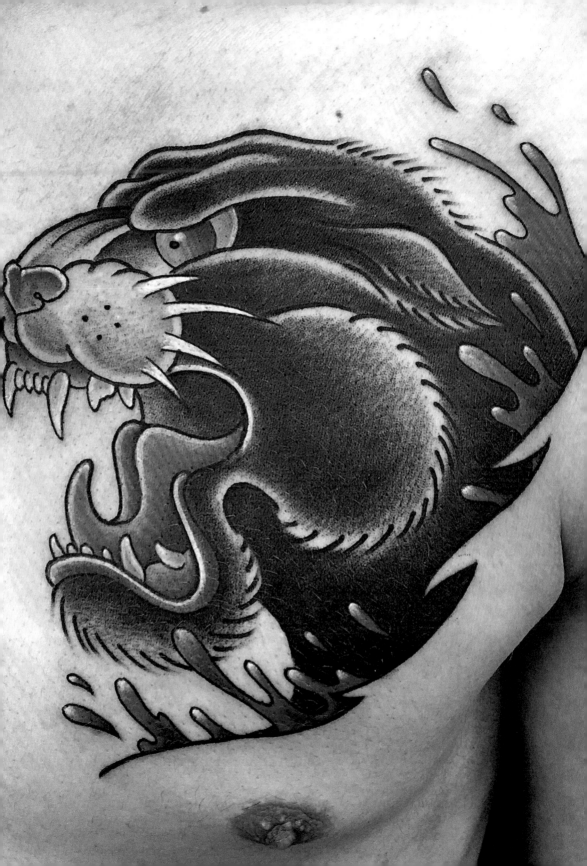

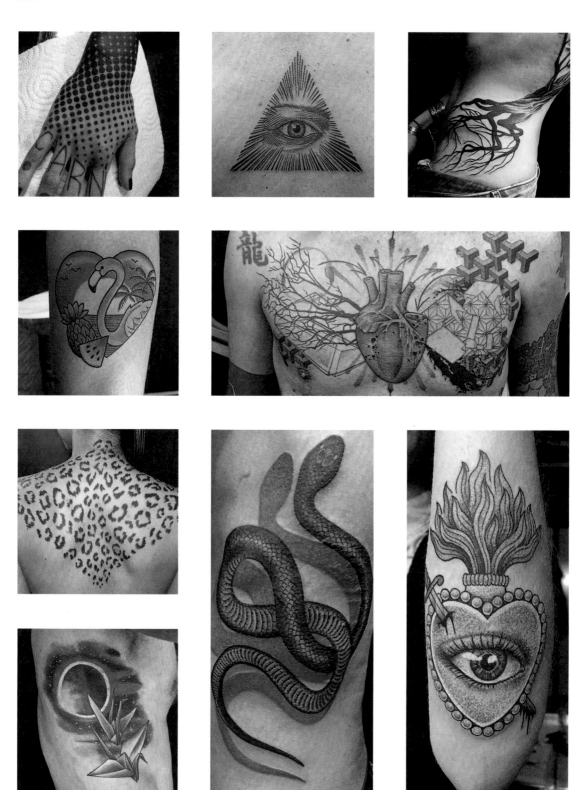

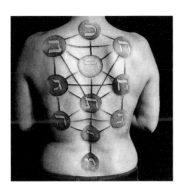

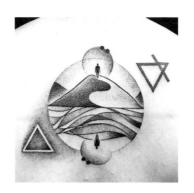

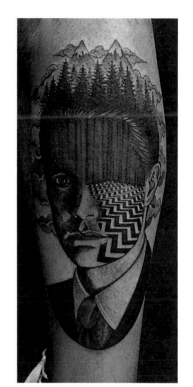

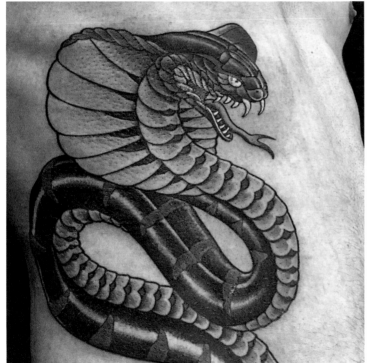

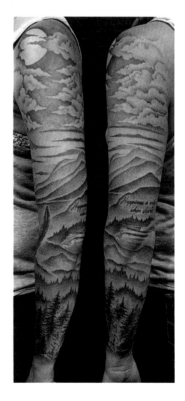

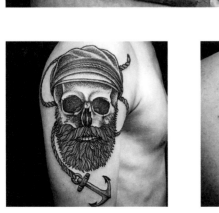

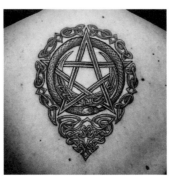

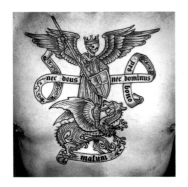

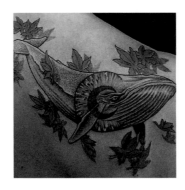

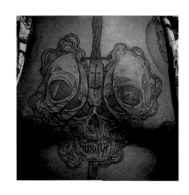

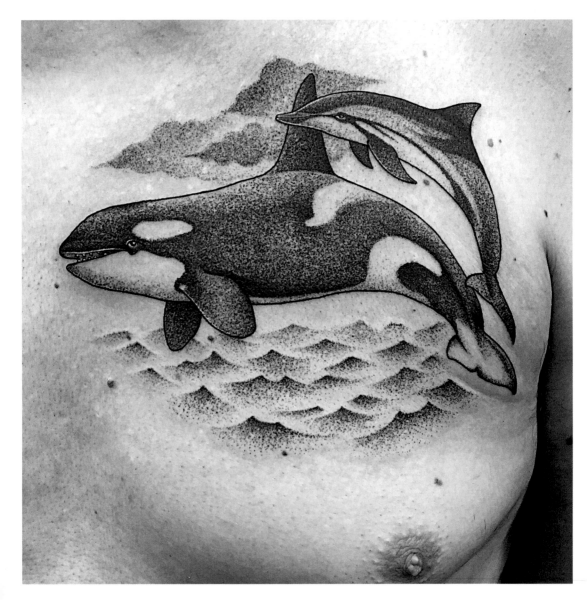

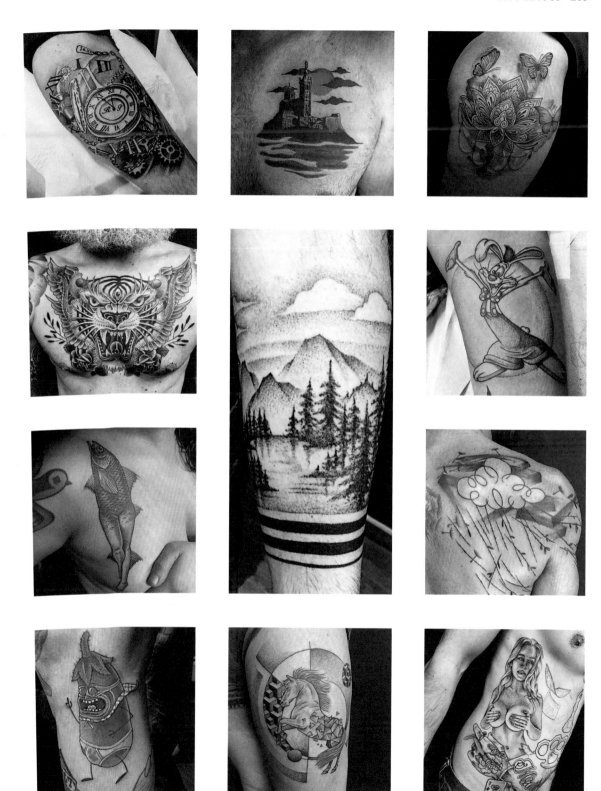

Photo credits

P. 2: ©Wang Da-Gang-China University of Mining Technology-Xuzhou; p. 3: ©Ann Ronan Picture Library Heritage Images/Getty Imaged; p. 4: ©Bridgeman Images/RDA; p. 5: ©Fine Art Images/ Heritage Images/Getty Images; p. 6: DR; p. 7: Omai -Joshua Reynolds, 1776: Collection privée/ DR; p. 8: Bridgeman Images; p. 9: ©Musée Carnavalet/Roger-Viollet; p. 10: Cesare LombrosoLuomo delinquente: Atlante Torino-Fratelli Bocca 1897/DR; p. 11: machine de Samuel O Reilly/DR ; p. 12: Sutherland McDonald/DR; p. 13: Yakuzas/DR; p. 14: ©Rue des Archives/Everett; p. 15: ©Hippies: Michael Ochs Archives/Getty Images; p. 16: ©Michael Scott Slosar/Contour by Getty Images; p. 17: ©Logo: Alliance of Professional Tattooists/D; p. 24-29: ©Scott Ellis; p. 30-33: ©Roberto Dardini; p. 34- 37: ©Andrey Svetov; p. 38-41: ©Corey Weir; p. 42- 45: ©Yome; p. 46-49: ©Tomas Tomas; p. 50-55: ©Chaim Machlev; p. 56-59: ©Maud Dardeau; p. 58 : © Gregory Conraux; p. 60-65: © Ben Viamontes; p. 66-71: ©Gakkin; p. 72-77: ©Rocky Zero; p. 78-83: ©Shamus Mahannah; p. 88-91: ©Norm; p. 88- 91: ©Nam; p. 92-97: ©Sadhu Le Serbe; p. 98- 103 : ©Arno Schultz; p. 104-107: ©Jeykill; p. 108- 113: ©Lisa Orth; p. 114-119: ©Lesha Lauz; p. 120-123: ©La Barbe Tattoo; p. 124-129: ©Volko & Simone; p. 130-133: ©Sanya Youalli; p. 134-137: ©Lorenzo Anzini; p. 138-141: ©Amiral Tattoo; p. 142-145 : © Jürg; p. 146-151: © Naoki; p. 152-157: ©Roma & Nick Broslavskiy; p. 158-163: ©Dimitris Chatzis; p. 164-167: ©Laura Satana; p. 168-171: ©Aga Mlotkowska; p. 172-177: ©Mark Wakefield; p. 178-181: ©John Ma; p. 182-185: ©Colin Dale; p. 186-189: ©Daru Manu; p. 190-195: ©Sergey Murdoc; p. 196-201: ©El Patman; p. 202-205: ©Christian Nguyen; p. 206-209: ©Rob Weiss; p. 210-215: ©Karolina Czaja; p. 216-219: ©Ote Hono; p. 220-223 : ©Sandra Massa; p. 224-229: © Javi Castaño; p. 230-233: © Endhovian Ovo; p. 234-239: ©David Morisson.